PRINTED
IN

NORTH
KOREA

Nicholas Bonner with
Simon Cockerell & James Banfill

PRINTED IN

NORTH KOREA

The Art of Everyday Life
in the DPRK

FROM THE PROSAIC
TO THE POETIC
6

THE MAKING OF A
NORTH KOREAN ARTIST
8

PRINTED IN
NORTH KOREA
14

CHOP MARKS
232

INDEX
236

FROM THE PROSAIC TO THE POETIC

In 2004 I was asked to co-curate the sixth Asia Pacific Art Triennial in Australia that, for the first time, would include work from North Korea. The brief I gave the artists was to depict the people of the Chollima Steelworks, not posed in heroic stances, but as they were in day-to-day life. The artist who stood out was Hwang In Jae – a small man, 61 years old, with white hair and an unassuming demeanour that gave no clue to his artistic talent. Over the years he and I discussed subjects ranging from the French Impressionists (whose work he had admired at university) to abstract work that he simply failed to engage with. For the commission he made a number of prints, including *Worthwhile Break* (p.46) and *Break Time* (p.47). Hwang In Jae and the other four artists were invited to the opening of the Biennale in December 2009, which for most of them would have been their first ever trip outside the DPRK.

More than a decade earlier, on my first visit to North Korea in 1993, I was struck by the level of artistry in everything I saw from subway mosaics to the simple beauty of product design. This was clearly a country that placed great value on artists and artisans to create Pyongyang, a city that would serve to inspire its residents and promote the revolution to visitors, whether from the hinterland or foreign countries. I may not have been influenced by the propaganda, but I was certainly fascinated by this unusual destination. That year we set up Koryo Tours, specialising in travel, film and cultural exchange with the DPRK, which allowed me to travel to the country on a regular basis.

I started collecting North Korean artwork and graphics on that first visit to Pyongyang. The best artists belonged to either Mansudae or Paekho Art Studios and the prints from these studios became an important part of my collection, which now consists of over 700 prints dating from the 1950s to today. The subject matter ranges from the prosaic (a potato researcher in a laboratory, a woman cleaning a bus) to the poetic (the towering pine forests of the north,

raging waterfalls and moonlit lakes). What they all have in common though, is the delivery of an unambiguous political or social message. Nonetheless, and as every print in this book testifies, the artistry, sensitivity and talent of artists in North Korea are evident in abundance.

Buying art in North Korea is not a problem, but buying good art can be fraught with danger. More than a few collectors have fallen for what appears to be a great work of art, not realising what they have purchased. As well as authentic works of art, there are also legitimate 'copy works' of popular pieces that are signed by the new artist while acknowledging the original. Forgery is seriously frowned upon in the DPRK, nonetheless I have seen works that are deliberate counterfeits. This is not helped by the lack of a recognised system of provenance and a lack of understanding of the history of North Korean art.

Older works from the 1950s tend to be woodcuts, but in the late 1970s linocuts printed with viscous inks came to the fore and are the most well-represented in this selection. Various styles can be seen in the following pages - from the reduction method (one colour applied and printed before re-cutting the lino and applying a second colour) - to applying various colours directly on to the linocut for specific areas. What is common is that no more than fifteen prints are made from each linocut, because after this the ink clogs up the cuts and the fine details are lost.

Art in North Korea ranges from the purely aesthetic to the politically laden. While simple decorative paintings and prints are produced for homes and restaurants, works for public display tend to be of the 'Juche realism' genre. The works are shown in exhibitions and printed in magazines with the aim of imbuing the public with a sense of pride and purpose: no matter how mundane your job, you are an important part of the revolution, the country therefore remains strong and will care for you. Many prints, especially those selected for the annual year book on the arts, are simply archived, but some make their way into the hands of foreign visitors browsing in one of the art studios.

Each print, including every one in this book, was made to be believable and to resonate with a Korean audience even if, in some cases, it is an exaggerated, almost technicolour, reality. I sincerely hope that this selection of prints will resonate with readers as works of great skill, and in their own way beauty, as an important reminder that North Korea is a three-dimensional country filled with people and places that go way beyond the headlines.

This was exactly why Hwang In Jae was so happy to be involved in North Korea's first truly international exhibition. Sadly, he and the other artists did not attend the 2009 opening to see their works on display. They were denied entry by the Australian government on the grounds that they were artists from art studios associated with propaganda aimed at glorifying and supporting the North Korean regime. It appears politics is always part of the agenda. Hwang In Jae's dream of visiting are no longer possible - he died a few years ago.

Nicholas Bonner

THE MAKING OF A NORTH KOREAN ARTIST

What is it that makes an artist? And is it any different for a North Korean artist? Mainstream media tends to talk about North Korea as a bastion of otherness, total in its oddity and difference, scary and unpredictable. I would like to turn the tables and look at North Korea from the inside out. The focus here will not be on the state, the political system, or the domineering figure of the Leader, but on the individual artist. In changing the perspective, I hope to momentarily disrupt the ingrained ways of seeing North Korea and take a view that offers insights that will enrich the way we engage intellectually with North Korea.

The making of an artist in North Korea, as elsewhere in the world, is generally understood to be rooted in a combination of an unusual power of observation and a unique strength of expression. The former depends on the ability to see, sense and read reality more broadly and deeply than other people. It presupposes a physical, sensual and emotional openness to the world, and the talent to capture an essence that is more intense than what is immediately apparent. The latter relates to the ingenuity of the artist in conveying these sensory impressions in such a way that they touch the viewer. Only a uniquely gifted individual whose talent has been honed to perfection is capable of creating artwork that leaves an everlasting impression. The truism that only great artists beget great art also holds in North Korea.

While it may have much in common with the rest of the world when it comes to the making of an artist, when it comes to the art itself, North Korea is very much an outlier. Decrying art for art's sake as a bourgeois deviation, North Korea does not see art as a self-referential realm. Instead, art holds a subsidiary position in the service of the people, the Workers' Party and the Leader. North Korea has no qualms about admitting that art and culture are an explicit part of an elaborate propaganda system that answers to the

Workers' Party. The (North) Korean Artists' Federation sees to it that art fulfils its assigned ideological, political and social mission and upholds the party line. It does so by overseeing art education, organising professional artists, and vetting all works of art according to their 'aesthetic and ideological character' before their release into the public domain. For all intents and purposes, the Workers' Party is the patron of the arts, which explains why art for art's sake is a non-starter in North Korea.

Seen from a contemporary western perspective in which it is generally understood that true art is the expression of unbridled creativity and artistic freedom, it may feel like an oxymoron to speak about art in such a constricted context. In practice, however, the creativity of North Korean artists is not crushed but rather steered and managed by educational and professional institutions. The institutionalised North Korean art system is geared towards identifying and tracking young talent from a very young age. If children indicate an interest in art, they are encouraged to attend afterschool drawing classes where they learn basic sketching and drawing skills. Additionally, parents may approach professional artists for private tutoring for their offspring. At the age of sixteen, persevering youngsters showing potential can proceed to pre-university classes that put them on a track towards a career as a professional artist.

The most decisive next step is to gain admission into the Pyongyang University of Fine Arts (PUFA), the pinnacle of art education in North Korea. At PUFA, students are immersed in academic-style classes dedicated to a single fine art form and their training is further augmented with art history and theory instruction. It is at PUFA that ideology takes over and moulds creativity, where students study the meaning and purpose of art in North Korean society and discover the social obligation that comes with being a professional artist. They learn to direct their creativity towards subjects that glorify the Leader and the revolution, that support the party line, that inspire national pride and enthuse the people. Upon graduation from PUFA, a career as a professional artist beckons in one of the numerous art studios around the country. Cities, provinces and several government ministries have their own art studios producing artwork that highlights local interests, or in the case of the Railway Ministry, the Ministry of Public Security and the armed forces, artwork that reflects and encourages the *esprit de corps* of its employees.

However, no art studio in North Korea is more prominent than the Mansudae Art Studio in Pyongyang. Testimony to the political importance of art in North Korea is the fact that the Mansudae Art Studio operates under the special guidance of the North Korean Leader, who is not only a frequent visitor to the studio, but also provides 'on-the-spot guidance' and shares theoretical insights with the artists. Mansudae employs close to 1,000 artists, covering the entire gamut of the visual arts, from drawing, painting, calligraphy, printmaking and embroidery to pottery, sculpture, mosaic and monumental art. This number is augmented by another 3,000 craftsmen who produce on site art supplies such as paper, paint, brushes and mosaic tiles used by the artists,

or who contribute manual labour for the execution of large-scale monumental art projects. The artists are organised by art form in various creative teams that are further subdivided into work groups, spread out over a number of shared work rooms where artists occupy individual work stations. Only a select number of individual studios are available for a small number of artists, which reflects the social hierarchy and the seniority-based ranking of artists within the art studio.

Mansudae provides a close-knit social environment where artists mix moments of intense focus on their own art with social and leisure activities, communal work duties and collective study sessions. The vast compound is a proper campus where employees have the use of a barbershop and beauty parlour, a spa and health club, sports fields and fitness facilities, a kindergarten and a convenience store. This material largesse on the part of the state is an indication of the political importance of art in North Korea. Public accolades and awards, such as 'Merited Artist' and the more prestigious 'People's Artist', which are granted by special order of the North Korean Leader for a particularly impressive artwork, further add to the high social standing artists enjoy in North Korean society.

As employees of the art studio, artists execute orders or commissions. Mansudae Art Studio is one of the main centres for the creation of the many monumental art projects that mark historic sites and public spaces throughout the country. When a public art commission is received, artists in a particular creative team produce a set of designs for the Leader, the Party or the government to choose from. During the execution phase, depending on the size of the project, artists from other studios, or PUFA staff and students are drafted in to finish the work on schedule.

Creative teams or work groups are also mobilised to contribute artwork for the interior decoration and ornamentation of public buildings and museums. Such artwork typically involves the paintings of the Great Leader(s) that greet visitors in the vestibules of schools, factories and hospitals, but also the murals that are regularly encountered in the lobbies of hotels and cultural palaces, or the numerous historical paintings on the walls of museums in Pyongyang and beyond. Leader paintings can be the work of individual artists affiliated with a work group specifically dedicated to the production of these works, while large-scale works are typically collective works. The production of a collective work is not merely a matter of expediency, but also ideologically motivated. The belief is that the quality reached by a joint endeavour exceeds the individual talents of the artists combined.

Although such work assignments are an integral part of what it means to be an artist in North Korea, they do not monopolise all the working hours of an artist. In fact, when they are not on assignment, the primary task of professional artists is to produce original artwork, driven by nothing but their own character, interests and inspiration. From a North Korean perspective, these two aspects are not in conflict, but rather are commensurate. The only difference for the artist is the fact that in the former case, the work is

initiated by commission. In terms of dedication, creativity and execution, the work process is identical because ultimately the same evaluation criteria, the aesthetic and ideological quality as judged by the Korean Artists' Federation, applies to both.

North Korean artists are invested in society. They take great pride in their work and receive public, material and institutional recognition for fulfilling their assigned role in society through the exhibition of their work, and the commendations and bonuses they receive, are all at the behest of the Korean Artists' Federation. Their inspiration comes from life, but their eye and mind is guided by a preordained set of acceptable themes. They find beauty in an ideologically grounded view of life and depict it as the culmination of a unique historical and revolutionary process. Their work expresses a contentment that is best summarised by the slogan seen on many North Korean school buildings, 'Nothing to Envy'. From a young age North Koreans learn that there is nothing to envy because they are blessed with a carefree existence under the wise rule of the benevolent Leader.

That is what 'Juche realism', North Korea's unique version of socialist realist art, seeks to impart, but it is also the core message of the North Korean propaganda system in general. Eager to affirm North Korea's exceptionalism in art, Kim Jong Il devised the term 'Juche realism' in his 1992 treatise *On Fine Art*, which remains to this day the bible of North Korean art theory. Juche realism reflects Stalin's iconic definition of socialist realism – that it be socialist in content and national in form. However Korea's unique aesthetic sensibilities, epitomised in Korean-style ink wash painting, define the Juche realist style. North Korea's monolithic ideological system which declares the Leader the guarantor and protector of North Korea's socialist system, provides a hierarchy of thematic subjects for artists to depict.

In the hierarchy of genres that governs North Korean art production, nothing compares to the 'theme paintings' that document the life and struggles of the Leaders, the revolutionary history of the Workers' Party of Korea, the development of the Workers' Paradise and finally the struggle for Korean unification. After theme paintings, landscape paintings are the most important. And at the bottom of the pack linger still-life paintings, traditionally known as 'flower and bird paintings'.

Theme paintings can best be understood as ideological allegories that depict a bond between the Leaders and the historical fate of the nation. Countless artworks revisit the Leaders' presence in the North Korean revolution and the post-revolution construction of the workers' paradise. Numerous are the depictions of the happy lives of the people under the Leaders' reign, where the toiling masses are cheerful and the harvests bountiful. Landscape paintings and prints, for their part, evoke the beauty of a blessed nation, graced by the presence of the Leaders, and still-life paintings summon images of abundance. At its most innocuous, such artwork simply depicts ordinary everydayness. However, by creating scenes from everyday life, North Korean social norms, practices and institutions are captured in an ideological hue.

The everyday life that North Korean artists portray is the social and organisational life of the people. Their artwork communicates the notion that the meaning of life is to be found in work and service to the community and the state. Rather than the private life or emotions of a single individual, the focus is on the emotional power that stems from the camaraderie among partisan fighters, steelworkers and farmers as they join forces to chase production targets, improve harvest yields or clean up the neighbourhood. When people sit for portraits, their personality is caught in an aura of work pride, dedication and diligence. They are shown as true labour heroes in their work garb, either at their work stations or with relevant props.

Whether everyday pastoral scenes, depictions of the boisterous industriousness at construction sites, the smoking chimneys of industrial landscapes, or the portrayal of the bold physicality of steelworkers, North Korean art tends to exude an air of cheerful happiness, blended with a sense of purpose, conviction and determination that ideologically evokes loyalty and trust in Leader and Party. These cheerful scenes are often punctuated with slogans and banners that provide an all-important political context. In contrast, other images portray the desperate struggle for reunification by South Korean citizens, or the abysmal state of exploitation of the downtrodden masses in pre-revolutionary Korea depicted in history paintings.

North Korean artists find inspiration in, and document, North Korean life, past and present. Their understanding of life is rooted in a deep ideological awareness of the history and current state of the nation. Their artwork aims to reveal the heroism of the seemingly trivial lives of ordinary people. By making it the subject of art, artists lift everyday life out of the ordinary to an aesthetic and ideological height. Artists only succeed in doing so convincingly because they have experienced life. North Korean artists study history, visit factories and construction sites, climb mountains and meet people. Along the way, they pull out their sketchbooks, take photographs and collect impressions. They observe reality with an ideologically trained gaze and capture fragments of meaningful life.

Back from their forays in the country, artists get to work on transposing their lived experiences into works of art. The effectiveness of this effort depends on the selection of a scene that is sufficiently eloquent without being too obvious. The challenge for an artist is to create a canvas in such a way that a single depicted moment opens on to a story that the composition gradually gives away, training the eye of the viewer to an aesthetic insight that exceeds the immediately visible. This is where, in North Korea, under the inescapable spectre of propaganda, great works of art bear the hallmarks of personality and character paired with skill and technique.

Koen De Ceuster

ART
NOT RELATED
WITH THE
REVOLUTION,
ART FOR
ITS OWN SAKE,
IS USELESS

Kim Jong Un

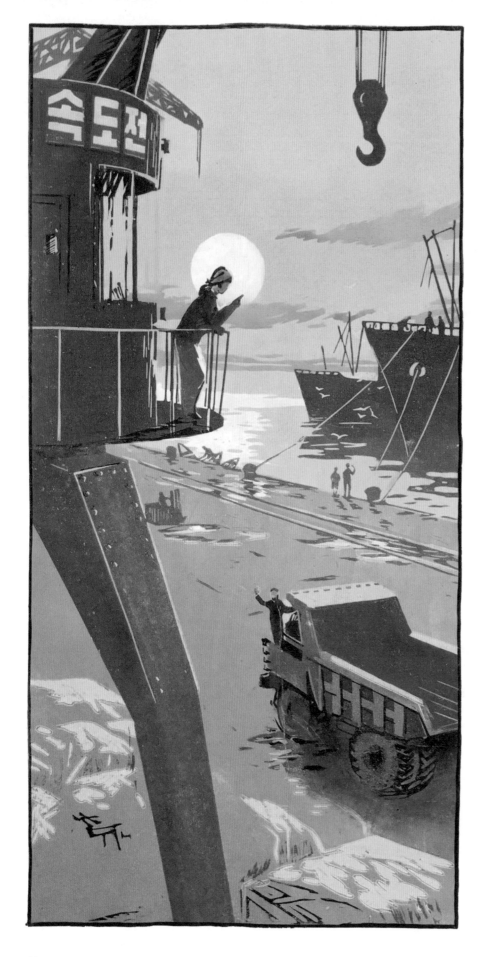

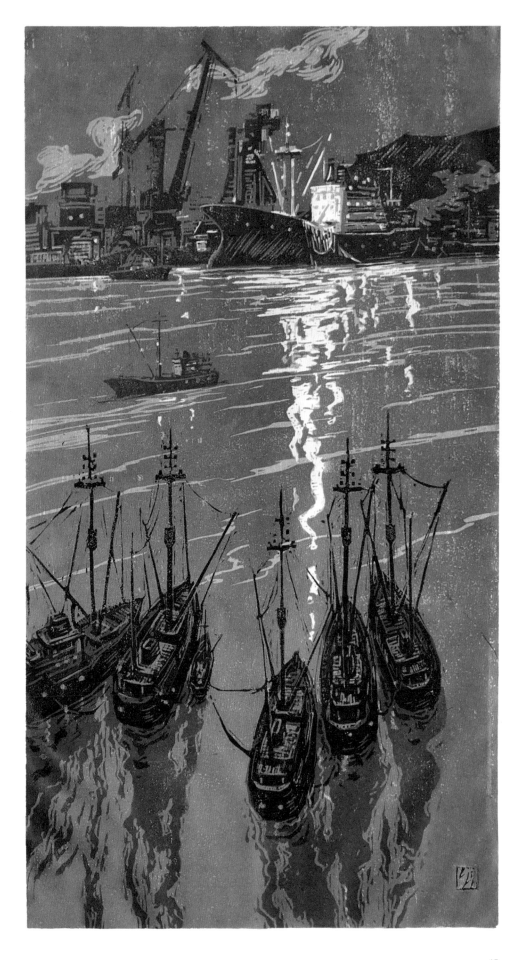

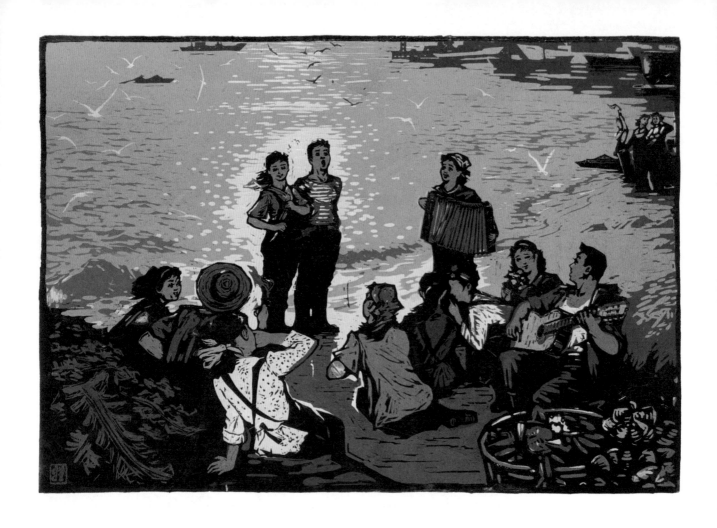

PREVIOUS PAGES LEFT: *Night at the Port* by Ri Yun Sim, 1983. An evening scene as a crane operator catches up on her revolutionary reading. In North Korea, ideological study is as much a part of the workplace as practical tasks and manifests through study sessions, self-criticism and campaigns. The sign on the side of the crane reads 'Speed Battle', a slogan from 1974 that encouraged workers to accomplish projects at breakneck pace. PREVIOUS PAGES RIGHT: *Night at the Port* by Ju Si Ung. The armistice agreement of 1953 created a military demarcation line that splits the Korean Peninsula between north and south with a roughly four-kilometre-wide Demilitarised Zone, known as the DMZ. However, the sea border was not included in the agreement and has led to clashes with the South, mainly on the West Sea. Where the North and South both agree is that the East Sea should not be called 'The Sea of Japan' and that the Japanese have no right to ownership of the disputed Dokdo Island.

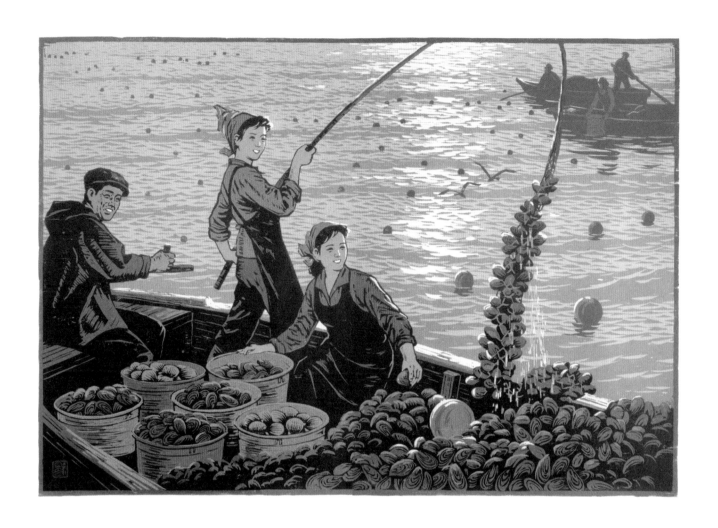

OPPOSITE: *The Girl and the Boy* by Song In Chol, 1978. The girl and the boy sing to the accompaniment of an accordion and guitar in a harbour town. Outdoor picnics accompanied by music are a common type of social gathering. The heroism and romanticism of 'youth' and its contribution to the future of the nation is a common theme in North Korean art, film and literature. ABOVE: *Sea Farmers* by Ri Sok Nam, 1988. Workers pull a harvest of mussels, suspended on ropes by glass floats, from the sea. In Korea, there is a long tradition of women's involvement in aquaculture alongside men in seaside communities. In *Song of the Sea* a North Korean neo-traditional ballad, the 'seafood-processing team maidens' support the men of their community in the fishing fleet - a socialist realist spin on an age-old culture.

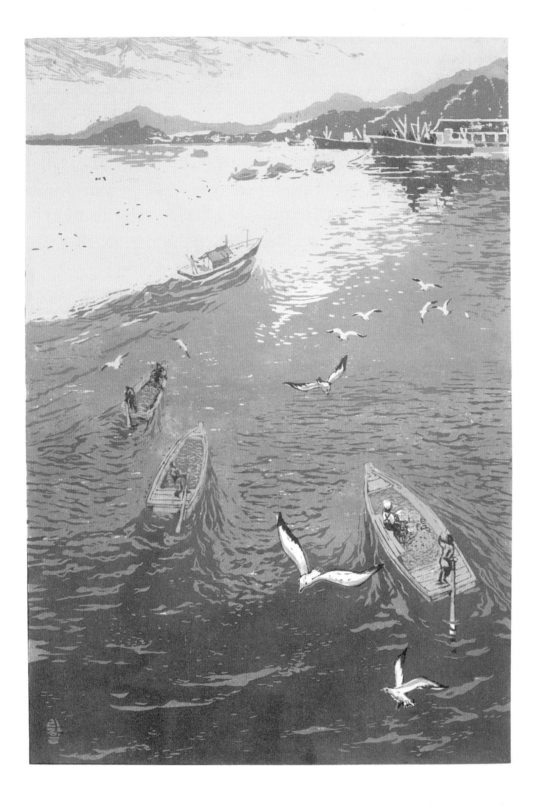

ABOVE: [Untitled] by Ri Kang Il. In 2014, Kim Jong Un visited the Eighteenth Fishery Company and placed increased emphasis on developing the 'golden seas' surrounding Korea. Maps of Korea always show both sea and land as one country and North Koreans refer to the country as having a 'division' but not a 'border'. Elsewhere to the north, north-east China is landlocked, so many Chinese companies trade with the DPRK for their fish reserves. OPPOSITE: *Kelp* by Ri Sun Sil, 1985. Kelp is dried and used as an ingredient in some traditional Korean broths, teas and side dishes. Kelp from Rajin, in the north-east of Korea, is recognised for its size and flavour. In 2017, North Korea opened a new algal research institute, focused on aquaculture-based technology and innovations.

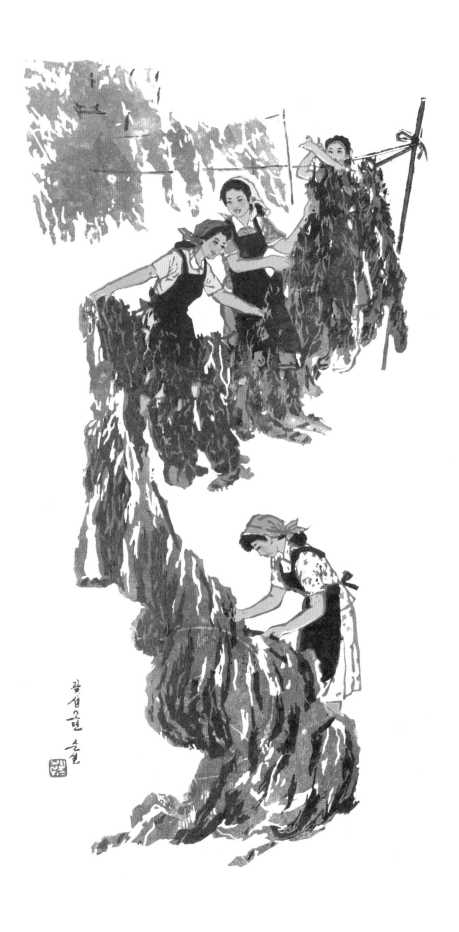

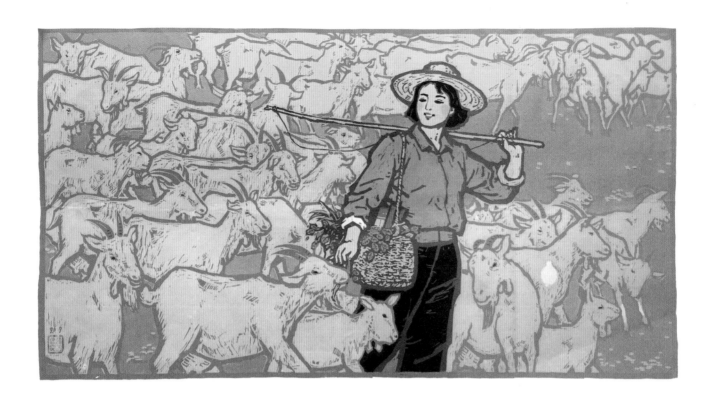

PREVIOUS PAGE: *Autumn in Chongsan-ri* by Ri Pong Chun. Part of the slogan 'Fertiliser is Rice and Rice is Socialism!' stands in the field highlighting the long-established preference for industrial agriculture in the DPRK where fertiliser is chemically manufactured. However, today the majority of farming is done by hand, most fertiliser is organic and machinery is a luxury. The red flags in the field denote the presence of a work team.

ABOVE: *Goat Herder* by Pak Hwa Sun, 1996 and OPPOSITE: *Joyful Farmers* by Kim Pun Hui. North Korea's territory is around eighty per cent mountainous and largely unsuitable for anything but grazing, fruit trees and forestry. Almost all arable land is utilised for crops, mainly rice, maize and potatoes. Both pigs and goats are unfussy eaters and provide opportunities for providing meat where conditions are tough. Not an inch of space is wasted in the North Korean countryside. Farmhouse roofs are used for drying chillies, climbing crops such as pumpkins grow on walls and fences, and livestock is raised both in collectives as well as by individual farmers.

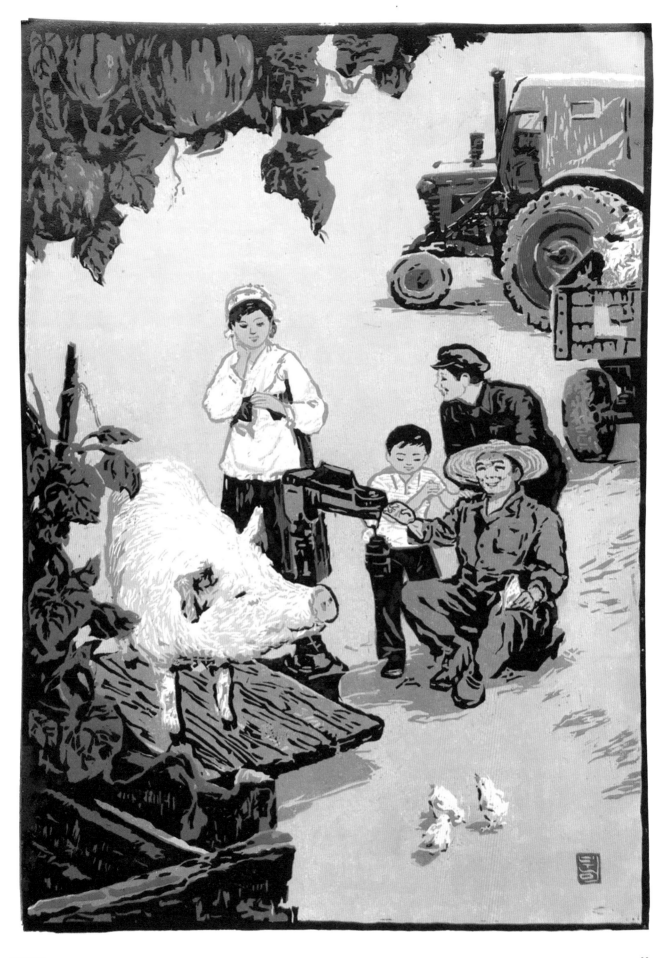

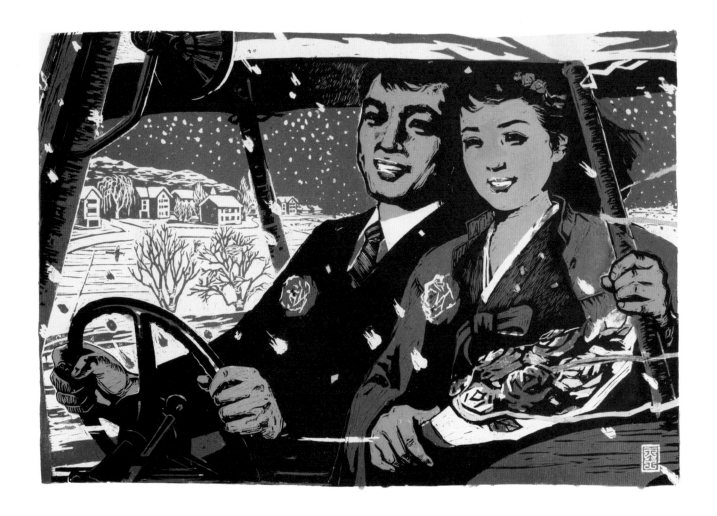

PREVIOUS PAGE LEFT: *Good News* by Yun Ok Kyong. In early spring, rice seedlings are prepared in seedbeds of fertile soil and protected from the elements by plastic or straw mats. According to folk tradition, magpies herald good news, in this case the coming of spring and a potentially abundant harvest. PREVIOUS PAGE RIGHT: *Support* by Ho Kang Min, 2010. Gifts of food arrive for those working on the construction of the Huichon Power Station. The dam was completed in 2012 and has a strong symbolic meaning in North Korea as a project carried out at a surprisingly fast pace despite adverse conditions. 'Huichon Speed' and the 'Huichon Hour' are now common terms to describe a task being carried out quickly and efficiently.

ABOVE: After a wintry rural wedding, this happy couple are driving off in a tractor. Traditionally marriages are arranged by parents. These days young couples are more likely to make their own choice of partner, but family approval is still extremely important and parents may 'introduce' many potential candidates. The standard age of marriage for women is 25-28 and for men 27-30. Traditionally, it is the duty of the older son and his wife to move into his parents home to take care of them. OPPOSITE: [Untitled] by Jon Chol Nam. A 'Red Flag' electric goods train runs from an industrial complex through precisely laid out rice paddies. Electrification of the railways in North Korea was a major government project started prior to the Korean War and picked up again from the late 1950s to the early 70s. Unfortunately, since that time the electrical supply has been somewhat unreliable and as a result diesel trains are more likely to run on time.

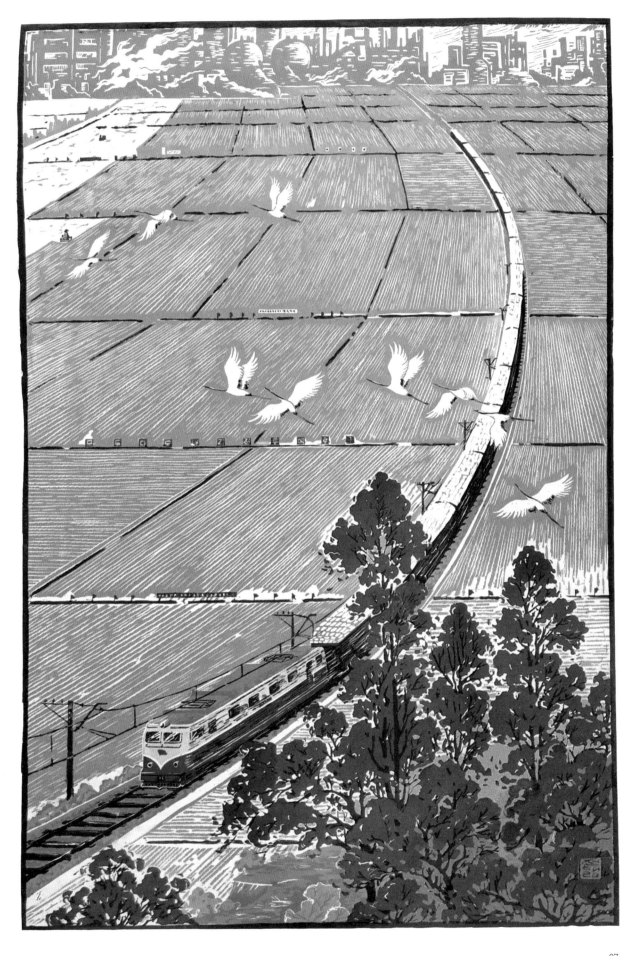

OPPOSITE TOP: *Night* by Kim Chol Un, <u>OPPOSITE BELOW</u>: [Untitled] by Jo Yong Pom and <u>ABOVE</u>: *Morning* by Tong Ha Nul, 1999. In the DPRK almost every task can be presented as a 'battle' of some kind and the militarisation of terminology in fields like agriculture goes along with behaviour such as marching in formation to and from work. During critical times of the year such as planting and harvest, workers will work, eat and rest together throughout the day. This serves to demonstrate to participants the crucial importance of unity in undertaking matters of national importance. But rural life isn't all campaigns and battles. While most agricultural work is group-oriented, it is largely concentrated around planting and harvest times. Throughout the year there are opportunities for solitary activities such as tending the fish farms and individual plots, small parcels of land around farmers' homes managed by the family outside of the co-operative framework.

ABOVE: *Girl in the Forest* by Kim Kuk Po, 1989. A girl tends to livestock in a remote mountain valley.
A popular film, *Ask Yourself,* features an urban girl who volunteers to become a herder in a remote
valley and becomes a Party member for her dedication. Long-term service in remote regions is often
a prerequisite for acceptance or advancement in the Party.

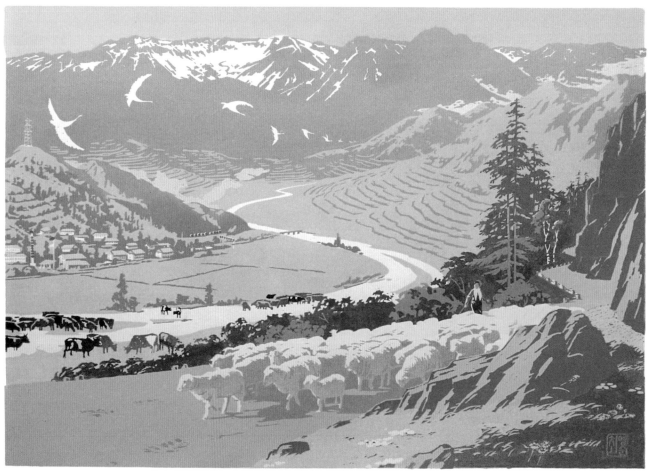

TOP: [Untitled] by Ri Sun Sil, <u>ABOVE</u>: [Untitled] by Choe Yong Sun and <u>OPPOSITE</u>: *Good Harvest* by Sok Nam. These prints illustrate idealised rural scenes, rather than the reality of farming in North Korea. The DPRK invested heavily in mechanised agriculture in the 1960s and 70s, but with the loss of trading partners following the collapse of the socialist market and severe weather conditions, the country suffered what is referred to as the 'Arduous March' in the mid-1990s in which food shortages and famine had a devastating impact. Idealised artworks during this period give the impression all would soon improve. Slogans included, 'Let's smile, even going through a hardship' and 'Let's live for tomorrow, not for today'.

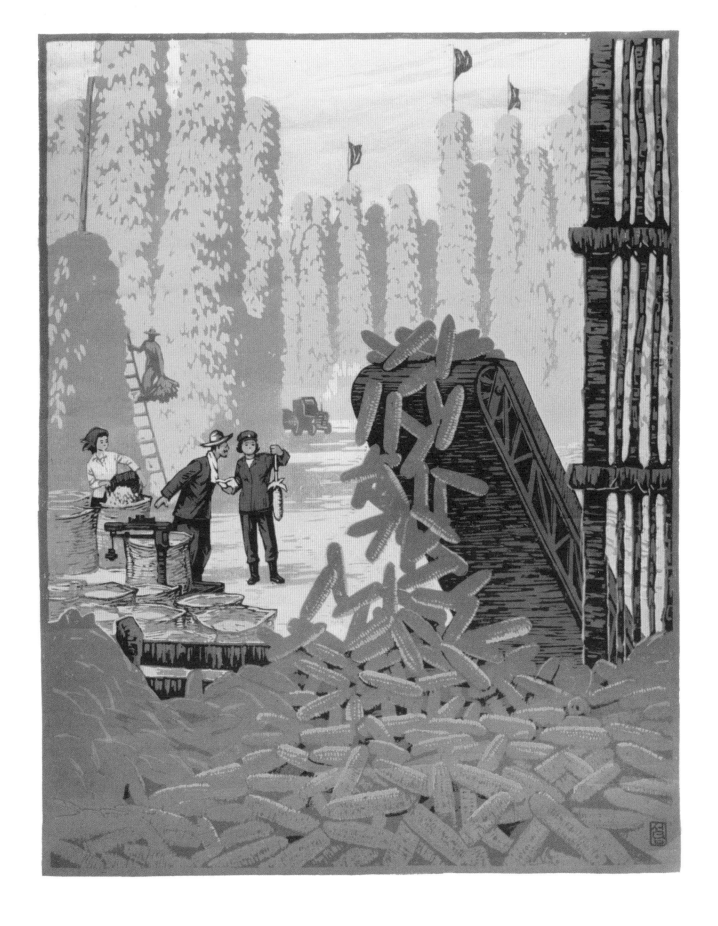

ABOVE: [Untitled] by Jae Won, OPPOSITE TOP: [Untitled] by Hang Song Ho and OPPOSITE BOTTOM: [Untitled] by Jang Song Pom and Ri Hong Chol, 2010. Whether it be industrial workers commuting on bikes, co-workers checking on the coal-fired power station in Pyongyang, or rice seed researchers and their bundles of rice plants, film and art often promote the idea of communal pride and joy centred around the workplace as well as dedication and service to the collective, the revolution and the Leader. Many towns and cities in North Korea rely heavily on one or two major industrial plants, for example Nampo's heavy industry and steelworks, while Hungnam produces chemical fertiliser.

FOLLOWING PAGE: *Artistic Propaganda Group* by Kim Kwang Nam, 1999. Female members of an art and propaganda troupe come to encourage and congratulate members of the 'Cha Kwang Su Youth Shock Brigade'. Shock Brigades are typically mobilised to volunteer in speed campaigns at construction sites. The prominence of the slogan 'We do Whatever the Party Decides' is striking and gives this work a particularly ideology-laden glow.

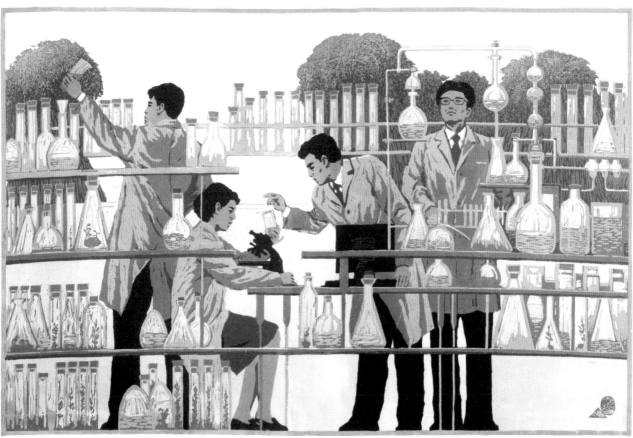

THE MASSES OF THE PEOPLE ARE MASTERS OF SOCIALIST ART & THEY ALSO CREATE & ENJOY THEM

Kim Jong Un

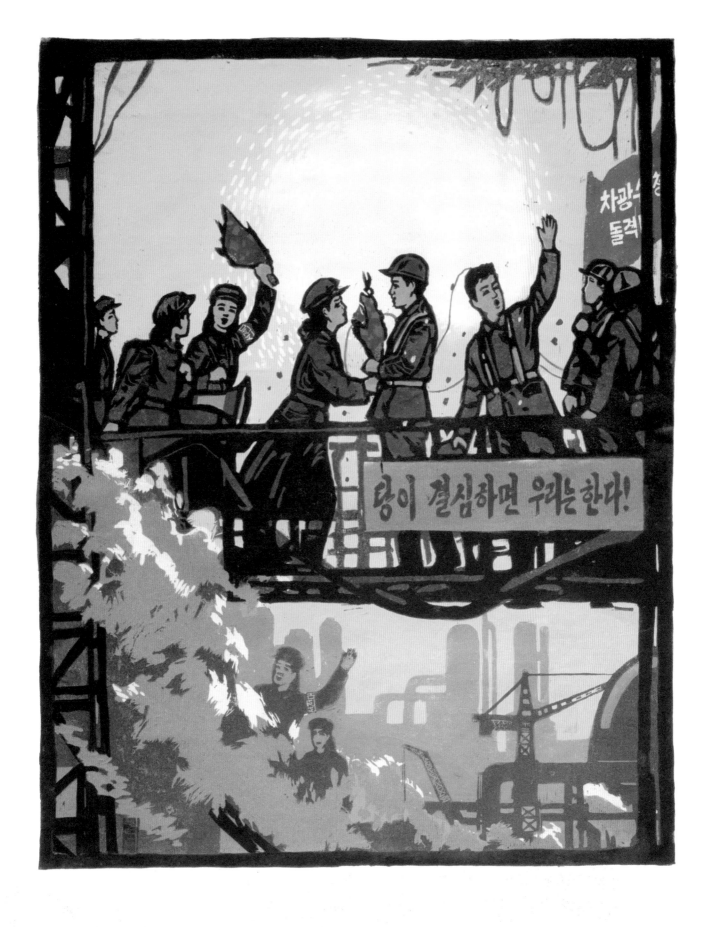

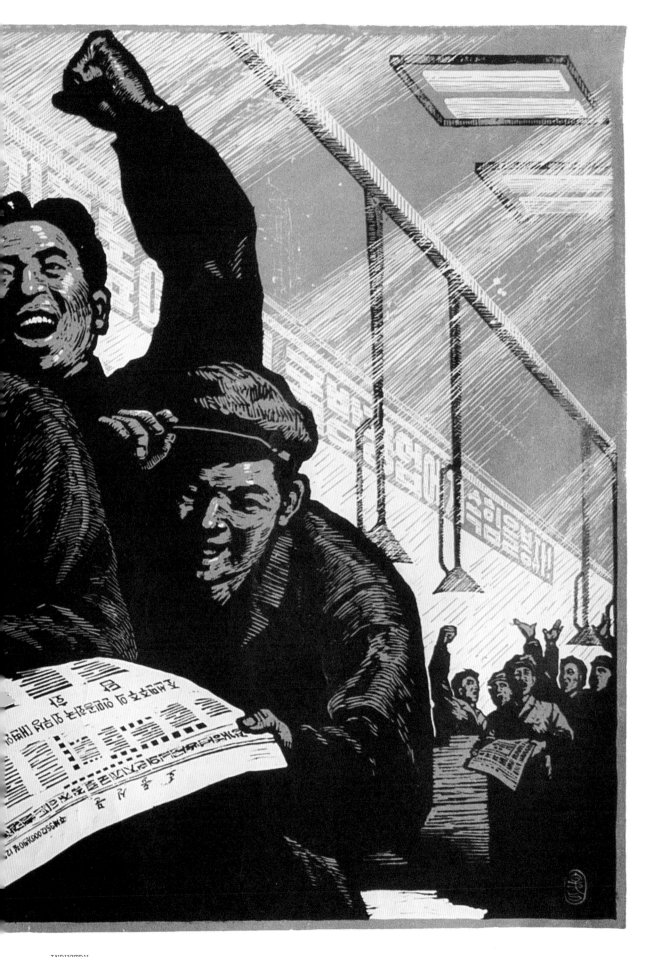

PREVIOUS PAGE: *With Our Skill and Strength* by Ri Hong Chol, 2004. Factory workers celebrate as they read about their impressive exploits in the newspaper. The slogan on the wall above the men's heads reads 'Let's Continue to Focus on the Defence Industry Following the *Songun* Policy'. *Songun* literally means 'military-first' and the policy gives priority to the military above all other sectors. Songun was first mentioned by Kim Il Sung in 1930 at the Karyun Conference, and it is believed that Kim Jong Il developed it in 1995 during his 'on the-spot-guidance' of the Tabaksol Guard Post.

ABOVE: *Our Factory* by Pang Son Hwa, 1971. There are still active steam trains in the DPRK, many of them dating back to the 1930s, and they are used mainly in mines and in locations like the Sunchon Cement Plant shown here, one of the most famous and iconic industrial sites in the country.

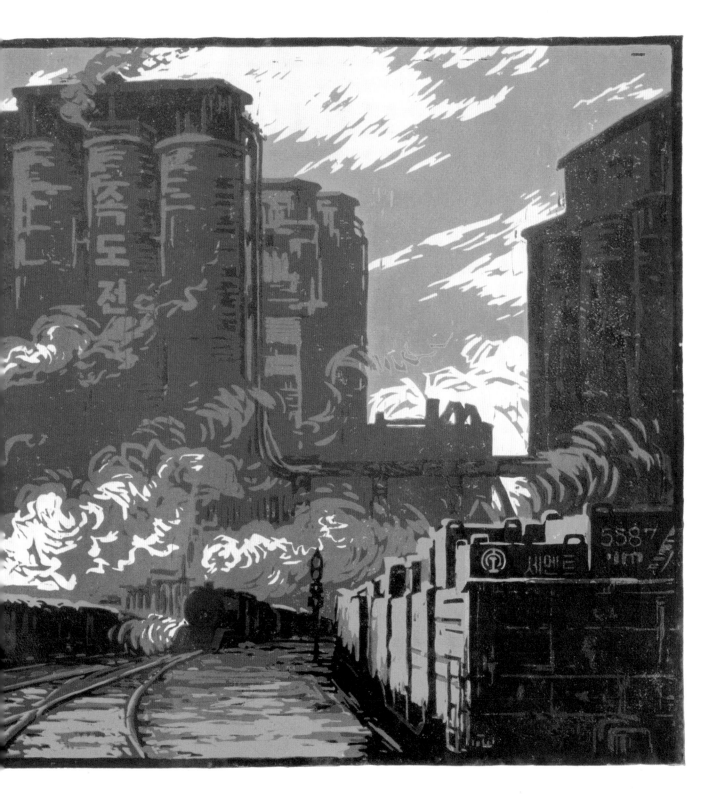

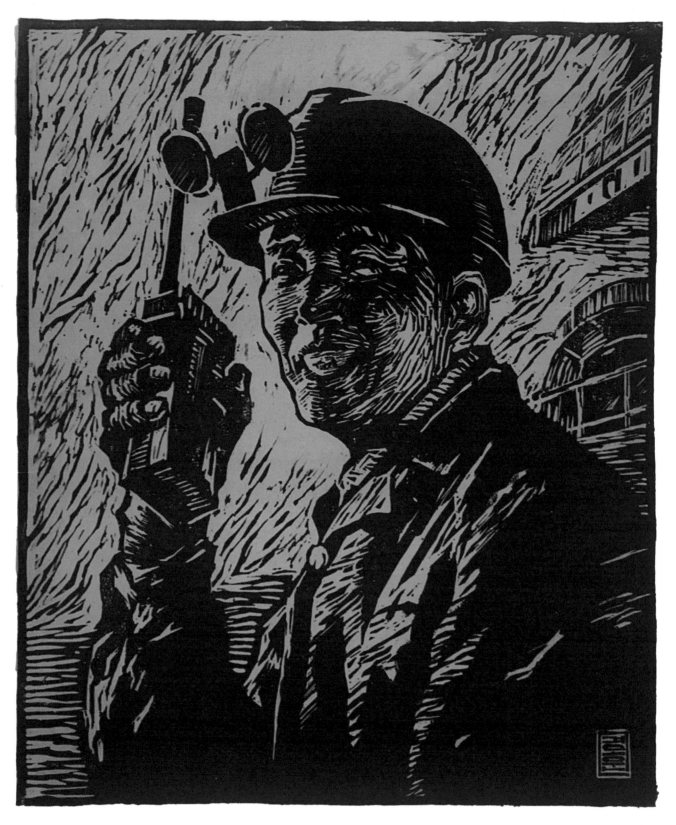

ABOVE: *Flames* by Kim Kyong Hun, 2007 and OPPOSITE: [Untitled] by Min Song Sik. During the colonial era, Japan industrialised the northern half of the Korean Peninsula due to its abundant mineral resources, deep-water ports and hydroelectric potential, while the southern part of the peninsula remained largely an agrarian-based economy. Recognising the critical importance of steel to the development of the economy and following in the footsteps of the Stalinist heavy industrial model, Kim Il Sung is said to have made the 'decision in the fork of the road' to visit the workers at Kangson Steelworks before visiting his own family in the nearby village of Mangyongdae.

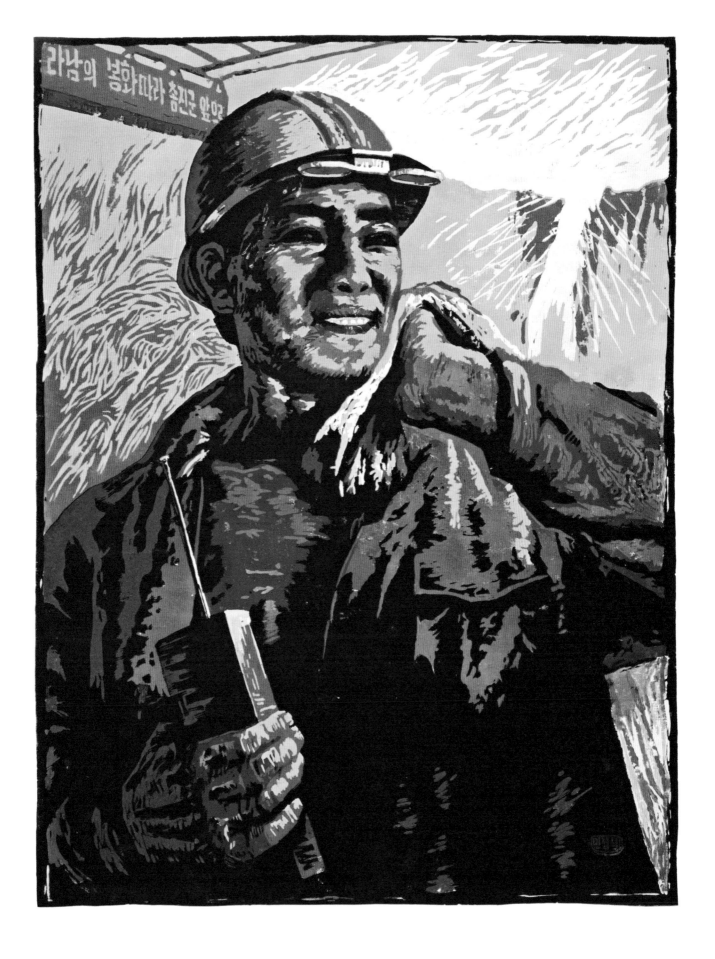

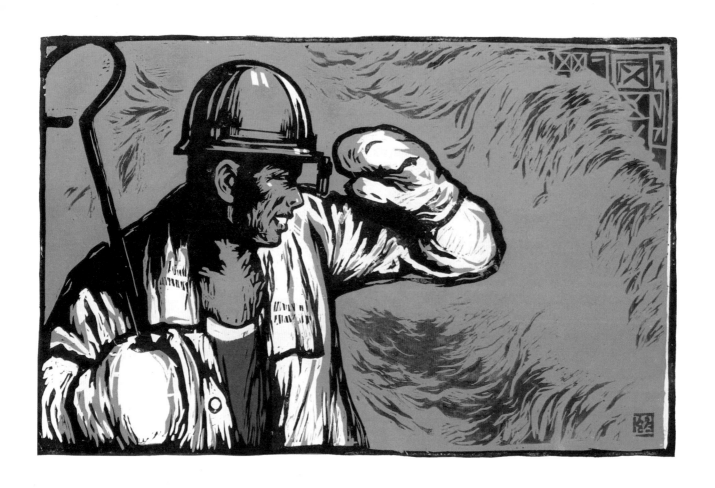

ABOVE: *Steel Soldier* by Han Sung Won, 2004 and <u>OPPOSITE</u>: *Steelworkers* by Rim Chol. Much of North Korea's industrial base was destroyed during the Korean War, and there was an enormous demand for steel for the country's reconstruction. The Kangson Steelworks was rebuilt over the ruins of the Mitsubushi Steelworks and went into overdrive. In 1956 its increase in production launched a speed campaign known as the 'Chollima Movement', which spread throughout the country. The Kangson Steelworks, renamed the Chollima Steelworks in 1989, became a North Korean icon and launched a culture around steel production that permeated society and continues today, as made evident by these prints.

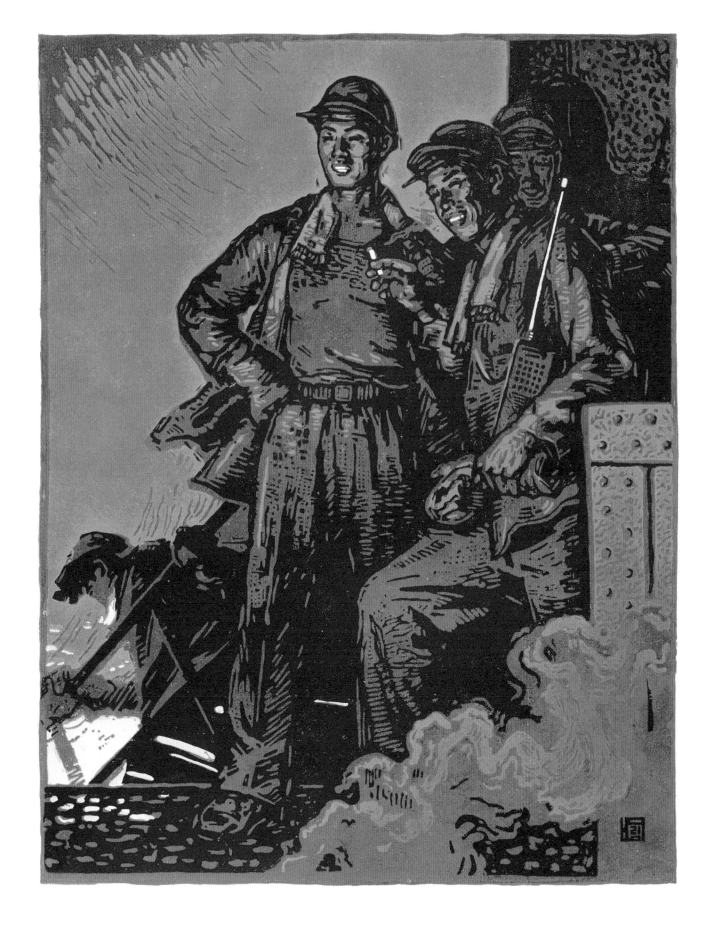

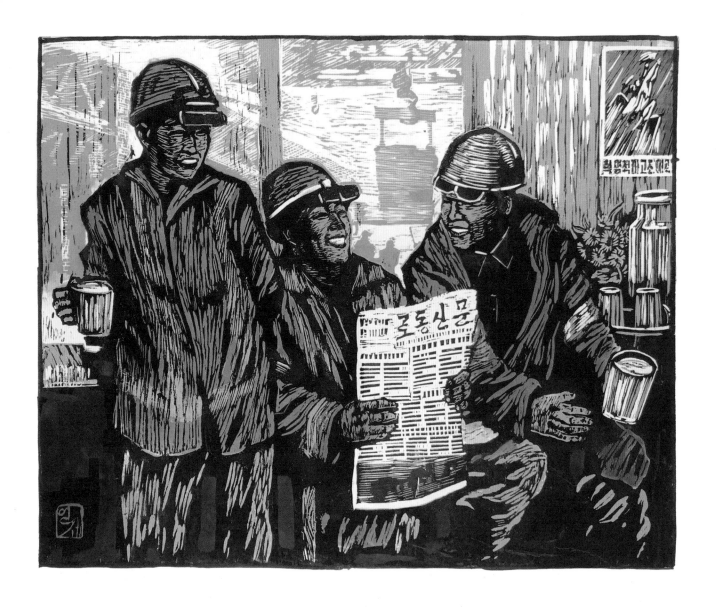

ABOVE: *Worthwhile Break* by Hwang In Jae, 2009 and OPPOSITE: *Break Time* By Hwang In Jae, 2009. In the DPRK Socialist Constitution the chapter for the fundamental rights and duties of citizens states, 'In the Democratic People's Republic of Korea, the rights and duties of citizens are based on the collectivist principle, "One for all and all for one".' The slogan was used by President Kim Il Sung in the late 1950s in recognition of the Chollima Movement that was sweeping the country at the time (contemporary Chollima posters featuring the leaping Chollima horse and slogans can be seen in this linocut). The collectivist principles are to unify the masses around the Party, with each encouraging and guiding the other to place the interests of the group over the individual.

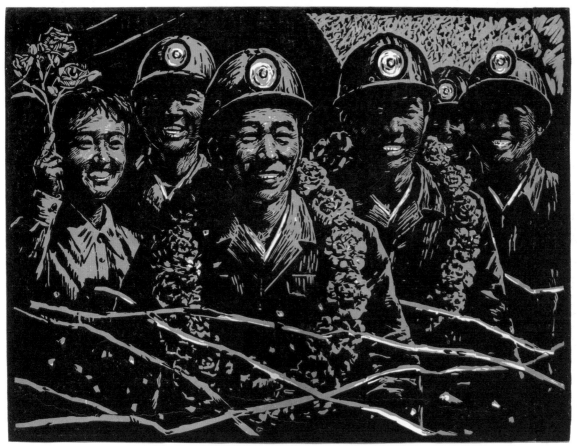

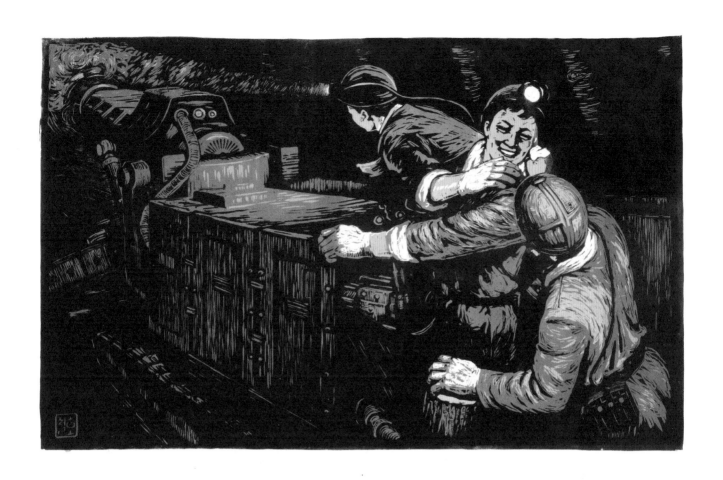

OPPOSITE TOP: *Congratulations to my Innovative Father* by Ho Song Chol, 1989, OPPOSITE BELOW: *Innovators* by Kim Chol Jun and ABOVE: *Coal Miners* by Hwang Chol Ho, 1990. North Korea is exceptionally rich in mineral resources, including magnesite (the second biggest reserves in the world), zinc, iron, tungsten ore, anthracite, coal and gold. Images of workers exceeding production quotas or celebrating innovative production techniques that contribute to new production records are common subject matters in North Korean art. Some of these minerals, such as magnesite, zinc, iron and tungsten, could be sold on the international market. However, recent international sanctions mean both necessary investment and potential buyers are largely absent.

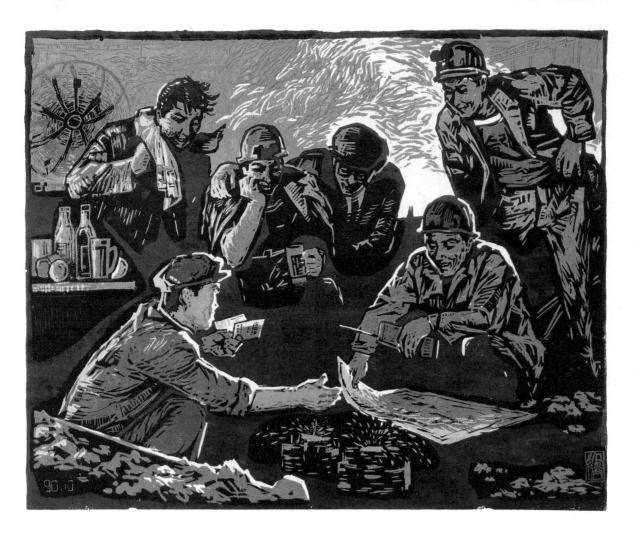

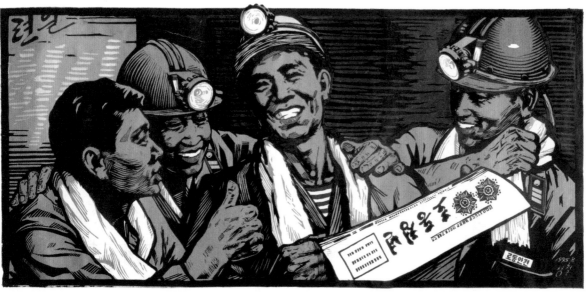

<u>TOP</u>: *Scientists* by Choe Myong Kuk, 1997, <u>ABOVE</u>: [Untitled] by Song Chol, 1995 and <u>OPPOSITE</u>: *The Father and the Son* by Hwang Chol Ho, 1990. Schoolchildren are given report cards to take home to show their parents. Schools in the DPRK also display boards ranking the students, from top to bottom for the whole school. The same system will apply throughout their lives, regardless of profession. In the mines, each work team will be judged against the others in their output, with the winners receiving prizes and accolades in the newspaper and those that fail having to account for their shortcomings.

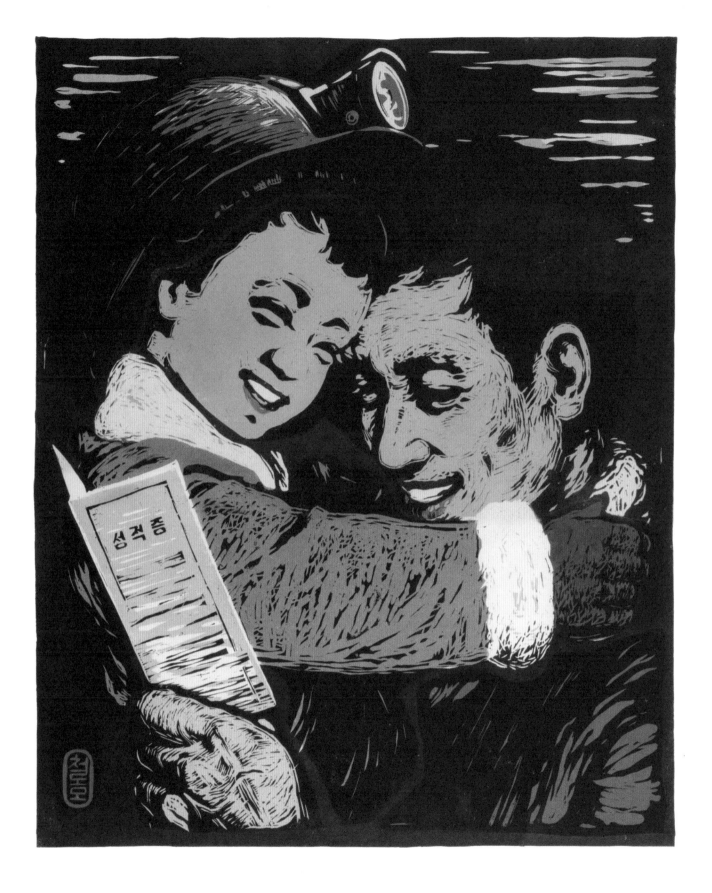

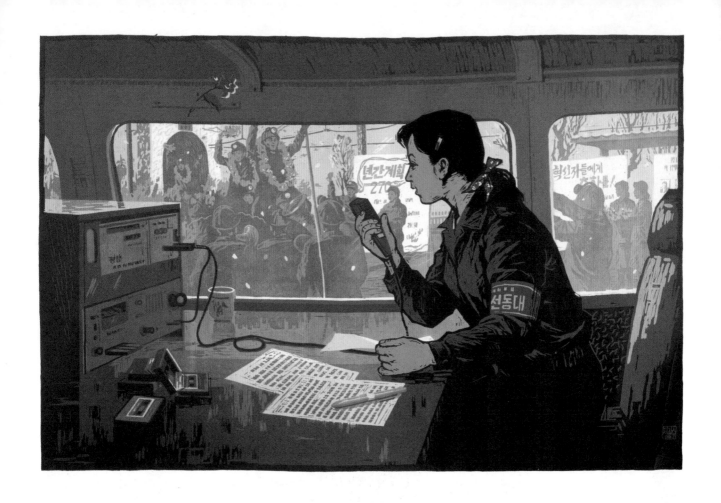

ABOVE: [Untitled] by Jong Kwang Su, 1988. While miners celebrate the fulfilment of their quota, this woman reads out the announcement celebrating their success. Propaganda vans equipped with large speakers on the roof can be found all over the country at construction sites, coal mines and other large work sites, announcing news, propaganda and playing music. In between belting out various inspiring songs the oratory skills of the announcer will come into play. Their voice is a passionate vibrato, a tone that is learned and practised by those aspiring to be newsreaders or announcers of any kind. Workplace decoration (provided in this case by the plastic flower pinned to the roof) represents an indication of her care and commitment to her job.

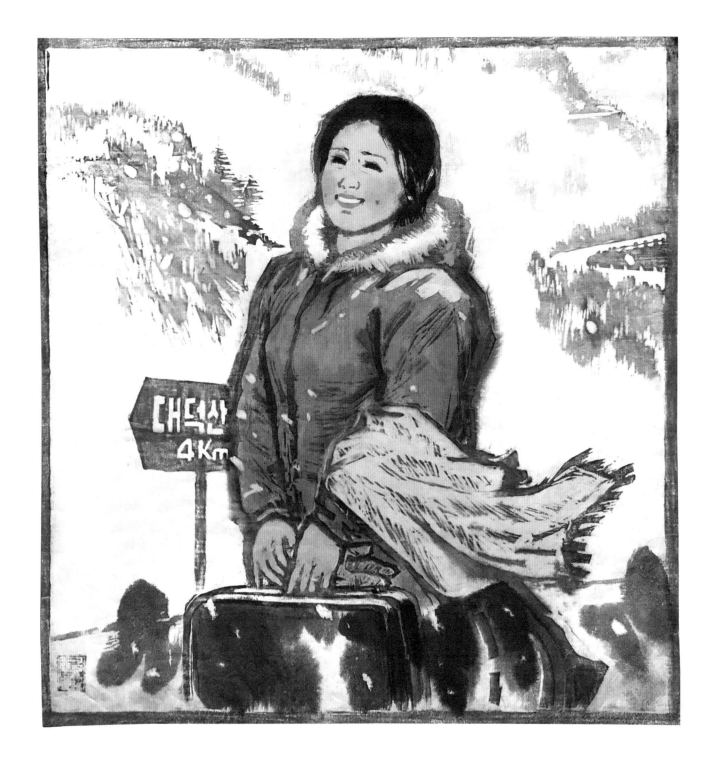

ABOVE: *Pyongyang Girl* by Kim Chol Ho. A girl from Pyongyang is volunteering to work in Taedoksan, an area known for its livestock, and made famous after a visit by the leader Kim Il Sung. The elimination of differences between the countryside and the city, as well as class distinctions, is a regular trope in North Korean literature and film. High school or university graduates volunteer in groups to work in Shock Brigades. These are a rite of passage for many young people entering the adult world and give them a chance to travel, engage in work with their friends and peers in different parts of the country, to help local communities and get involved in infrastructure or agricultural projects.

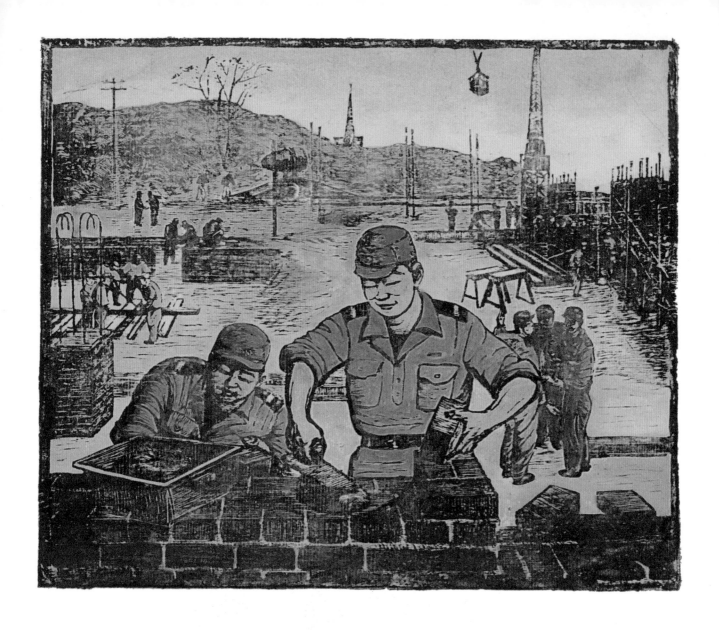

ABOVE: *After The War Reconstruction Site* by Pae Un Song, 1954. This is an early woodcut showing soldiers participating in the post-Korean War reconstruction of Pyongyang. During the war, American aerial bombing and incendiary attacks practically levelled the city with the exception of a few structures. While this essentially gave North Korean urban planners a blank slate to remodel the city in their own socialist image, practical necessity meant that some imprint of the pre-war city remains in street patterns and the locations of some prominent buildings – for example, city halls, schools and athletic fields stayed in the same locations. In the background Moranbong Park and the Liberation Monument, dedicated to the USSR's contribution in the liberation of Korea in 1945, can be seen.

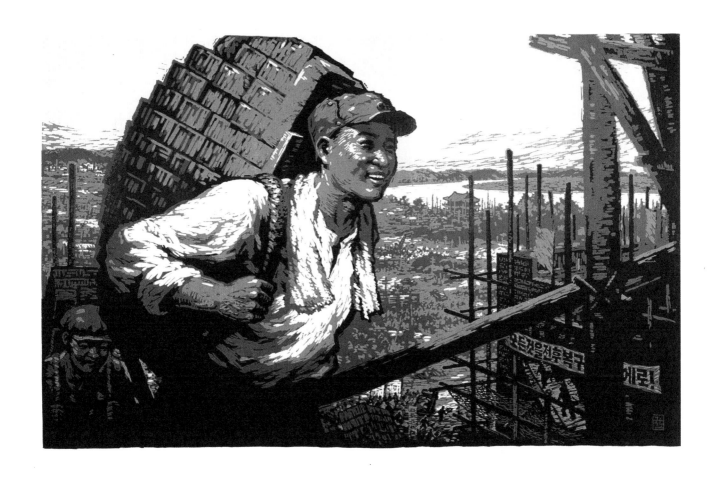

ABOVE: *On Empty Lands* by Kim Kuk Po, 2003. This linocut print shows a soldier carrying a brick hod as part of the rebuilding of central Pyongyang. On the scaffolding is the slogan 'Everything for the Reconstruction of the Country'. The construction site overlooks the river and the Taedong Gate, the east gate of Pyongyang's old city walls. The post-Korean War reconstruction of North Korea was supported in particular by aid and technical advice from the USSR, China and East Germany. The Chinese People's Volunteer Army remained stationed in North Korea until 1958 to aid in the reconstruction.

ART SHOULD
SENSITIVELY REFLECT
THE SPIRIT
OF THE TIMES &
THE TREND
OF DEVELOPING
SOCIETY &
BE PULSATING

Kim Jong Un

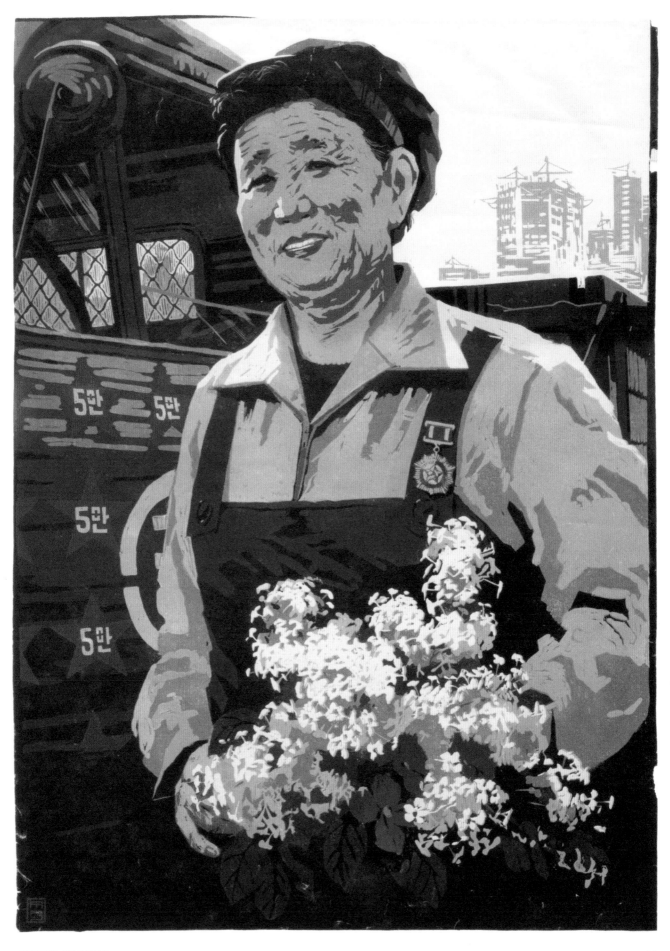

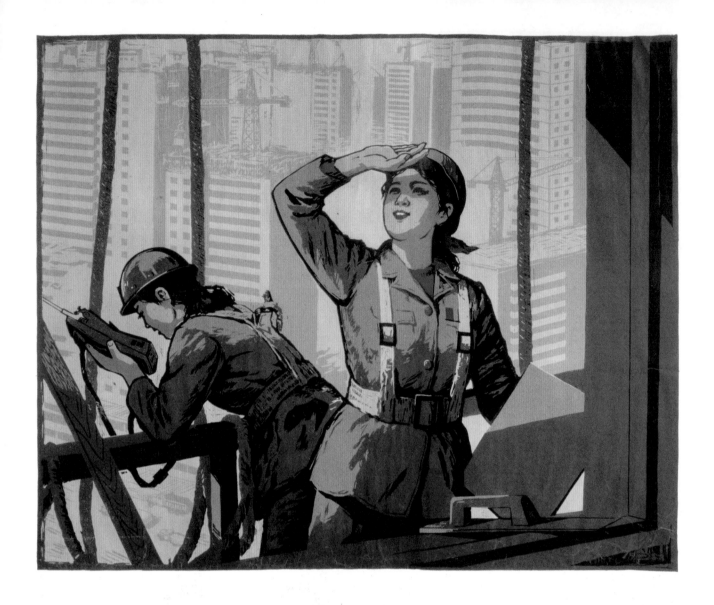

PREVIOUS PAGE: *The Spring of Life* by Pak Ae Sun. This print depicts an elderly woman driver who has been awarded the Labour Hero Medal. The purpose of the title, *The Spring of Life,* is to promote dedication to the country even when one is no longer young. Retirement for men occurs at the age of sixty and for women fifty-five in North Korea. The red stars on the left of the image are awarded to the vehicle (not the driver) for each 50,000 kilometres driven without an accident. The stars can commonly be seen on buses and trams in Pyongyang and other cities. The film *Road* is based on a true story of an old woman who spent most of her life behind the wheel and was praised as a 'labour heroine' by going far beyond the goal of 50,000 kilometres of safe driving.

ABOVE: [Untitled] by Kyong Sik, 1988. A 'Shock Brigade' of young female volunteers is depicted plastering a new apartment block in preparation for painting. Since 2012 (to mark the 100th anniversary of the birth of Kim Il Sung), there have been a number of major residential building projects. In general, Pyongyang citizens would rather live around the Central District in West Pyongyang. East Pyongyang on the other side of the Taedong River is quieter but has fewer facilities and no metro. OPPOSITE: *Painting Pyongyang* by Choe Yong Sun, 2005. Just up the road from Pyongyang railway station, whose clock tower can be seen in the background, workers paint yellow ochre on a residential building. Until around 2010, most buildings in residential parts of Pyongyang were white or dull neutral colours. Since then, an unusual variety of candy colours has been in favour.

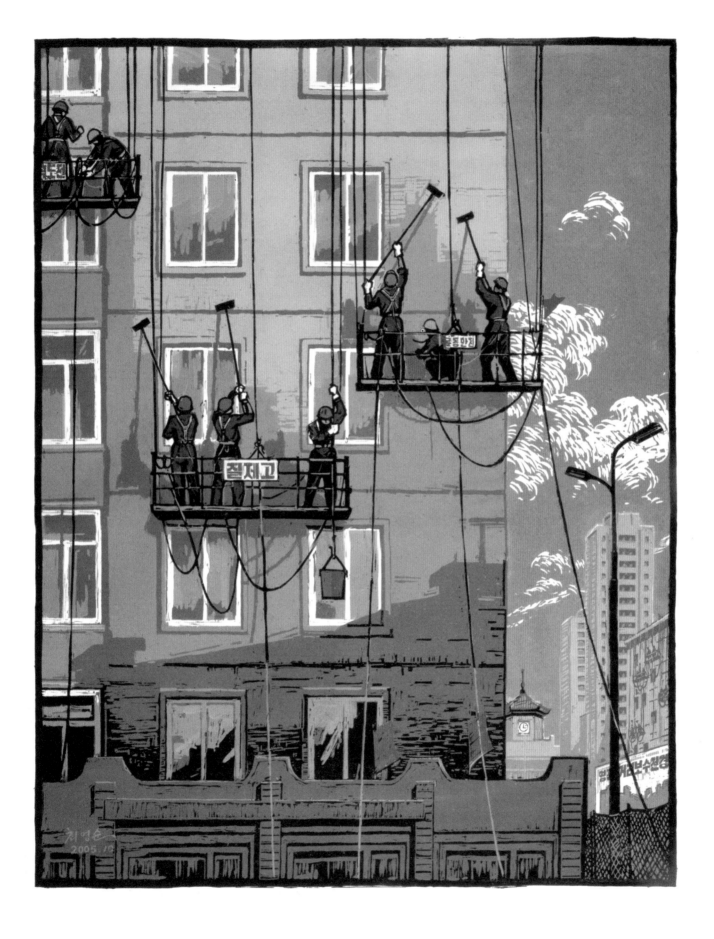

RIGHT: *Pride* by Hong Chung Ung. Pyongyang trains its own architectural students but a select few have studied abroad - most notably in France. Their designs are added to the rich stylistic mix in Pyongyang, which consists of various styles from Neo-Classical and Modernist, Khrushchev-era Soviet-style and traditional Korean (but made of concrete) and, in the latest construction boom, a Retro-Futurism style.

ABOVE: [Untitled]. A university student studies under a statue of soldier-martyrs who were prepared to be 'human bombs' (suicide missions). The Korean War, known as the Fatherland Liberation War in North Korea, is still kept very much alive in the media, in the arts as well as the education system. This image captures two realities – a society that is both highly militarised and highly educated.

ABOVE: *Today's Newspaper* by Jon Chol Nam, 2006. Deep in the Pyongyang subway, a guard puts the latest edition of the *Rodong Sinmun* (the Workers' Daily – the newspaper of the Central Committee of the Korean Workers' Party) in a glass display case. Every station in Pyongyang displays this newspaper, which is the main organ of the Workers' Party and the main source of printed news in the DPRK. Additionally, if you move further down the platform, you can read the *Army Paper*, *Sports Paper*, *Youth Paper* and the *Pyongyang News*.

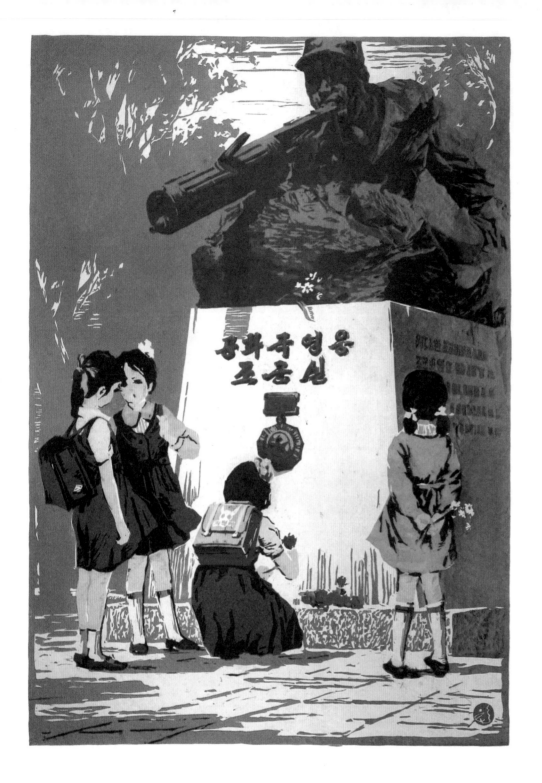

<u>ABOVE</u>: *Jo Gun Sil, The Spirit of the Hero* by Kim Un Suk, 1992. Jo Gun Sil is etched on the memories of the Korean people as the 'Hero of the Republic'. Even after losing all four limbs during the Korean War, he kept firing his machine gun with his mouth. A renowned martyr in the DPRK and an iconic symbol of refusing to give up, Jo Gun Sil Wonsan Technical University was built to commemorate his courage, altruism and his spirit of self-sacrifice. Many student organisations show their determination in front of his statue before joining the military. <u>OPPOSITE</u>: *Going to a Congratulatory Performance* by Kim Un Hui, 1981. Pyongyang's Tower of the Juche Idea is one of the most iconic monuments in the DPRK. At 170 metres high, this symbol of the guiding ideology of the nation (Juche literally means 'the master of one's destiny') can be seen throughout the city. It is illuminated by a torch, the Juche Flame which glows during the night. This linocut print was made in 1981, a year before the tower's completion. Its opening was timed to coincide with the seventieth birthday of President Kim Il Sung on 15 April 1982.

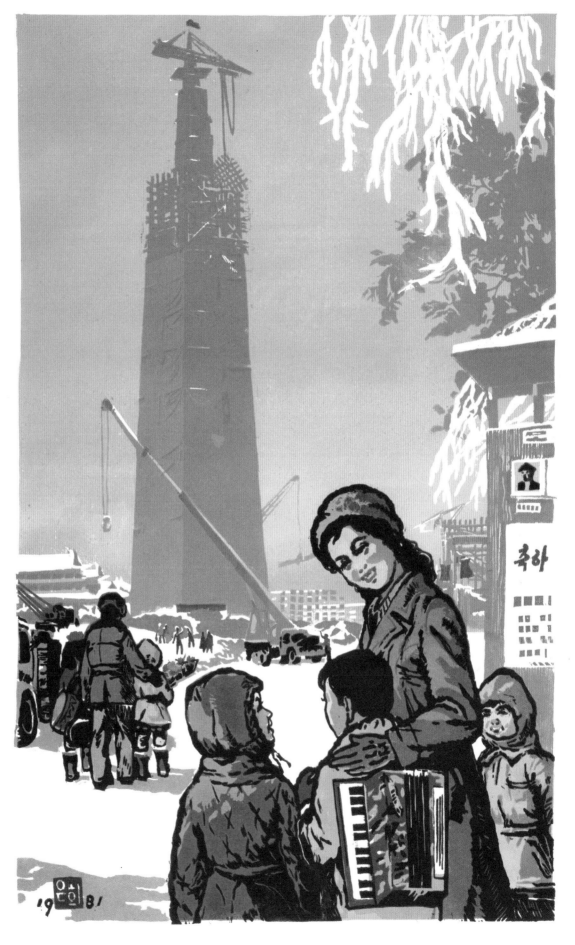

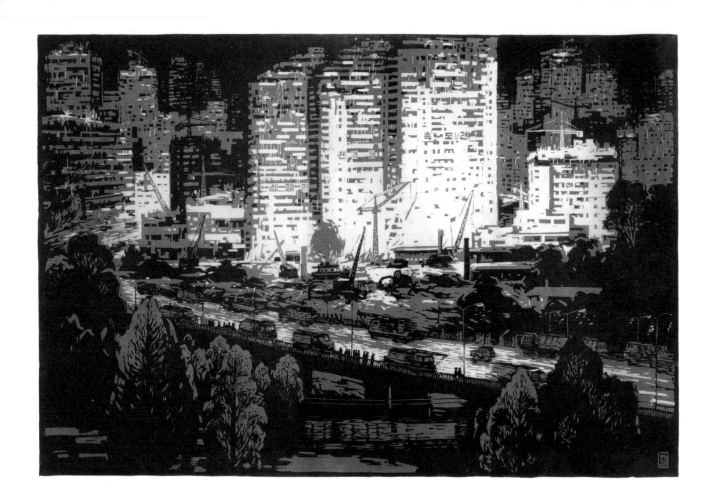

Pyongyang was designed as a showpiece model city, a place to reinforce the values and power of the Party and to provide space for revolutionary activities from parades to meetings. With around three million inhabitants of a total population of twenty-five million it is considered a privilege to live in Pyongyang. However the city is not just a place for the elite to live an easy life. Like any city in the world, and perhaps more so in Pyongyang, the great majority of citizens work hard for a living. The North Korean working week is six days, with Sunday the only day off.

ABOVE: *Night at Tongil Street* by Pak Yong Il, 1992. This print shows the construction of Tongil Street ('Reunification Street') during a night shift. The work took place from 1990-92 and the street is mainly residential blocks with shops and restaurants. Night construction is common to complete projects more quickly and during summer, to avoid extreme heat. OPPOSITE TOP: *Marching on the First Morning* by Pak Yong Il, 1999. The Chollima statue on Mansu Hill symbolises the 'indomitable spirit of the Korean people'. The parade consists of Pyongyang citizens who are volunteering to work on the construction sites after hearing the 'New Year's Greeting' speech of the Leader. Various slogans that can be seen include 'Let's Become the Champion in the Construction of a Powerful Nation', 'All for the Second Chollima Great March' and 'Long Live General Kim Jong Il the Sun of the Twenty-first Century'. OPPOSITE BELOW: *We Will Never Forget!* by Kim Song Ho. A view of Pyongyang from Mount Taesong's Revolutionary Martyrs' Cemetery, where giant bronze statues are dedicated to the heroes who fought against the Japanese during the colonial period of 1910-45. If someone has a relative buried in the cemetery, then their revolutionary and patriotic family background are considered impeccable.

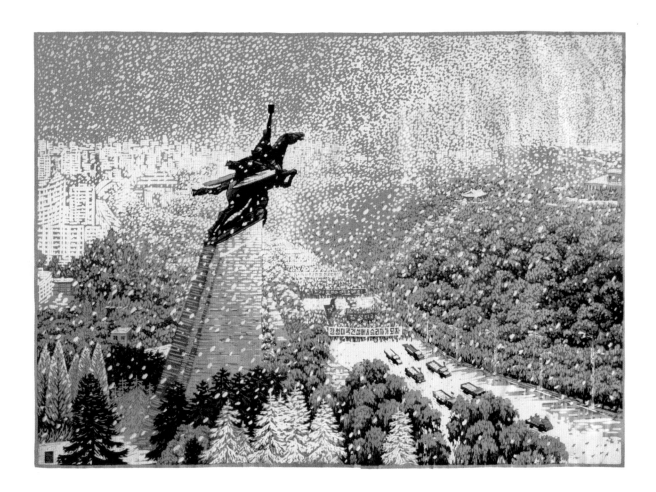

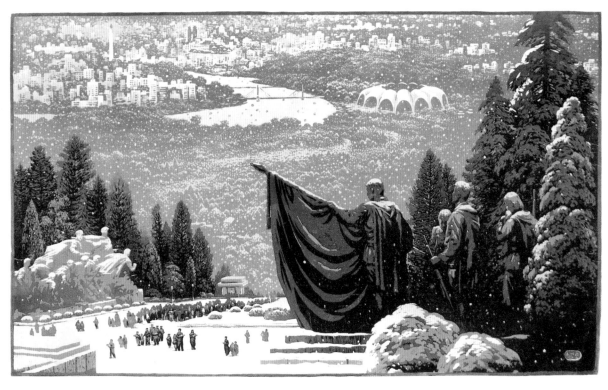

PREVIOUS PAGE: *Worthy Workplace* by Pak Chang Nam. 1997. Domestically developed sweeping carts head past the Pyongyang Circus and along the one-hundred-metre-wide Kwangbok Street in Pyongyang. Originally built in 1989 to accommodate delegates and participants in the World Festival of Youth and Students, a kind of alternative Olympics for the socialist world, the street is now residential.

ABOVE: *August Morning* by Jang Song Pom, 1994. Families visit the Revolutionary Martyrs' Cemetery each year to pay homage to those who dedicated their lives to the struggle against Japanese colonialism on Liberation Day, 15 August. The flowers will either be presented at the Republic Hero Medal at the foot of the cemetery, honouring all who are buried there, or at the grave of Kim Jong Suk, the wife of Kim Il Sung, at the top of the hill. President Kim Il Sung reportedly chose this site so that the martyrs might watch over the city that their sacrifice helped to build. In the far distance the Kumsusan Palace of the Sun, formerly the Kumsusan Assembly Hall and Kim Il Sung's residence can clearly be seen. Kim Il Sung's office was designed to look out on to the cemetery. Today the Kumsusan location serves as a mausoleum to the DPRK leaders.

ABOVE: [Untitled] by Chun. This print depicts a view of the landscaped setting of Mangyongdae, 'place of ten thousand views'. Once a village and now the most revered site in the country, the immaculately restored tenant farmer's house is the birthplace of North Korean leader Kim Il Sung, who was born on 15 April, 1912. For anyone to visit Pyongyang and not make a stop here would be unthinkable and school classes, factory workers, military units and retired people's groups, among others, will queue here every day for a guided tour. There are many stories from Kim Il Sung's youth associated with items and particular spots on this site.

<u>ABOVE</u>: *Older Brother* by Jang Song Pom, 2003. On the collars of the soldier's uniform can be seen one stripe and three stars, which implies he is the company commander, while the title of the print refers to the way the officer looks after his men, like an older brother. A surprise party is being prepared in the canteen for one of his soldiers – the flowers are wrapped in birthday paper. The wall chart shows the amount of grams and calories of various food types distributed to each soldier everyday. Until the 1990s, the government provided almost all provisions through a nationwide Public Distribution System. These days, this system provides only a partial allowance of basic goods such as rice, oil and some meat. <u>OPPOSITE</u>: *Rich Supplies of Food for the Military* by Pak Hwa Sun. Every military unit raises its own pigs, chickens and rabbits, and out-of-season vegetables like cucumber, tomatoes and garlic are grown in greenhouses. This linocut portrays abundant and varied food supplies in the military despite being in the midst of winter. Extending the growing season with greenhouse technology is an important task for rural communities and remote military units.

ABOVE: *The General is Here* by Pak Hwa Sun. The leader, Kim Jong Il, visited a women's coastal artillery unit several times and they subsequently received the moniker of the 'Persimmon Squadron' because of the fruit trees on site. The government also sent cosmetics to the squadron and the Leader promised to return when the persimmons had ripened. 'On-the-spot guidance' in the form of visits by the DPRK's leaders and high officials is common in locations of economic importance and the military. Such visits are often publicised and are meant to show the leadership's interaction with society and individuals.
OPPOSITE: *The Greenhouse of our Company* by Ro Chi Hyon, 2005. Greenhouses are utilised to cultivate climbing crops such as pumpkins and gourds, which also provide shade. In a country with a serious ongoing lack of food security, the artist here is taking the opportunity to show that, in fact, all is well and security is guaranteed by a strong and healthy military.

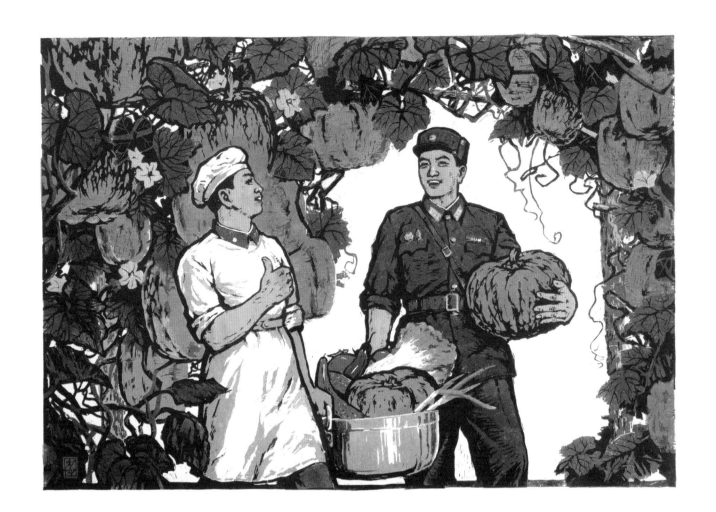

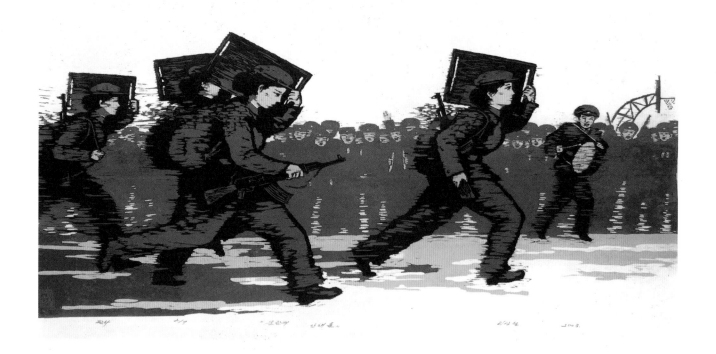

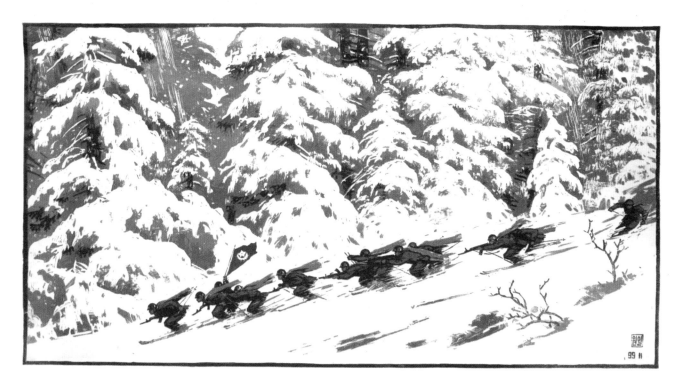

TOP: *Officers' Wives* by Ri Kwang Chol, 2003. Officers' wives take part in the military sports day race -
running while carrying an ammunition case and a weapon. They are wearing 'guardian clothes', the uniform
of civilians defending their own factories, not military uniforms. <u>ABOVE</u>: *Soldiers of the North* by Pak Won
Il, 2011. A military ski patrol in the north of the country carrying the Supreme Commander's Flag. In 2013
Kim Jong Un initiated the construction of a large ski resort that was completed by the military in just
ten months. <u>OPPOSITE</u>: *Il Dang Paek Soldiers* by Jon Chun Hui. 'Il Dang Paek' is written on the soldiers'
rucksacks, which means that 'One Person is a Match for 100'. Korean children spend more time playing
military games in the playgrounds than they do on computers and most of them dream of joining the army.

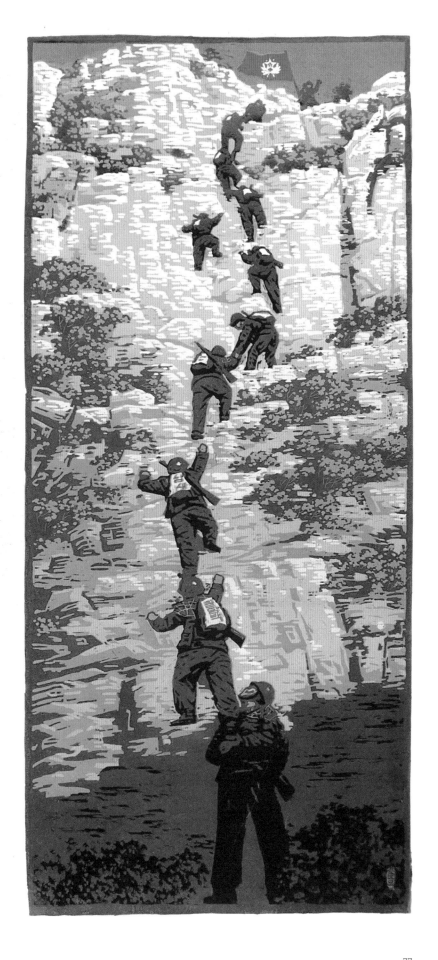

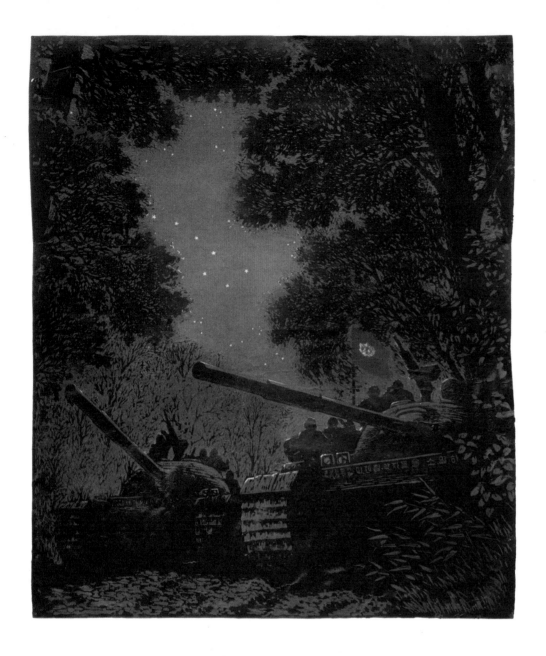

ABOVE: *The Big Dipper* by Kim Yong Ho, 2005. During the Korean War any soldier stuck behind enemy lines would orientate themselves using the Big Dipper constellation to reach the Supreme Commander, Kim Il Sung. The lyrics of the Korean song *Where are you, my General?* refer to this. OPPOSITE TOP: [Untitled]. A print depicting MiG aircraft pilots of the Korean People's Army Air and Anti-Air Force. In 2000, twenty-five years after the Vietnam War ended, both North Korea and Vietnam admitted for the first time that North Korean pilots had flown in combat against US aircraft over North Vietnam during the Vietnam War. Although the MiGs seen here are dated, many remain in service and can be seen at regional airports (which double as military airfields) around the country. OPPOSITE BOTTOM: *Snow Scene of Tabaksol Guard Post*, 2007. This print shows a battery of anti-aircraft guns on Taedong River at Tabaksol Guard Post where leader Kim Jong Il developed the 'military-first' policy on his surprise visit on 1 January, 1995. It was particularly notable because the visit was preceded that morning by his visit to Kumsusan Memorial Palace where his father lay in state. The snow scene of Tabaksol Post is considered one of the 'Twelve Scenes of the Military-First Policy' of the DPRK.

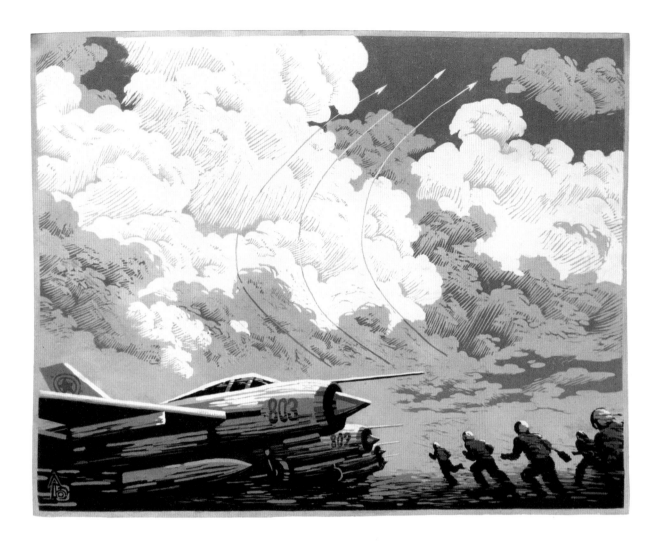

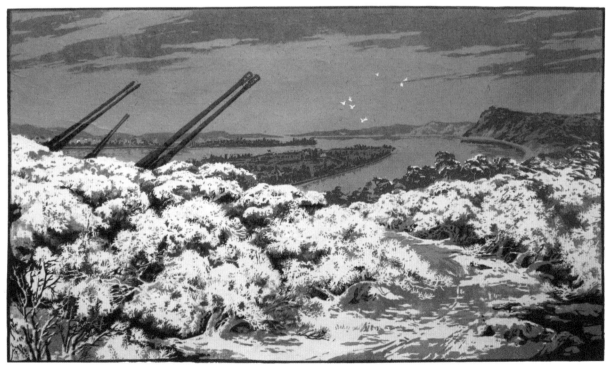

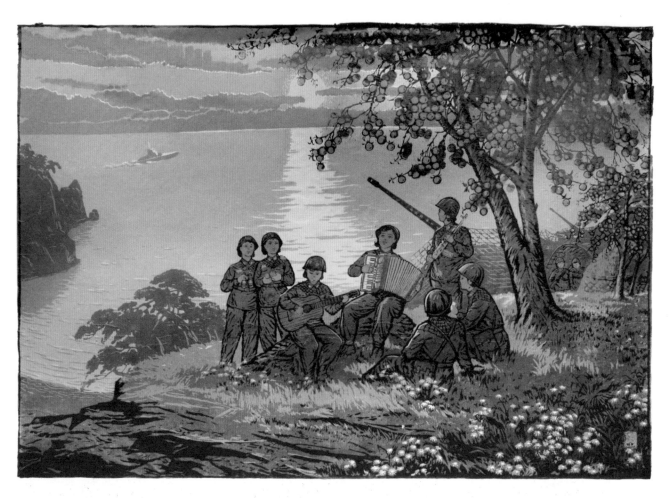

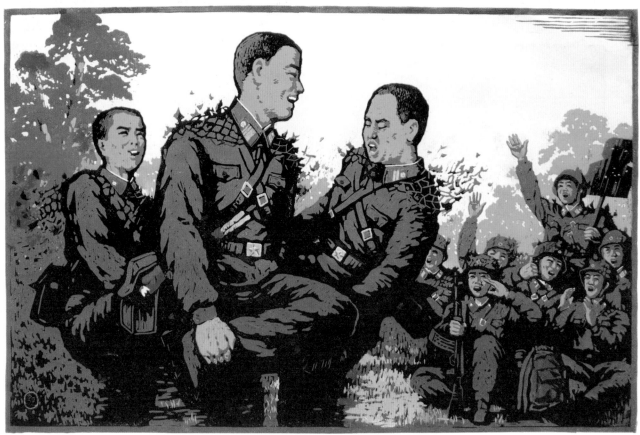

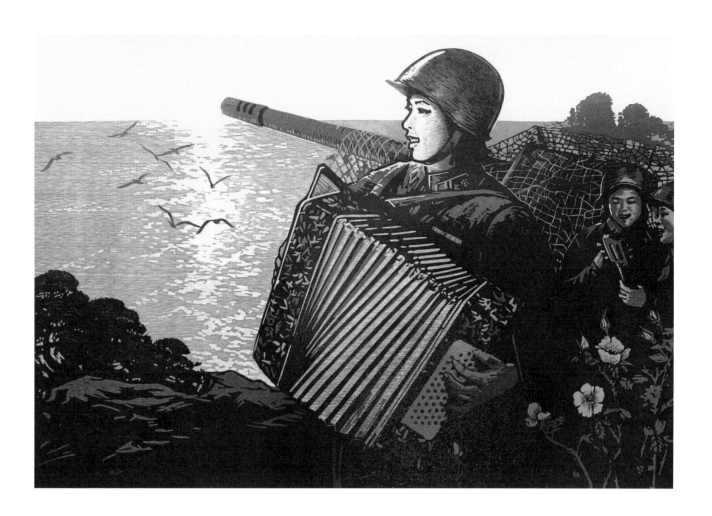

OPPOSITE TOP: *Night at the Persimmon Guard Post* by Choe Chang Hyon, OPPOSITE BOTTOM: *During a Break From Training* by Ri Hak Mun, 2008. ABOVE: *Rosa Rugusa of my Heart* by Ko Il Chol, 1998. While these pictures are clearly idealised, it isn't at all rare to see small groups of people, soldiers or otherwise, playing various instruments, singing and dancing to pass the time. Cultural activities aim to strengthen the bond between soldiers and workers; with most songs in praise of the leader. The all-female Persimmon Squadron are waiting for Kim Jong Il to visit again (the Rosa Rugosa flowers represent everlasting faithfulness to the Party) while male soldiers are knee-wrestling after finishing target practice, hopping around while smashing the opponent with their knee.

FOLLOWING PAGE: [Untitled]. Military units stress unity of troops - referred to as the 'one mind match' - between the commander and those of lesser rank; commanders should treat their juniors as their own family, and in turn juniors should follow the commander as their own brother.

AN
ARTISTIC WORK
INSENSITIVE
TO PARTY POLICY
WILL LOSE
ITS VIABILITY

Kim Jong Un

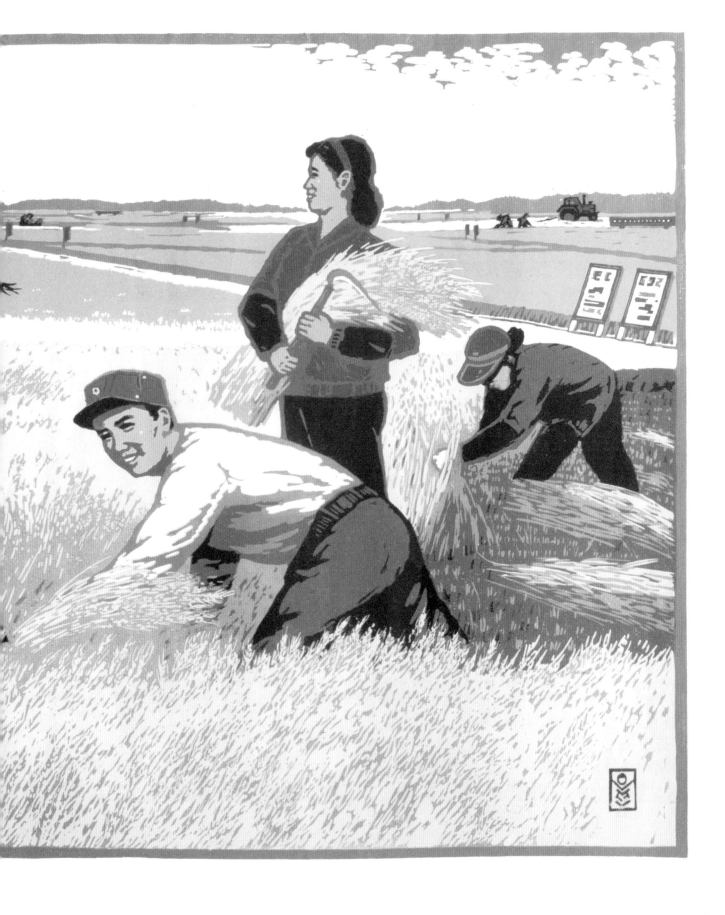

PREVIOUS PAGE: *One Mind* by Jong Il Son, 2007, <u>TOP</u>: *They Hear the Rice Sway* by Kim Dal Hyon, 1989, <u>ABOVE</u>: *Soldiers and the Future* by Kim Chung Kuk and <u>OPPOSITE</u>: *One Mind* by Kim Won Chol, 2003. North Koreans believe that the 'unity of soldiers and the people' is the strength of the country and see the mutual support as a social norm. General Kim Jong Il delivered the slogan 'Serve the People!' in January 1990 to ensure that all members of the armed forces fulfil their duty by serving the people's interests. This theme is clearly depicted in these prints in which soldiers and farmers can be seen working together in gathering grain grown over the winter, returning from shooting practice through the fields of rice they helped plant earlier in the year and helping to drive a herd of goats across a bridge.

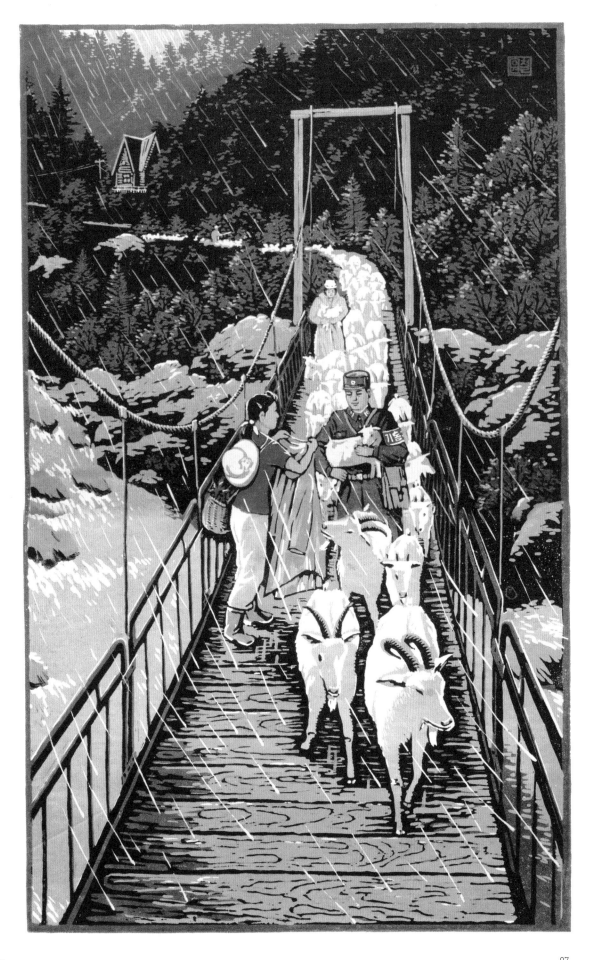

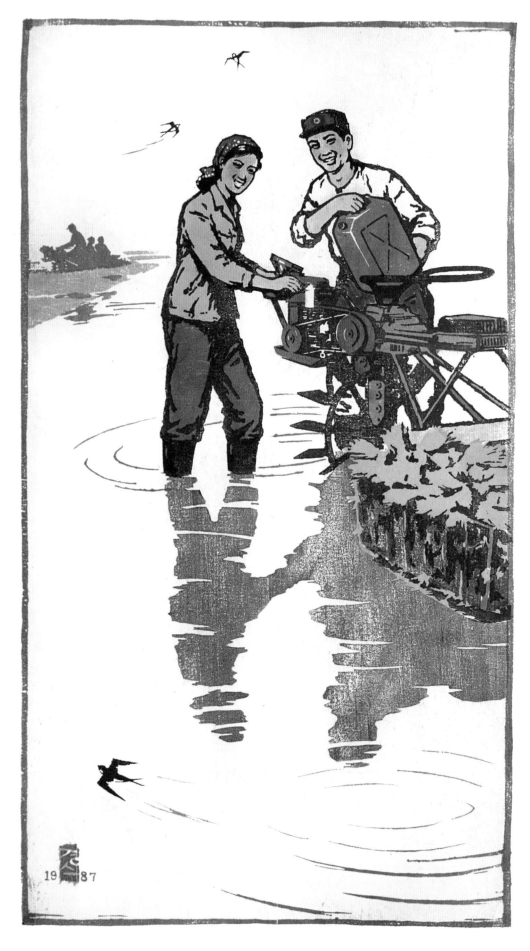

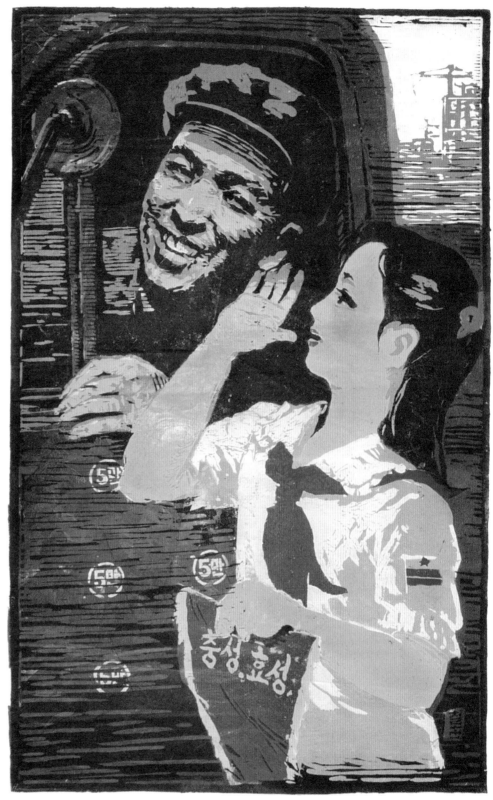

OPPOSITE: *One Mind* by Han Kyong Sik, 1987. A soldier helps a farmer fuel up her mechanical rice transplanter. Swallows are symbolic in Korean artworks; they represent both spring and a good crop. This belief comes from the traditional moral folktale *Heungbu and Nolbu* in which one brother saves a swallow and the other hurts a swallow, resulting in two very different outcomes. ABOVE: [Untitled] by Chol Hun. A student cheers on a driver who holds the record for driving safely for more than 50,000 kilometres, as evidenced by the red stars on his truck. It is mandatory for all third grade primary students to join the Schoolchildren's Union. Upon joining they receive a red bandana which can be seen here worn around the neck.

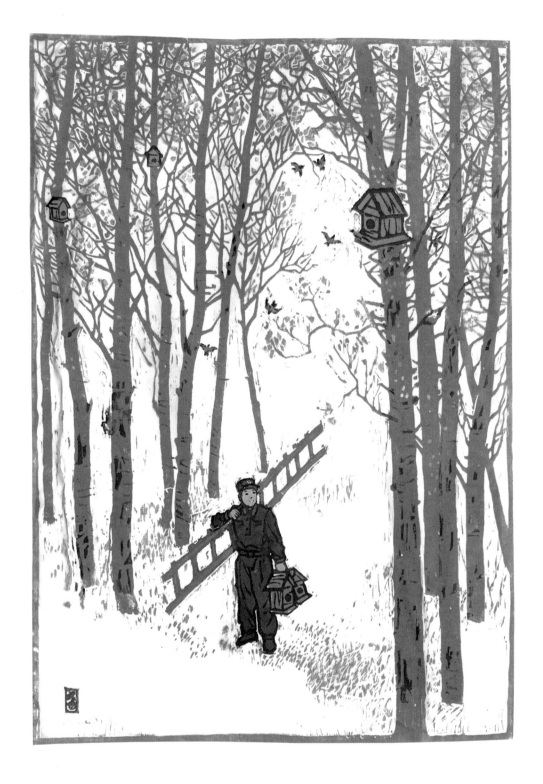

ABOVE: *The Birds Flying In* by Kim Chol Won. Efforts by the military to improve the areas in which they are stationed are commonly reported in DPRK news and propaganda. The slogan 'Let's Arm Ourselves Strongly with Kim Jong Il Patriotism', is defined as encouraging Koreans to 'love the country's grass, the trees with all [their] heart and grow them with [their] hot blood'. <u>OPPOSITE</u>: *Spring Rain* by Won Jong. Rice is a crucial staple crop in North Korea. Here, soldiers are helping the farmer cover the rice seeds with plastic sheeting. Straw further protects the seedbeds from the wind. In late spring, rice seedlings are transplanted to paddy fields using massed supplemental labour brought in from the cities.

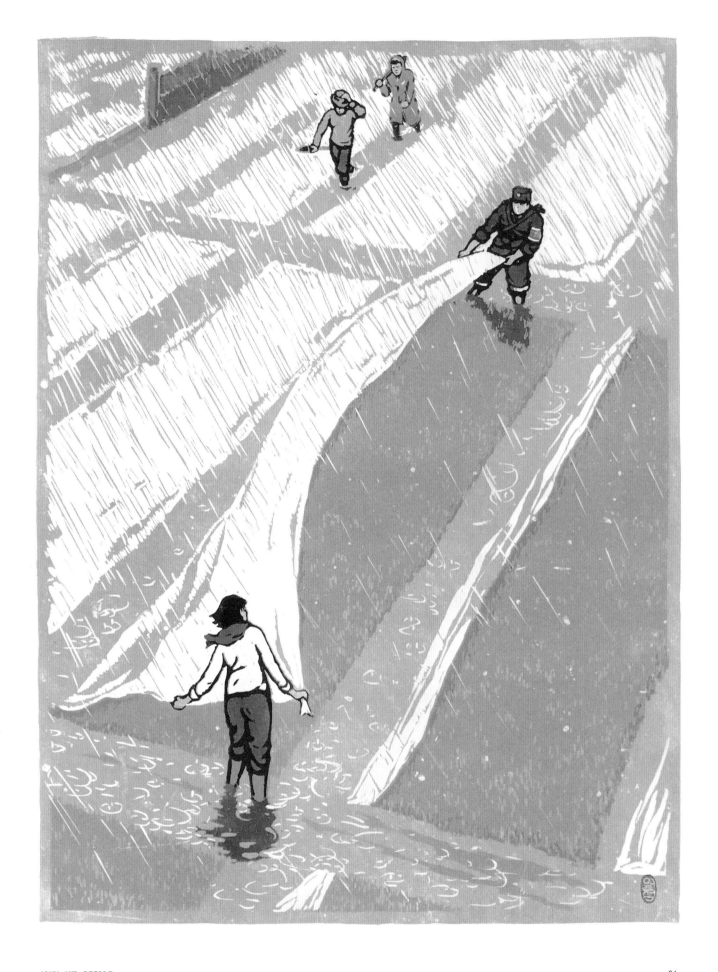

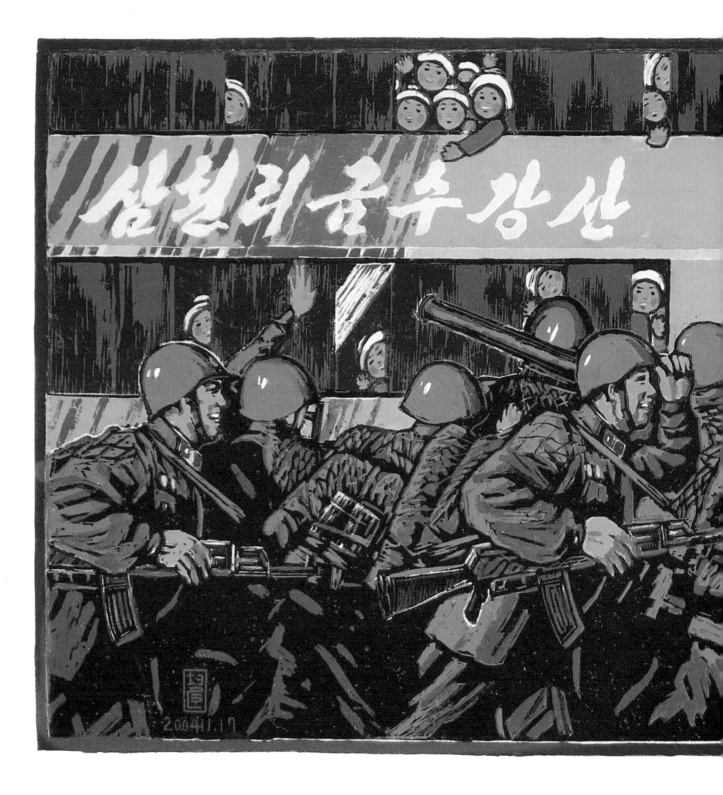

ABOVE: [Untitled] by Chol Ho. The bus bears the slogan 'Beautiful Land of Korea'. Koreans are able to join the army from the age of seventeen after graduating from high school. Almost all men join the army out of tradition, a sense of duty to the country and to gain opportunities in society. The 'Songun' (military-first) policy was the DPRK's primary national doctrine from 1995 until 2013, after which Kim Jong Un introduced the ideological notion of the 'Byungjin Line', or 'parallel progress', in which the economy and the military are of equal priority.

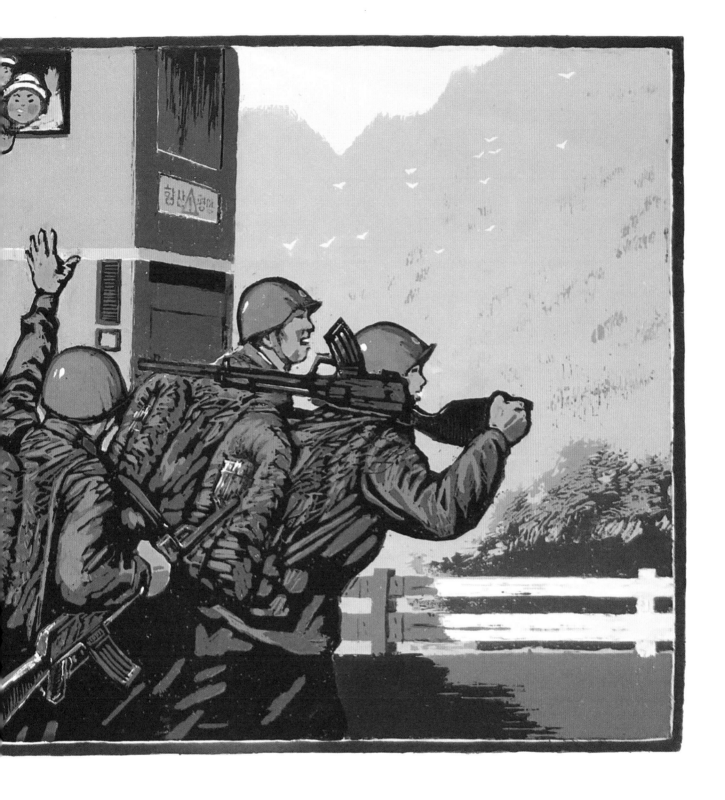

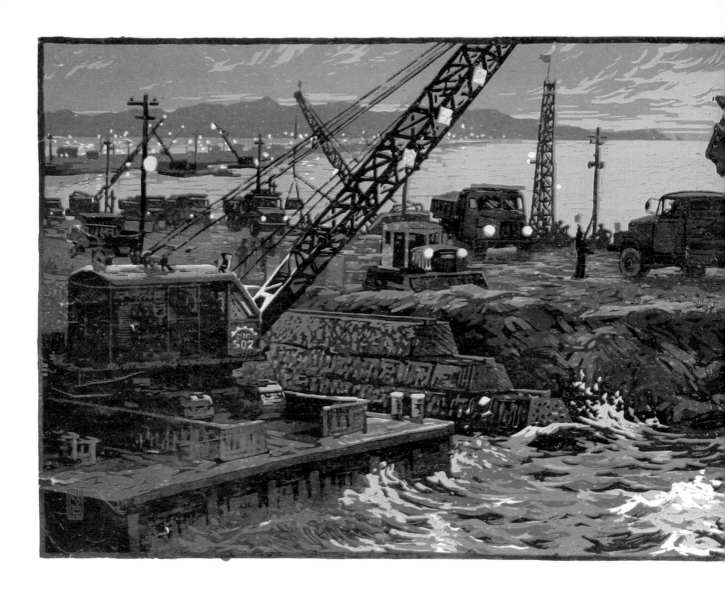

ABOVE: [Untitled]. The West Sea Barrage is a tidal dam at the mouth of the Taedong River between Nampo city and Hwanghae Province that controls the river's interaction with the West Sea of Korea (the Yellow Sea) and is considered to be a 'Monument of the Workers' Party Era'. Construction began in May 1981 and was completed in June 1986. The construction meant the Taedong River would provide fresh water for the irrigation of surrounding agriculture, with the added benefit of reclaiming land. It would also reduce the risk of Pyongyang flooding and provide a more controlled transport route for goods. The importance placed on this engineering feat was demonstrated when President Kim Il Sung accompanied former US President Jimmy Carter on a visit to the barrage during the 1994 negotiations over North Korea's nuclear programme.

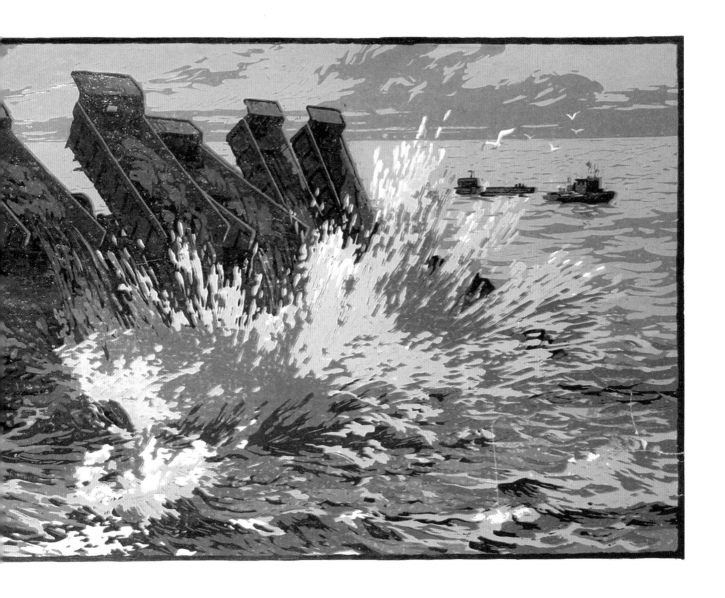

TOP: *Spring at the Orchard* by Jong Il Son and <u>ABOVE</u>: *Stardust of Samjiyon* by Hwang So Hyang, 2006. Korea is a small peninsula with a large population. North Korea is home to around twenty-five million people according to the 2014 census. Self-sufficiency in food is almost impossible in the DPRK. Eighty per cent of the country is cold, dry and mountainous and used primarily for forestry, while the foothills can be used for livestock grazing and fruit trees. It is only on the west coast and a narrow strip on the east coast that has level fertile land for growing staple rice and potato crops. With around twenty-five per cent of the population working in agriculture, there has always been a priority to increase land fertility and the land available for cropping.

<u>TOP</u>: [Untitled] by Jo Chol Jin, 1981 and <u>ABOVE</u>: *The Panorama of Migok-ri* by Ryon Kwang Chol, 2009. Significant improvements arrived during the 'Arduous March' in the 1990s when foreign experts introduced new farming methods and the 2002 economic reforms that allowed some increase in the autonomy of cooperative farms. For the individual farmer it has meant benefits such as the ability to have their own small plot of land, being allowed to sell excess produce and wages being paid according to the productivity of the farm, not on how many hours they worked. However, food production in the country is still far from adequate.

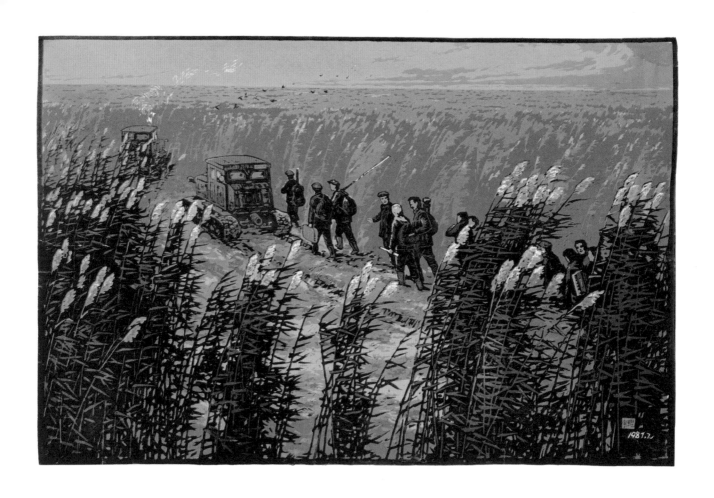

ABOVE: *Creators of Reclaimed Lands* by Jong Yong Chong, 1988. Turning marshes into agricultural land is no small feat and when it happens is subject to celebration through the state media and propaganda channels. The objectives of the 'Third Seven Year Plan 1987-93' was to reclaim 300,000 hectares of tidal land. The environmental impact often takes a backseat, however, and in 2018 North Korea committed to an international convention on wetland protection that stipulated the 'conservation and wise use' of its wetland resources. Rapid economic development in China and South Korea, as well as North Korea, has led to the loss of up to sixty-five per cent of tidal wetlands in the West Sea (the Yellow Sea) in the last fifty years.

ABOVE: *Big Blast and Controlled Explosion at Construction Site by* Hwang In Jae, Kim Chol Hun and Kim Yong Thae, 1998. Mega-projects in the fields of construction and engineering are constantly celebrated in both the news and art in North Korea. In recent years, notable projects have included the building of several new prestige neighbourhoods in Pyongyang, the Masikryong Ski Resort and the seaside resort complex at Kalma on the east coast. Military labour is commonly used on these rapidly built projects and the associated imagery of massive detonations as part of the construction process are often shown on the news along with images of hordes of soldiers working as one well-drilled unit to complete projects in record time.

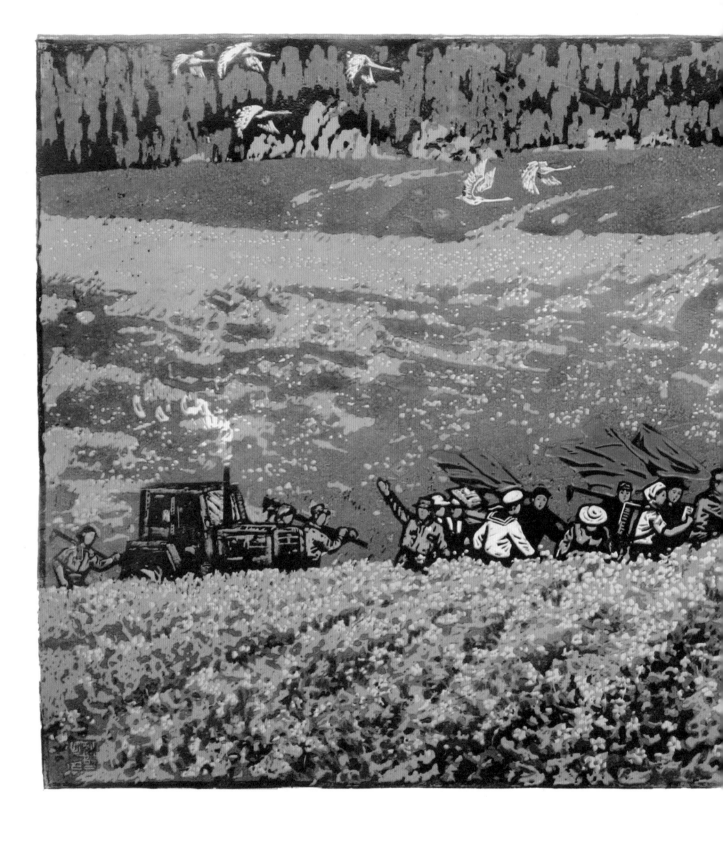

ABOVE: *The Scent of Potatoes* by Hwang In Jae, 1999. Workers in Taehongdan, the mountainous north of the country, overcame unfavorable conditions during the famine of the 'Arduous March' in the 1990s to turn forested land into potato farming. As a result, 'Taehongdan Spirit' means patriotic and self-sacrificing devotedness.

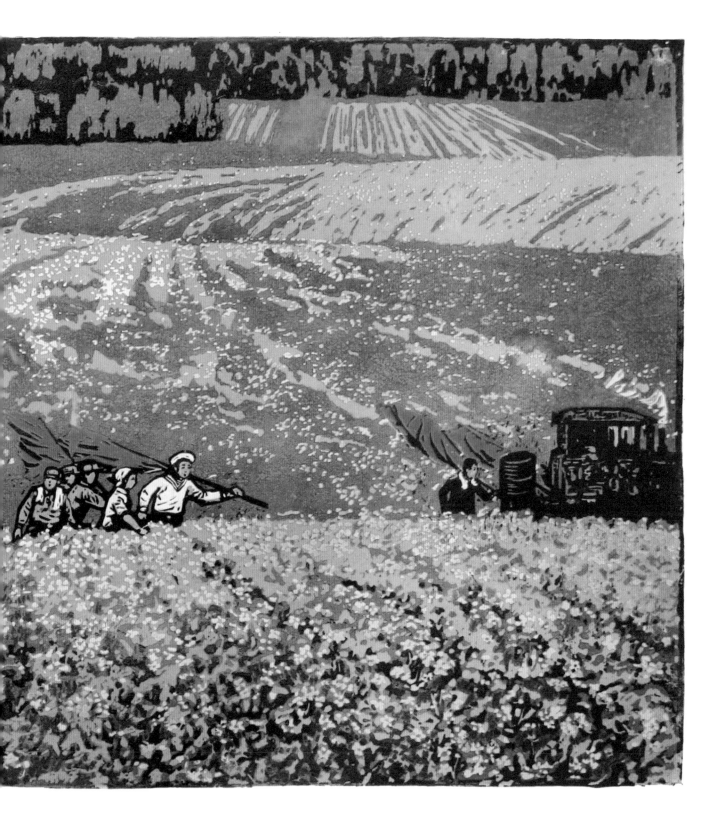

FOLLOWING PAGE: *Worthy* by Ri Ju Hyok. Members of the art troupe that came to encourage the workforce for a major agricultural irrigation project are returning after the completion of a section of an irrigation tunnel. The minecart bears the slogan 'Do or Die Accomplishment' and the poster on the tunnel wall refers to the piercing of the 220-kilometre-long Miru Plains irrigation channel in North Hwanghae province, the grain basket of North Korea.

THE GENUINE VIABILITY OF ART IS IN MAKING THE WHOLE SOCIETY ASTIR WITH REVOLUTIONARY PASSION

Kim Jong Un

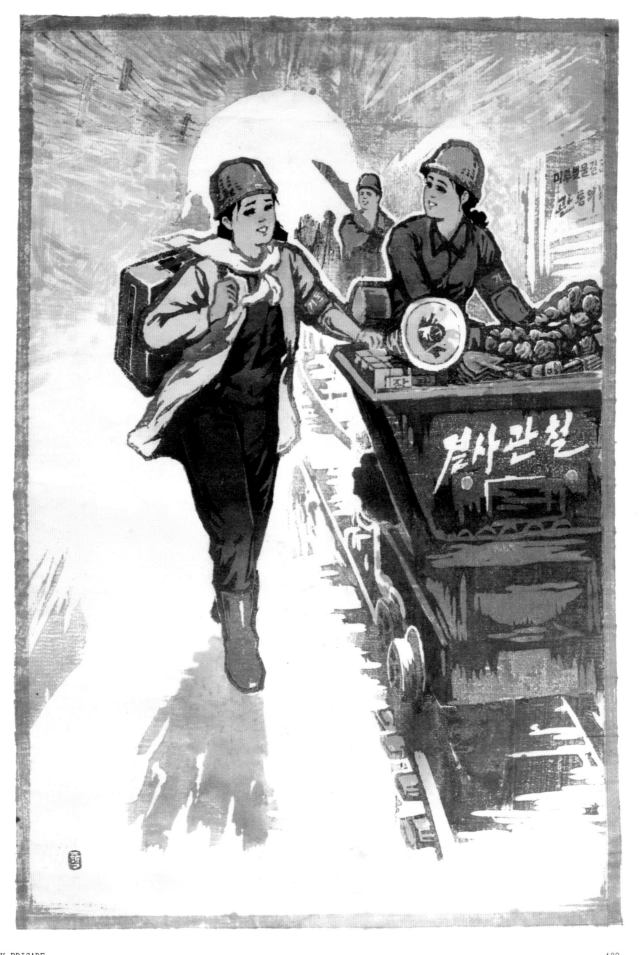

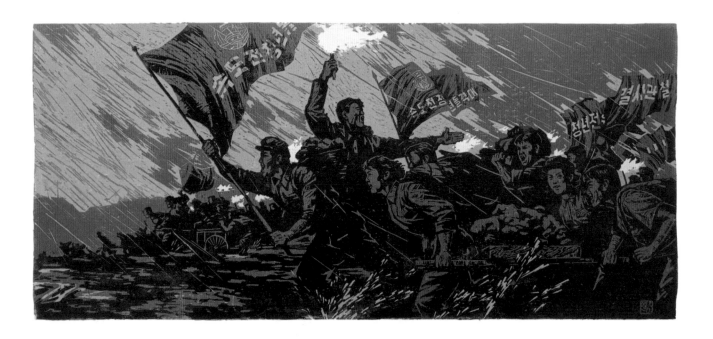

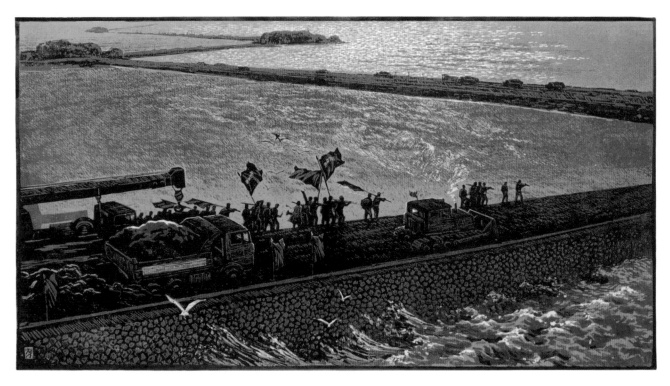

Having finished school, graduates will often volunteer in the 'Shock Brigades' for various major state public works projects around the country. As well as providing unpaid (and relatively unskilled) labour, the work also teaches young people about social adherence.

TOP: [Untitled]. Shock Brigade volunteers are depicted here as if charging in to battle, but this time it is the construction of the Nampo Youth Hero Highway, a forty-two-kilometre-long, eight-lane highway linking the capital Pyongyang to the port city of Nampo. The slogans on the red flags read, 'Speed Battle Youth Shock Brigade' and 'Accomplish With Do-or-Die Spirit'. ABOVE: Young people and construction workers head out to complete the West Sea Barrage.

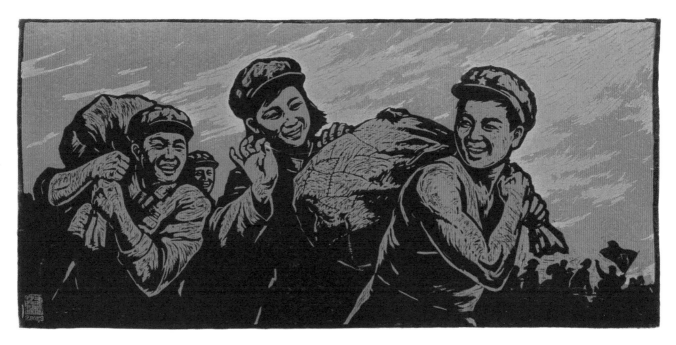

TOP: [Untitled] by Hwang In Jae. The Nampo Youth Highway was started in late 1998 and completed just two years later in time to mark the fifty-fifth anniversary of the Workers' Party. The project was mainly completed manually by 'Shock Brigades' from more than two hundred localities from across the country. The main slogan at the top of the crowd refers to leader Kim Jong Il and reads 'The General is our Father' and the flags contain such upbeat slogans as 'Tireless Efforts', 'Rifle and Bomb Spirit', 'Self-Reliance', 'Do-or-Die Spirit' and 'Decisive Defence'. ABOVE: *Fighting Against Time* by Kim Yong Po, 2005. Before 1945 women were expected to give birth to male heirs to continue the family line and had few opportunities to participate in the social, economic or political life of the country. Then, in 1946, a Sex Equality Law was introduced in North Korea and the saying, 'Women Turn Half the Cartwheel of History' was popularised. The title of this print *Fighting Against Time*, demonstrates that this linocut is more about solidarity between the sexes than depicting women's and men's roles. In the DPRK men and women, old and young, join together to make up the working masses under the guidance of the Leaders and the Party.

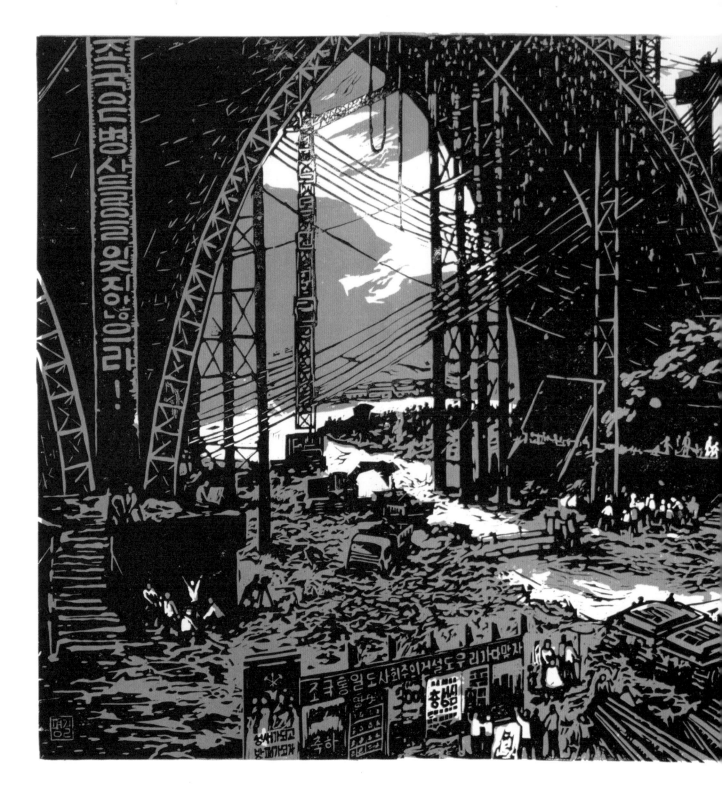

<u>ABOVE</u>: *The Country Will Not Forget the Soldiers* by Kim Pyong Kil, 1989. Propaganda vans blaring out patriotic songs, sloganeering and the on-site band are all part of construction site life aimed to exalt the worker. Slogans read 'The Country Will Not Forget the Soldiers', 'Let's Carry Out the Reunification and Socialist Construction All With Our Hands', 'Speed Battle Youth Shock Brigade', 'Accomplish With Do-or-Die Spirit' and stirring lines such as 'Let's Be the Fortress and the Shield!'. In 1989 when this print was made - the time of the collapse of the Communist Bloc - the government created new ideological slogans to rouse people to fight on with their revolution such as, 'The Spirit of Devotedly Defending the Leader', 'Self-reliance and Fortitude' and 'Spirit of Revolutionary Optimism'.

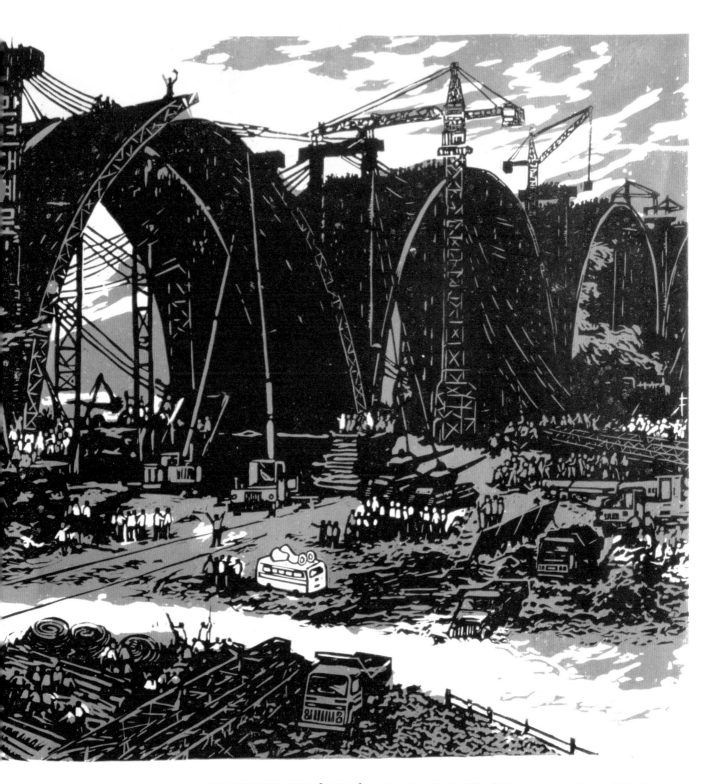

FOLLOWING PAGES LEFT: [Untitled] by Jong Yong Chol, 1988. Soldiers who have been mobilised to work on construction projects and technicians discuss construction methods for the Sariwon Potassium Fertiliser Factory which, as the name suggests, was to produce potash fertiliser. The construction of the factory (located between Pyongyang and Kaesong) started in 1986 with Soviet help. It was to be completed in 1990 as part of the Third Seven-Year Plan (1987-93) but when the Russians pulled out, the project was abandoned. FOLLOWING PAGES RIGHT: *Taechon Power Plant Barrage* by Kim Ung. Divers lay the underwater foundations for the Taechon Power Plant barrage. Constructed in the 1980s, it was the country's largest hydroelectric power station. However, the power transmission lines are old and power can only be supplied to local areas. While hydroelectric provides for localities in the immediate area, it is coal that makes up about seventy per cent of the country's energy output. Even in Pyongyang, the city's electricity and heating is provided by a thermal power station.

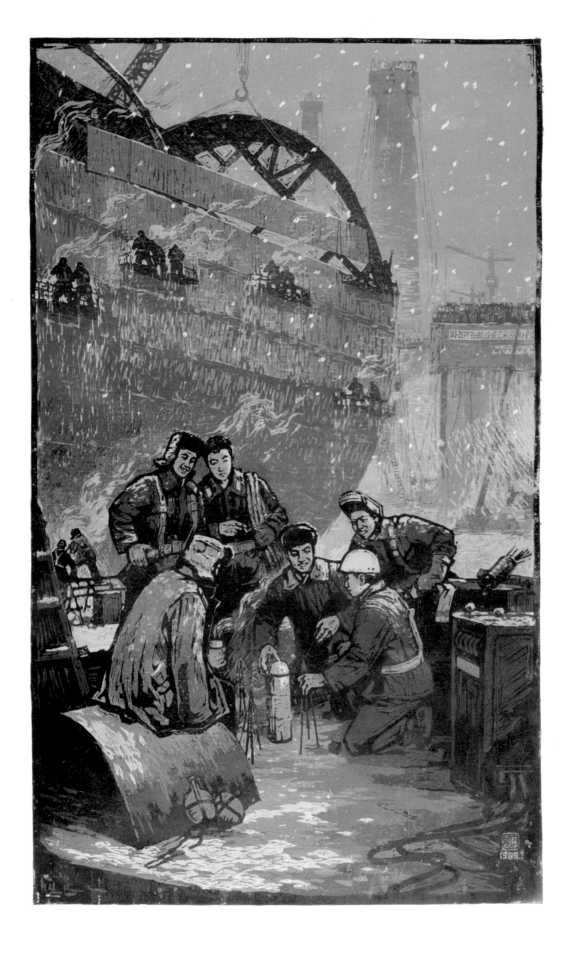

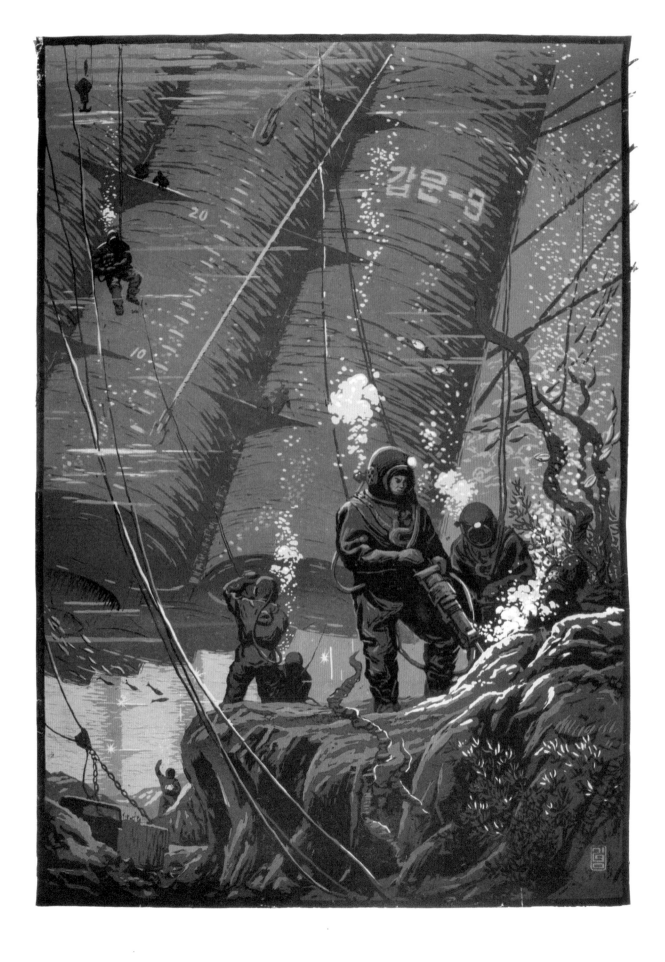

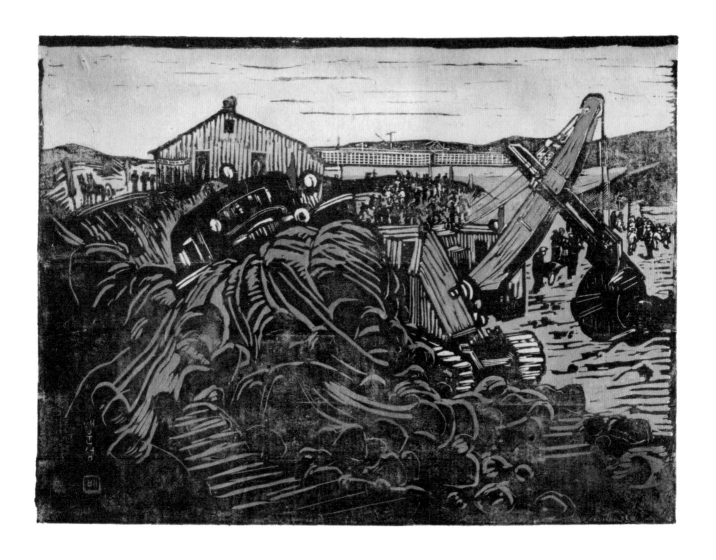

ABOVE: *Taetaryong Road Construction Site* by Pae Un Song, 1961. This early woodcut print of the Taetaryong Road construction site is a striking work in a style not seen in more contemporary prints. Taetaryong Road is the former name of Ponghwa Street – the name of the road came from the Taetaryong Dong, which was the name of a village on the outskirts of Pyongyang, later incorporated into the Potong River District as the city expanded. The twentieth century brought considerable change to place names in Pyongyang. Under Japanese occupation the official language became Japanese and pressure was placed not only to enforce the language throughout the country but even force Koreans to adopt Japanese names, a policy reversed immediately upon independence in 1945. The central avenue of Pyongyang was renamed Yamato Street during the Japanese occupation, becoming Stalin Street after 1945 and later Victory Street in 1970.

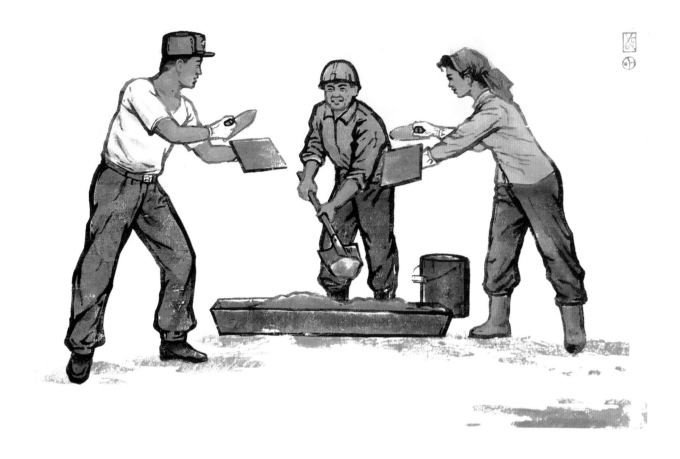

ABOVE: *One Mind* by Tong Ha To, 2004. Scenes of socialist co-operation are common in art, film and literature in North Korea. When we wrote the film *Comrade Kim goes Flying*, scenes reflecting the idea of equality and mutual support, popular tropes in Korean film, were included. The story became the first North Korean 'girl power' film about a young woman who decides to follow her dream even if men or rules get in her way. It became the first North Korean film to be shown to a public audience in South Korea (at Busan International Film Festival) and the first film in North Korea recognised as a film with the sole purpose being for entertainment, not to deliver moral, social or political guidance.

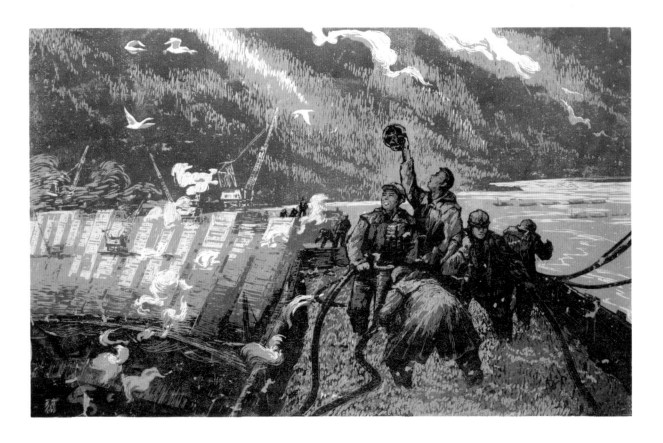

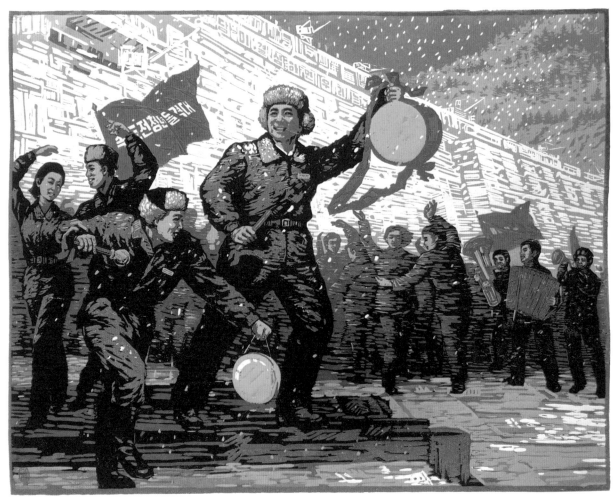

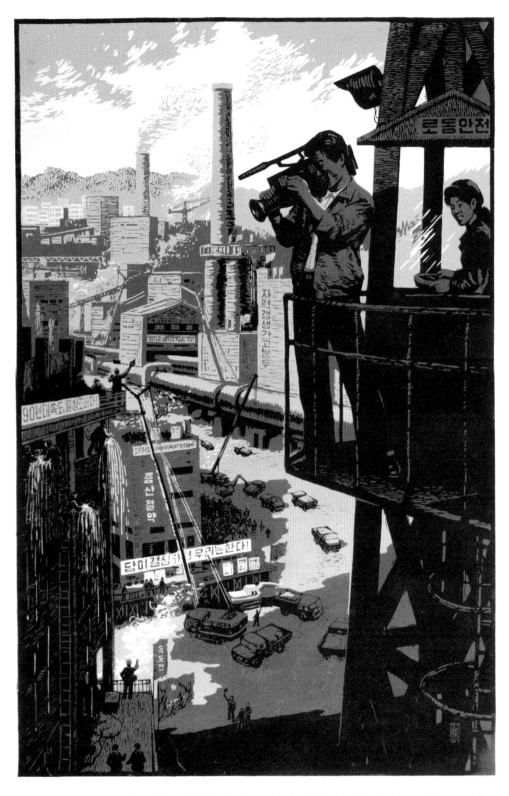

OPPOSITE TOP: [Untitled] and OPPOSITE BOTTOM: *Romantic Youth* by Kwon Kang Chol. Artists are often called to produce artworks that depict both the struggle for, and completion of, major construction projects. Young Shock Brigades with hand drums are seen celebrating after successfully finishing the construction of Huichon Power station. On the flag reads 'Speed Battle Youth Shock Brigade' and the slogan on the dam reads, 'We Will Do Whatever the Party Decides.' ABOVE: [Untitled] by Jong Ho. A journalist films workers at a cement factory in Sunchon. Showing scenes of heroic workers is a common trope on the North Korean 'news'. Usually the programme will explain at length what the factory does, what specific instructions various national leaders have given on site visits, and how the workers have benefitted from this 'on-the-spot guidance'.

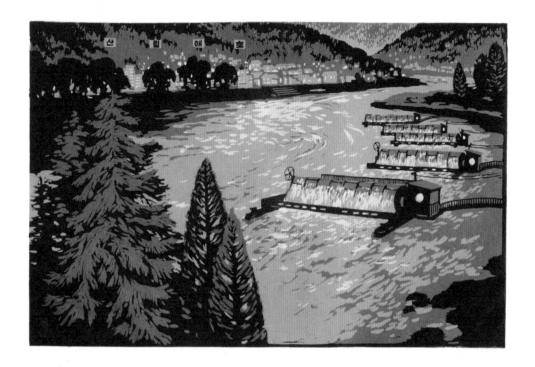

<u>TOP</u>: *Night at Pukchon River* by Ri Kwang Chol. Korean-made hydroelectric generators on the Pukchon River of Jagang Province provide power for the local town. The slogan above the town reads 'Protect the Trees'. The slogan 'Let's Smile Even Along the Difficult Path!' was created in Jagang Province during the 'Arduous March', where they built small and medium-sized power plants to solve the power problem. <u>ABOVE</u>: *Winter of Samsu* by Han Song Ho, 1999. Rugged terrain and severe winters give rise to the traditional folklore (and regional stereotypes) that those in the far north of the Korean Peninsula are 'savage dogs fighting in mud fields' and 'fierce tigers from the forest', whereas people from the south are referred to as 'fresh wind and a bright moon' and 'plum blossoms in the snow'. <u>OPPOSITE TOP</u>: *Train Whistle of the Northern Part* by Han Sung Won, 1978 and <u>OPPOSITE BOTTOM</u>: *Raft on the Tuman River* by Won Chol Ryong. Transportation in the north is limited, and major rivers have provided much of the transport for timber and goods for generations. Timber rafts travel down the Tuman River, the second longest river in North Korea, from March to late November, when the water is free from ice.

114

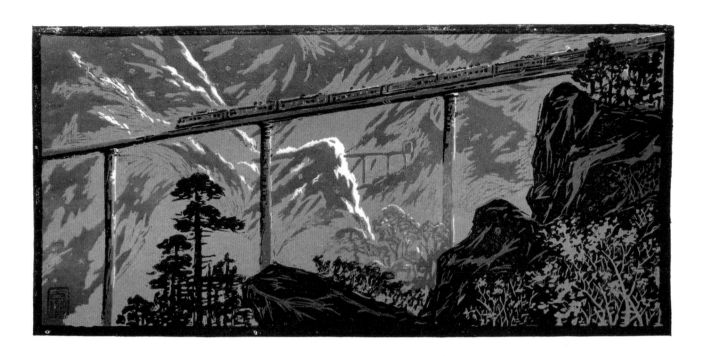

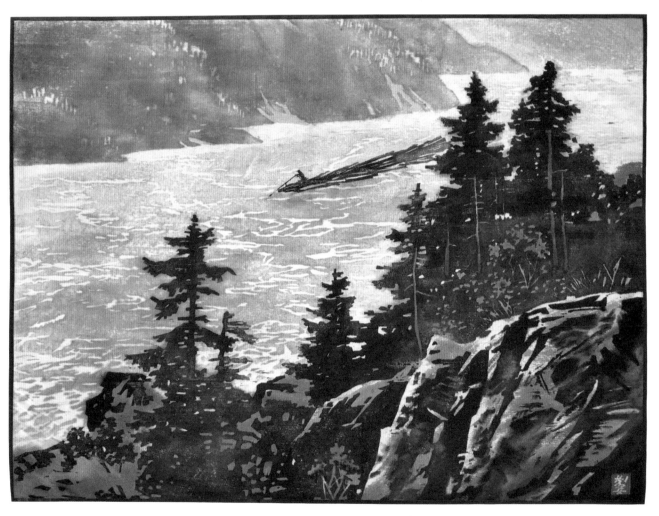

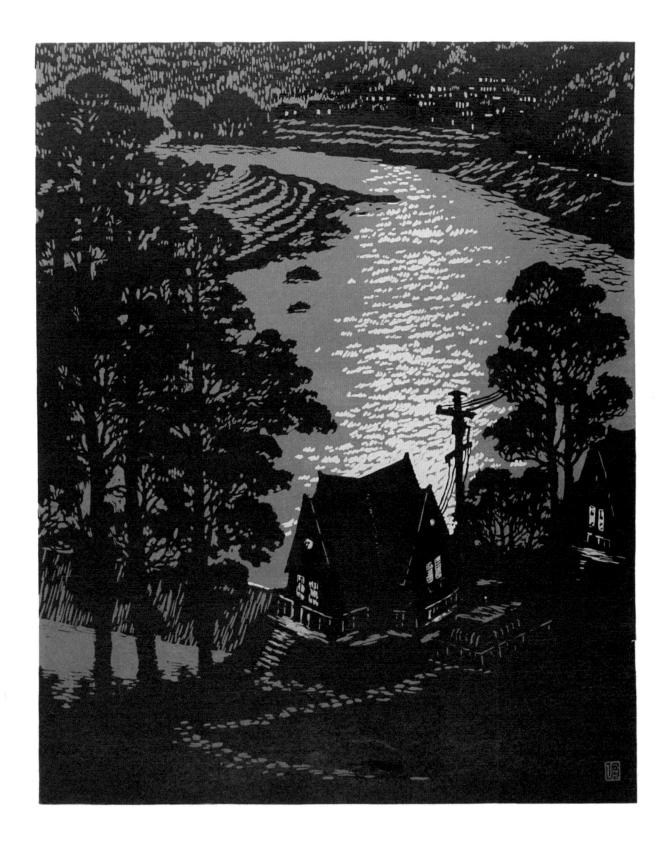

ABOVE: *Light* by Ko Yong Il, 1997. The Changja River, depicted here, is the first tributary of the Yalu River in Chagang province. Its 238-kilometre length has many favourable points for the development of small-scale powerplants that provide electricity to locations that would otherwise be off the grid. Maintaining equipment and supply of spare parts in rural areas is difficult. When filming the 2004 documentary *A State of Mind*, we were told 'If we don't have something and the state cannot provide it then we make it in the spirit of self-reliance'.

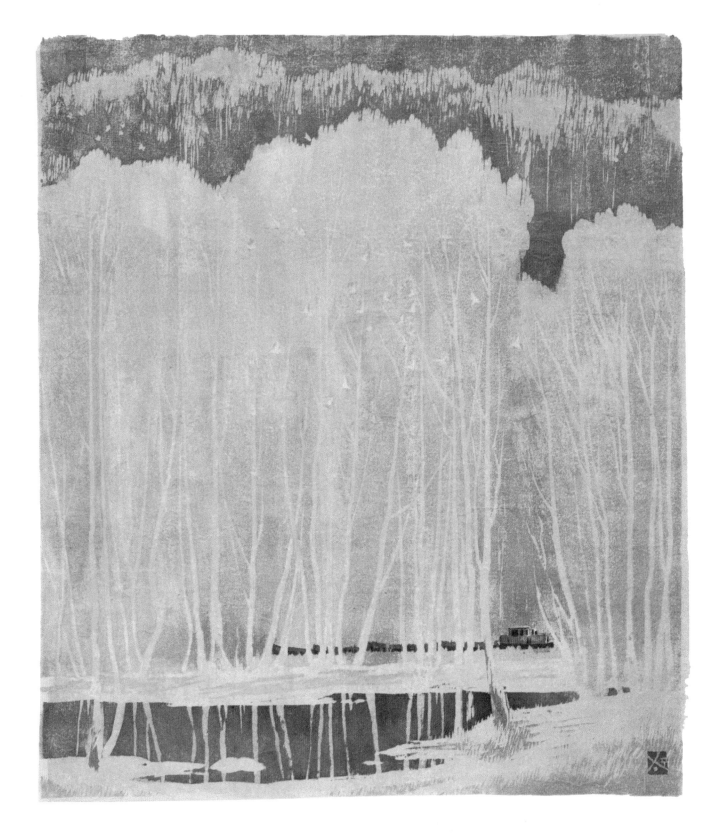

<u>ABOVE</u>: *Spring of Samsu*, by Tong Ha To, 2005. The name Samsu, a region in Ryanggang Province on the border with China, literally means 'Three Waters', which refers to the sources of the three tributaries flowing into the Yalu River. This inland highland region experiences, on average, the longest winters in Korea and is traditionally considered one of the toughest places to live on the whole peninsula. It finds its way into poetry common to both North and South Korea via the poet Kim So Wol (1902-34). In the poem *Samsu Kapsan*, he describes his desperate situation where he can't go back to his home town because of Japanese oppression. Spring in Samsu marks the end of a long winter in Korea.

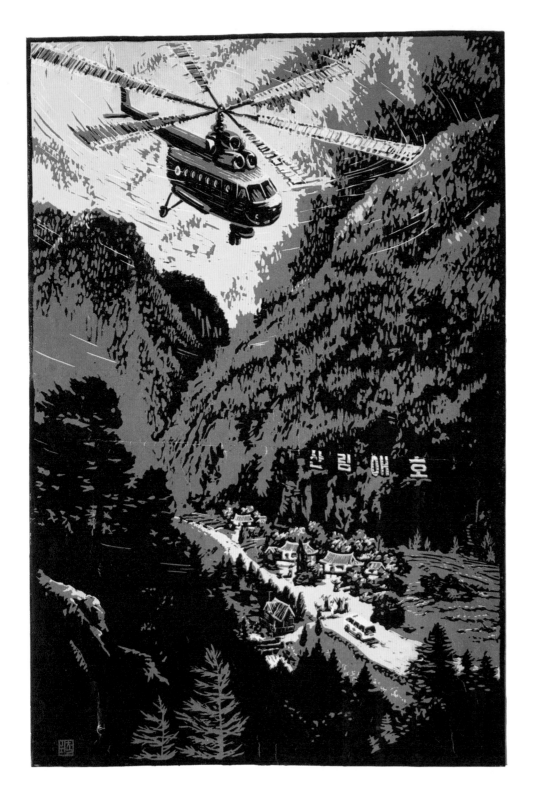

ABOVE: *Helicopter of Love* by Kim Won Chol, 1998. The title signifies that the government is all-caring and has mobilised forces to help a patient in a remote mountain region. Even though the ambulance has arrived, the helicopter will be quicker. In the 1980s, stories of helicopters picking up pregnant women was a popular news story. The slogan in the trees reads 'Protect the Forest'. OPPOSITE: *Electric Locomotive Construction* by Kwon Hyong Man, 1987. The rail network was largely destroyed during the Korean War. Electrification of the national rail network began in earnest in the 1960s and the first domestically produced mainline electric locomotive, the Red Flag, was rolled out in 1961. In November 2018, for the first time in more than a decade, a train travelled on a test run just over the border from South Korea into North Korea. The potential remains for travel and trade links across the border and for connecting South Korea by rail through to China, Russia and beyond.

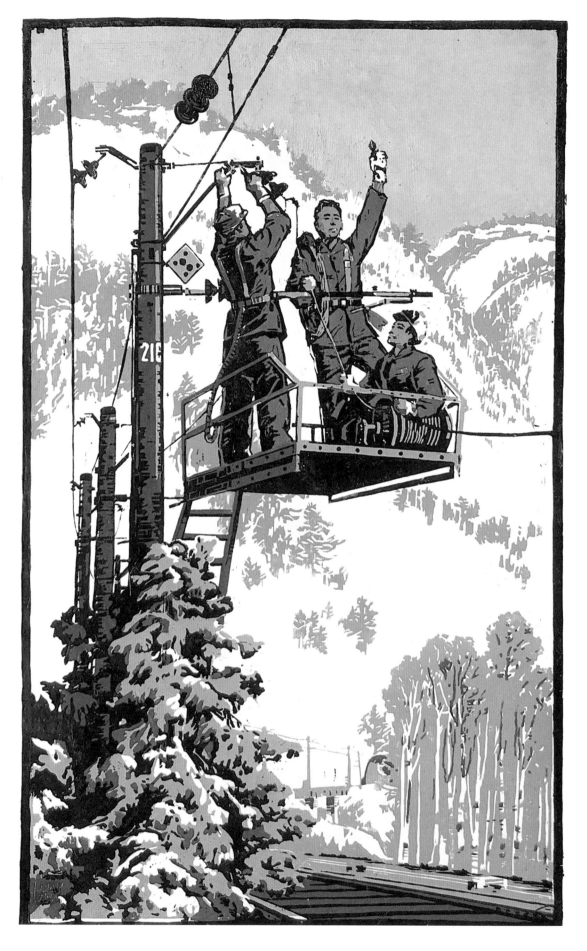

120

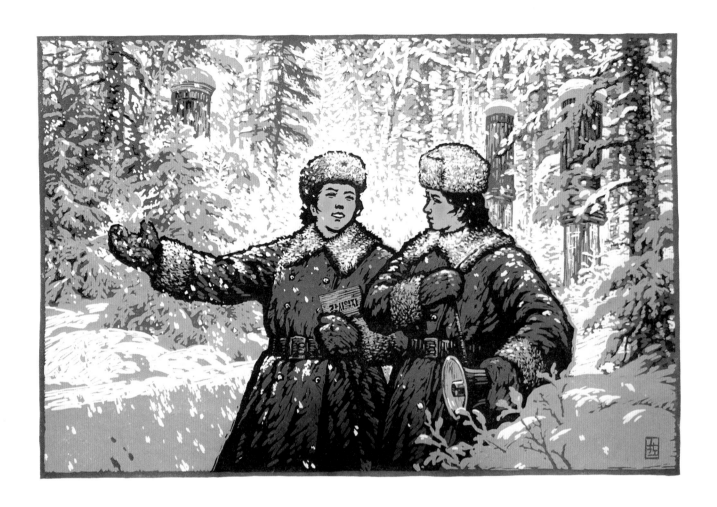

OPPOSITE: *Summer at Chongbong* by Kim Kyong Chol, 1999 and <u>ABOVE</u>: *Proud* by Kim Kuk Po, 2002. The Chongbong Bivouac is where the Korean People's Revolutionary Army (KPRA) spent their first night on the way to the northern area of Musan in 1939 from where the anti-Japanese guerrilla army of Kim Il Sung is considered to have based themselves and fought to liberate the country. These areas are home to the iconic 'slogan trees' that the guide will tell you were pine or larch trees on which partisans stripped bark and wrote patriotic slogans – many of these slogan trees keep being 'discovered' to this day. When found they are protected from the elements with glass cases or canvas covers, as seen in both these prints. Guides relate stories of how soldiers gave their lives to protect slogan trees from forest fires.

TOP: [Untitled] by Hwang In Jae, <u>ABOVE</u>: *Morning at Sukyonggak* by Kim Won Chol, 2006, <u>OPPOSITE TOP</u>: *Cable Car of Love* bu Kim Won Chol, 2008 and <u>OPPOSITE BOTTOM</u>: *Snowflakes of Rimyongsu* by Sim Won Sok, 2006. North Koreans refer to Mount Paekdu as the 'Sacred Mountain of the Revolution' and to all Koreans it represents the birthplace of the Korean nation. With a depth of 384 metres, Lake Chon lies within the caldera of the mountain. From mid-October to mid-June, the lake is typically covered with ice. In 2011, experts from North and South Korea met to discuss the potential for a significant eruption in the near future, as the volcano erupts every one hundred years or so - the last time in 1903. Lake Chon can be accessed by an old Swiss-made cable car, however young cadets and students will head out on a pilgrimage and walk up to the 2,750-metre-high ridge. The nearby Rimyongsu Waterfall is fed by the groundwater from Lake Chon and is a popular destination for visitors. There are popular songs about Mount Paekdu, Lake Chon and Rimyongsu Waterfall, and in North Korea they say that knowing the geography of one's country is patriotic.

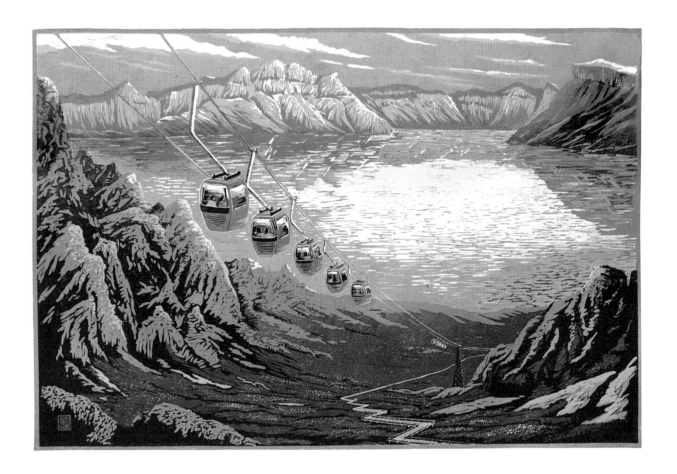

ABOVE: *During the Exploration March* by Ko Yong Chol, 1984. North Korean history relates the story of Kim Il Sung, age nine, following his parents to the northern Chinese region of Musong. When he was twelve, they sent him back to Korea alone, on foot. He stayed with local peasants and lived off the land so he could learn Korean customs, culture and language. It has since become part of the ideological education of children to undertake the 'One Thousand-ri Journey for Learning' pilgrimage. Today they travel partly by bus and stay in hostels, but it gives them a sense of distance and allows them to relate to the lives of the Leaders. OPPOSITE: *Water of Our Homeland* by Choe Il Chon, 1980. A schoolgirl on the 'Paekdu Historic Site Exploration March' at the sculptures of the anti-Japanese guerrilla fighters shown drinking the water of their homeland. After fighting the Japanese across the border in China, they returned to their homeland where the azaleas were in bloom and since then the plant has strong revolutionary credentials.

ABOVE: *War Site of June* by Ri Ju Song. A small group on their 'Exploration March' listening to the instructor in front of the Victorious Pochonbo Battle Monument to commemorate a battle that occurred on 4 June 1937. The Exploration March is a compulsory course in high school and university. In North Korean revolutionary history, it is taught that the Pochonbo Battle inculcated such hope and confidence in the hearts of the people that Korea could achieve independence that it aroused an all-out nationwide struggle against the Japanese. OPPOSITE: *Samjiyon* by Kim Yong Hwan. Samji Lake is a sacred place to North Koreans as the place where Kim Il Sung's guerrilla army rested before their attack on a Japanese garrison at nearby Pochonbo in the Musan area in 1939. The site is now commemorated by the Samjiyon Grand Monument statues complex and the rather more poetic sculptures of the guerrillas drinking from the lake.

FOLLOWING PAGES: *Ulim Waterfall* by Jang Su Il, 2006. The Ulim Waterfalls were 'rediscovered' in 1999 and on the rockface is the signature of the leader Kim Jong Il and '2001', the year it became a destination for tourists. The song *Echoes of the Ulim Falls* tells how the falling waters are 'banging their hearts to make the DPRK a strong and prosperous country'.

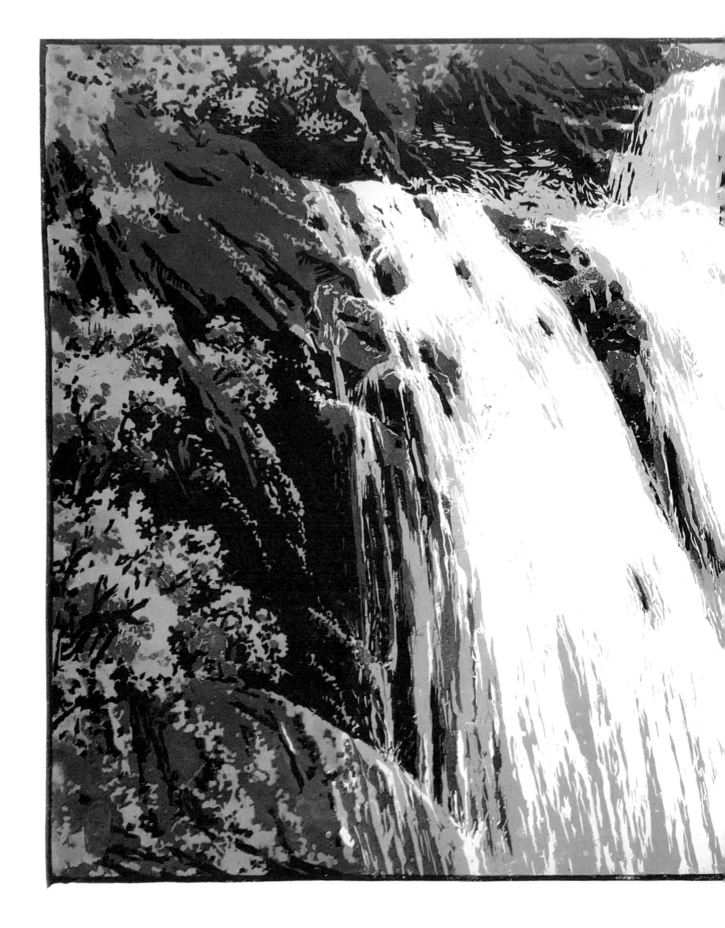

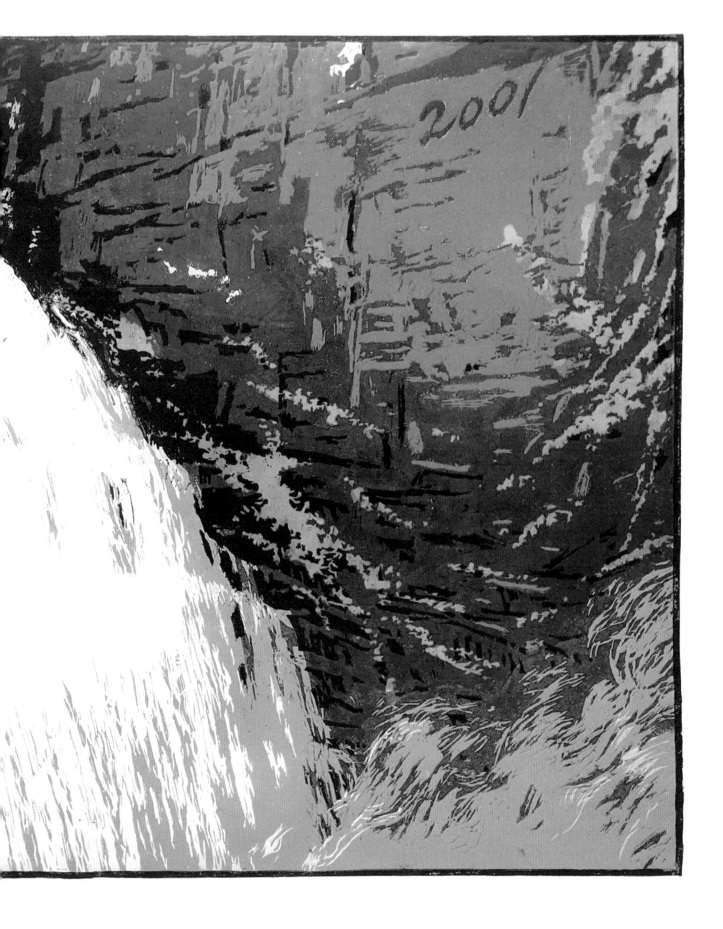

REVOLUTIONARY ART AWAKENS PEOPLE TO THE TRUTH OF STRUGGLE & LIFE & INCULCATES IN THEM RICH EMOTION & VERVE

Kim Jong Un

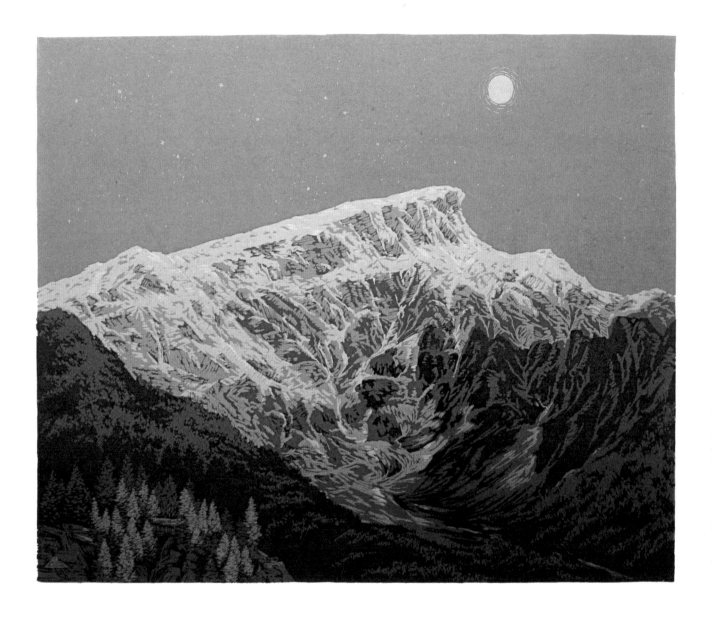

<u>ABOVE</u>: *The Night of Saja Peak* by Pak Yong Il, 2006. Sajabong Secret camp, one of the nine 'secret camps', is located in Saja Peak, in the southern part of Mount Paekdu. Saja Peak is where the anti-Japanese guerrilla forces held meetings to discuss plans for the liberation of Korea, and also where the Japanese colonisation of the Korean Peninsula ended on 15 August 1945. This day is celebrated annually as Liberation Day and is additionally notable for being the only Korean public holiday celebrated by both North and South Korea. The division of Korea began the same year. With the defeat of Japan, the Soviet Union occupied the north of Korea, and the United States occupied the south, the two zones separated by the 38th Parallel. Negotiations between the United States and the Soviet Union failed to lead to an independent and unified Korea and in 1948 two independent countries were formed with pro-Soviet Kim Il Sung in the north (the Democratic People's Republic of Korea) and pro-US Syngman Rhee appointed president in the south (the Republic of Korea).

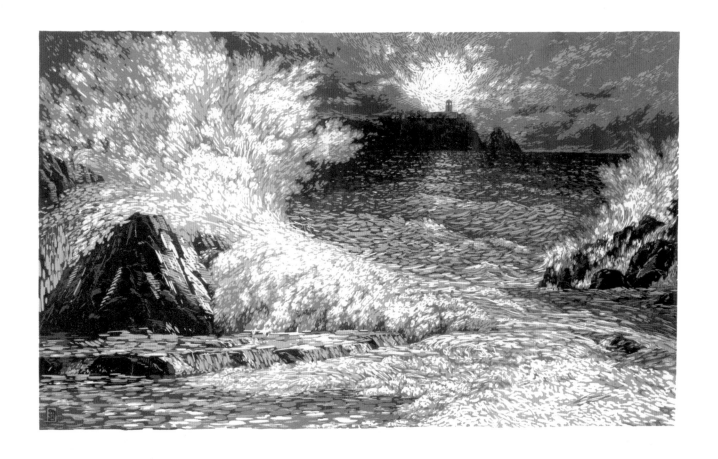

ABOVE: *Lighthouse* by Pak Yong Il, 1995. A lyric from the song *Victorious Workers' Party of Korea* reads 'The Workers' Party of Korea is our lighthouse, the Workers' Party of Korea is our guide.' Even though a seascape or landscape might appear as if it were created for its aesthetic value only, it is likely to be imbued with revolutionary meaning. In this case not only can the lighthouse be read as significant but also the waves crashing on to the shore reflect the strength, independence and solidarity of the country. Foreign dignitaries and the Korean leaders are often photographed with a backdrop of a crashing sea oil painting, as it's a symbol easy for North Korean audiences to decode.

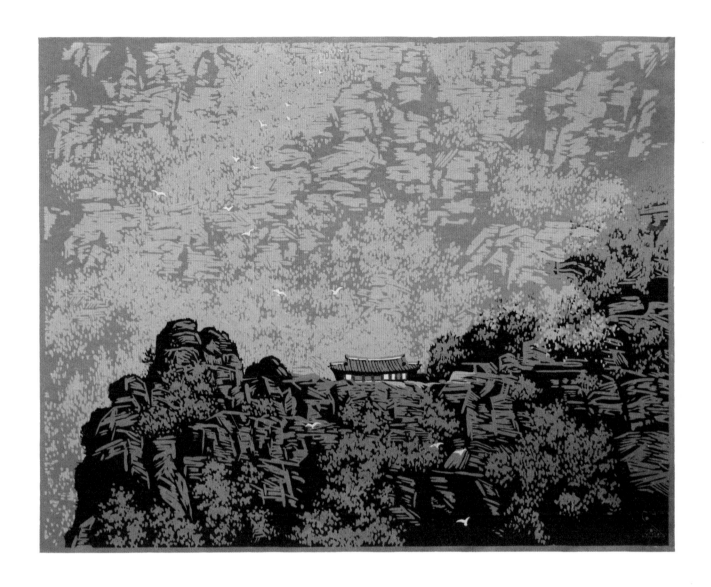

ABOVE: *Hyonam of Mount Jangsu* by Jang Song Pom and Pak Yong Il, 2004. This print depicts Hyonam Temple at Mount Jangsu. Korea is home to various religious traditions. Indigenous animistic shamanist practices predate the introduction of Buddhism in the fourth century. Confucianism entered Korea around the same time. During the Koryo Dynasty (918-1392), Buddhism was adopted as the state religion. The following Choson Dynasty (1392-1910) adopted neo-Confucianism as the state ideology. Christianity seeped into the country from the eighteenth century onwards, but converting people to Christianity only took off in the wake of the opening up of Korea in 1876. In the nineteenth century, Tonghak, a native religion that borrowed elements of Shamanism, Buddhism, Confucianism and Roman Catholicism, was established. It is known today as Chondogyo. Under Japanese colonial rule, Shinto veneration was imposed on the Korean population. Today in North Korea, religious practice is limited, although the constitution does claim freedom of religion. Limited places of worship for Christians, Buddhists and Chondogyoists do exist and are permitted to operate under strict state control.

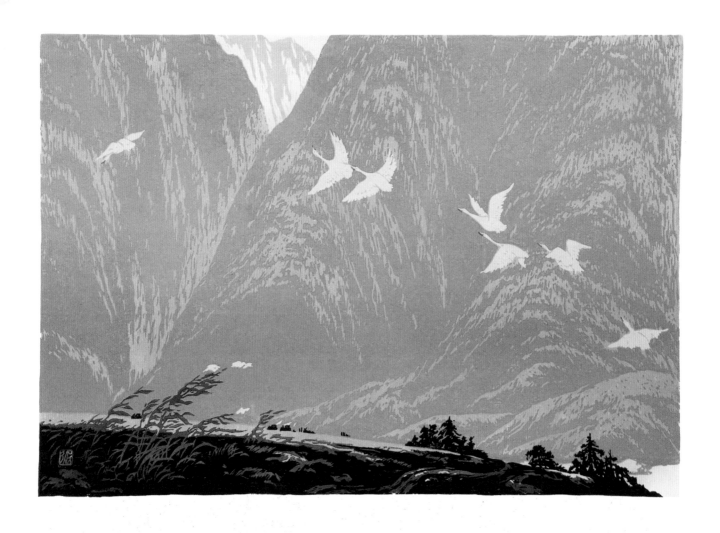

ABOVE: [Untitled] by Si Ung. While all might seem to be well in this print, the Korean Peninsula has experienced almost an entire century of war and destruction that has resulted in a severely degraded natural environment. The Japanese occupation radically increased exploitation of minerals and timber, particularly towards the end of the war, and a few years later the Korean War led to massive deforestation and pollution. In the 1960s and 70s, unchecked industrialisation further undermined the peninsula's ecological health. In the north, a lack of food and resources in the 1990s resulted in widespread deforestation and significant erosion of the area's mountains and habitats, while in the south urban sprawl and new agricultural practices have led to other types of ecological problems. The relative health of the Demilitarised Zone (DMZ) now stands in stark contrast to failing ecosystems in both North and South Korea. Created in 1953 during tense armistice negotiations, the four-kilometre-wide DMZ is bizarrely one of the most dangerous places on earth for humans but one of the safest for nature. Perhaps one of the greatest threats to this fabulous reserve will come if ever the country is reunified.

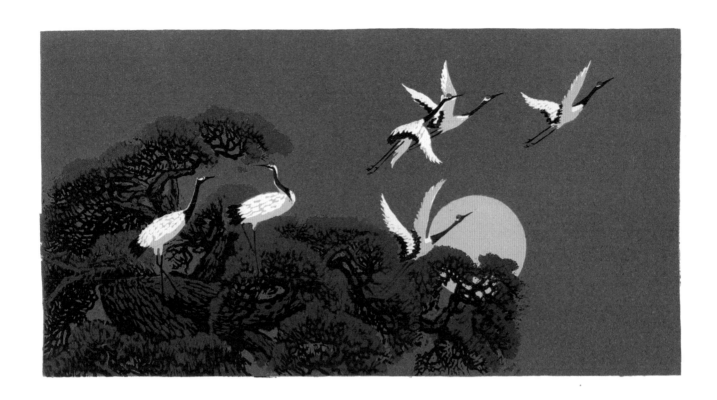

ABOVE: [Untitled]. Red-crested white cranes stand for good fortune and longevity because of their fabled life span of 1,000 years. In classic Korean art, these cranes have traditionally been accompanied by pine trees to signify lofty solitude, integrity, unworldliness and immortality. These symbols are also engraved on the doors of the Kumsusan Palace of the Sun, the mausoleum where Kim Il Sung and Kim Jong Il lie in state. The phrase 'The Great Comrades Kim Il Sung and Kim Jong Il Will Always Be With Us' can be found on 'Immortality Towers' in every North Korean locality. The largest Immortality Tower is located in Pyongyang at the entrance to Kumsong Street.

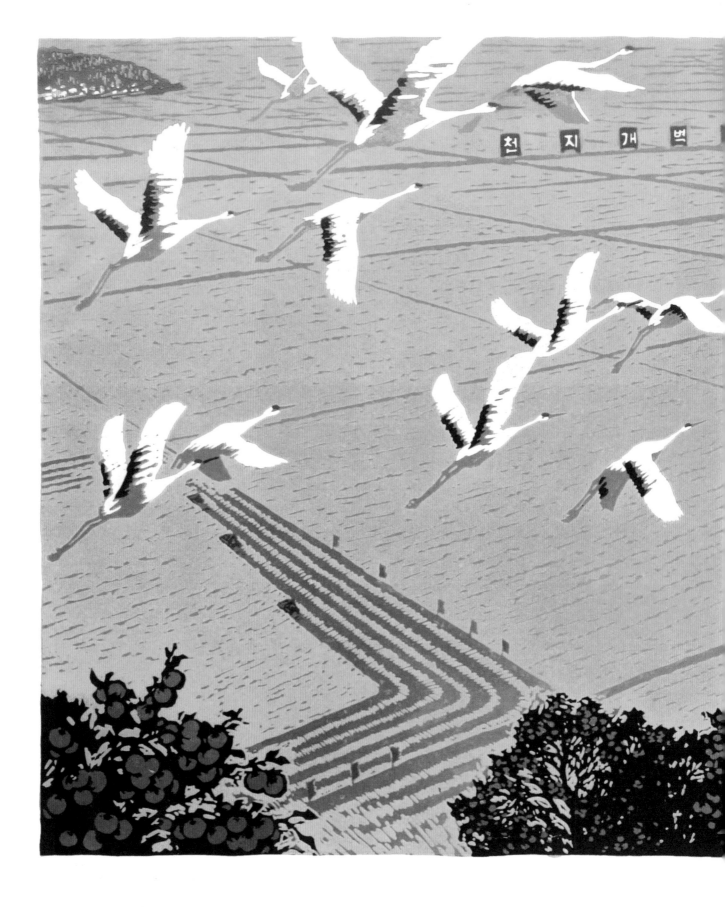

천 지 개 벽

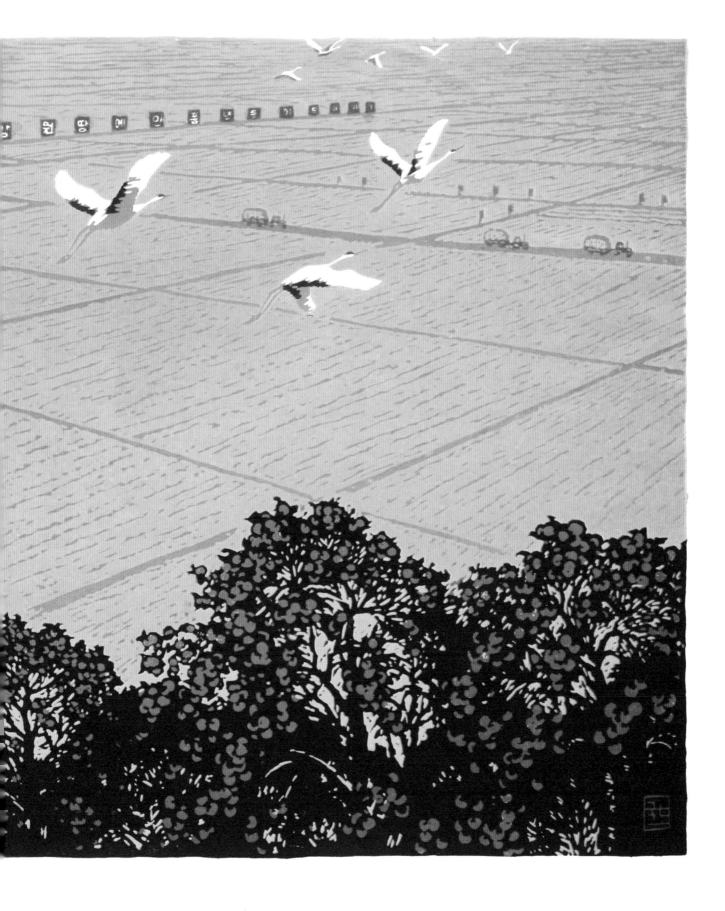

PREVIOUS PAGE: *Autumn in Anbyon* by Kim Kuk Po, 1999. The field slogan reads 'Let Us Achieve a Good Harvest in the Miracle Lands of Kangwon Province!'. The achievements of land readjustment in Kangwon Province in the 1990s may have compromised the natural environment but it has also established a crane conservation area in the Anbyon Plain just north of the DMZ near Wonsan that supplements migratory wintering grounds for both white-naped and red-crested cranes.

ABOVE: *Players* by Kim Hyon Chol. While the Taedong River in central Pyongyang is more well-known, the secondary Pothong River is more suitable for leisure activities such as fishing and rowing. Prior to 1946, the arable land where the Pothong entered the Taedong River was subject to annual flooding, then in 1946 the river was successfully canalised. In Pyongyang it is possible to visit a monument built to celebrate the 'Pothong River Improvement Project'.

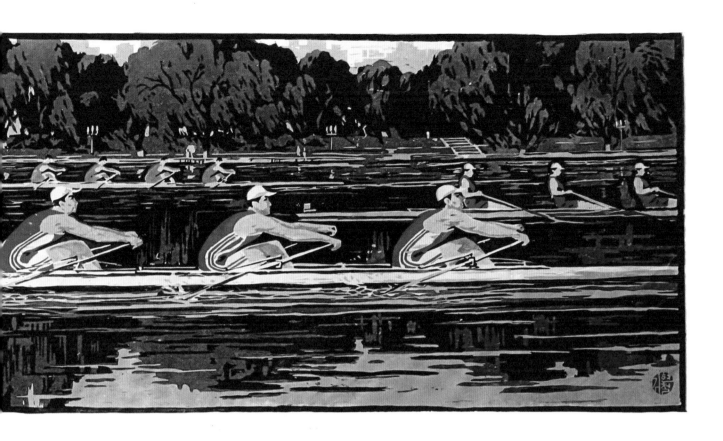

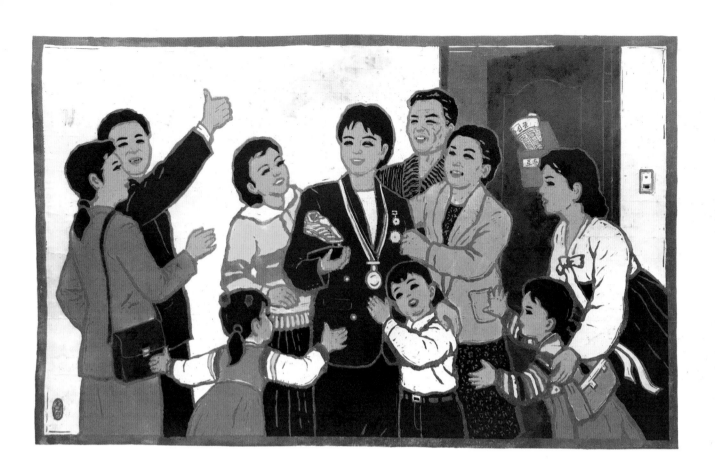

ABOVE: *The Pride of the Inminban* by Pak Song Chol, 2007. Jong Sung Ok, is one of the few sportswomen to receive the title of 'Heroine of the Republic' (1999) and the 'People's Sportswoman (1999). She won first prize in the women's marathon race at the Seventh World Championships held in Spain in August 1999 and is the subject of a biographical feature film. As a reward, she and her family received an apartment in the centre of Pyongyang and in this scene, her family and 'Inminban' (the neighbourhood unit) are welcoming her to the new apartment. OPPOSITE: *Our Player Has Won!* by Hwang Pyong Kun, 1985. Football (soccer) is the national sport of the DPRK and at the 1966 World Cup in England the DPRK team created the greatest shock in World Cup history by eliminating Italy 1-0. North Korea is a powerhouse in women's football with teams at various age groups consistently being among the world's best. They have won the AFC Asian Cup three times, the World Cup at various age groups (apart from the senior squad, a frustrating gap in the trophy cabinet), and consistently put together far stronger teams than their male comrades can manage.

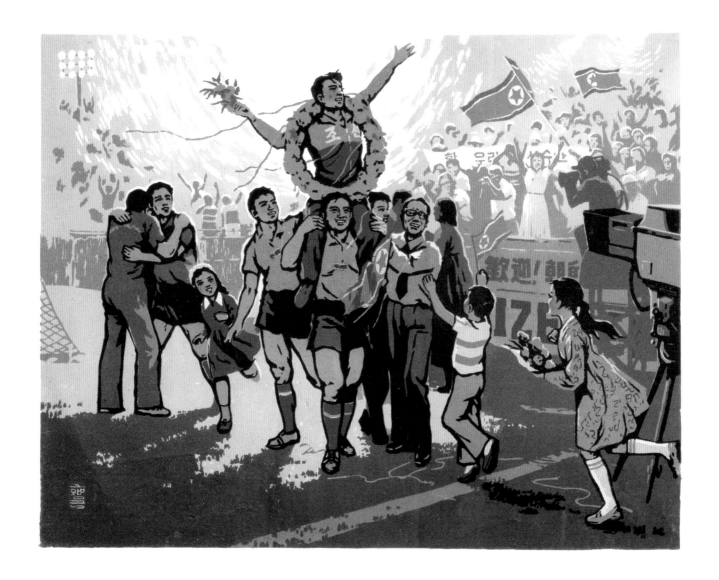

FOLLOWING PAGES LEFT: *Bumper Harvest Has Visited the Chongsan Plain*, by Kim Hyan Chol, 2001. The farmers brandish a traditional banner referring to the saying that 'farmers are the backbone of the country'. Chongsan-ri cooperative farm raised the first torch of the 'Three-Revolution Red Flag Movement' in response to the Party's call in 1973 to launch the ideological, technical and cultural revolutions. A local guide will proudly tell you all about the 'Chongsan-ri method' and 'Chongsan-ri speed', and that it was awarded the Three-Revolution Red Flag three times. If asked, the guide will sing *Bumper Harvest Has Come to Chongsan-ri*, which was composed to remember the efforts of all who participated in the movement. FOLLOWING PAGES RIGHT: *Yut Games* by Pyong Su and Kwang Su. *Yut* is a game played on traditional Korean holidays, as opposed to the national holidays that are more ideologically defined. This scene shows the game not as it is played today, but historically. In the depiction of a rural community coming together, this print evokes a nostalgic image of country life.

청년 풍년가락

ABOVE: *Ssirum*. Wrestling is a traditional folk game and athletic competition in Korea. It is normally played on Dano Day (on the fifth day of the fifth month of the lunar calendar, following the planting of rice seedlings, people pray for a bumper harvest). The main event is in Pyongyang where local champions from around the country compete. The Pyongyang event is televised and wrestlers compete for a chance of stardom and winning a bull complete with a golden bell. OPPOSITE: *Seesaw* by Hwang In Jae. According to tradition, and until recent years, the majority of marriages were arranged by parents, often with the help of a professional matchmaker. The exception was the Daeboreum and Dano Festivals at which people from all strata of society mixed. Games such as wrestling, seesaw, swinging, and *yut* provided a chance for people to show off their skills, character and appearance in a setting that would otherwise be limited by societal norms. Some of Korea's greatest love stories, such as the *Tale of Chun Hyang*, originate from these festivals.

FOLLOWING PAGES LEFT: *Holiday* by Jang Ok Ju, 2003. Swinging in Korea is more of a traditional competition for girls than a game, and is more prevalent in the north. The swings are tied to branches of large zelkova or willow trees that are often to be found at the entrance to villages. Competitions are mostly held on Dano Day (marking the start of summer) and the prizes are usually *norigae*, which are ornaments for *jogori*, the traditional jacket. Since division of the country, traditions have endured in both halves of the Korean Peninsula, but rarely in the same way. FOLLOWING PAGES RIGHT: *Taesongsan Resort* by Jang Song Pom, 2000. There are four major funfairs in Pyongyang, some equipped with modern Italian-made rides. This one however is older and located at the edge of the city and used mainly on national holidays.

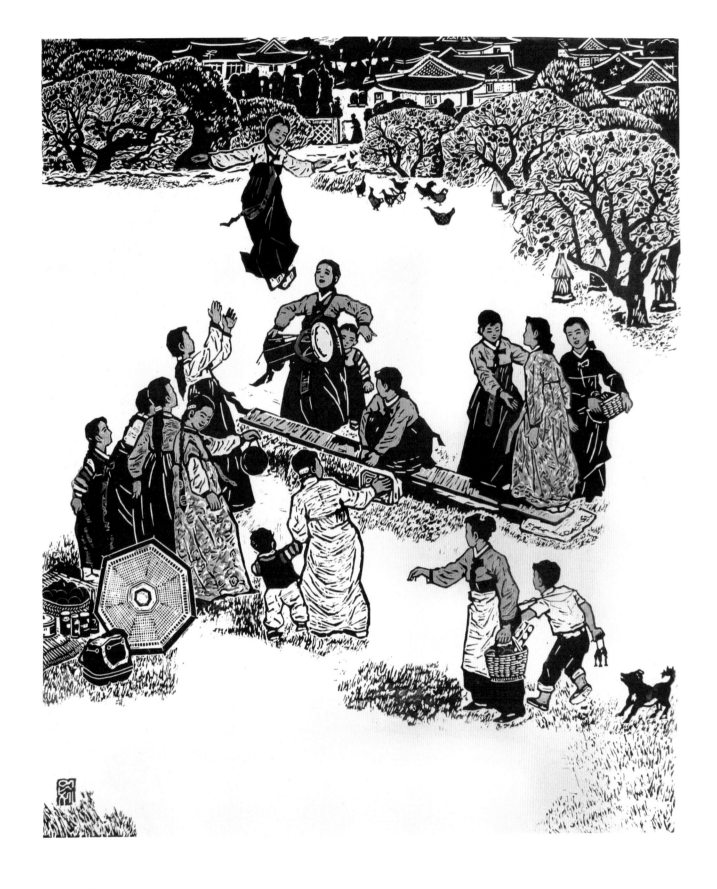

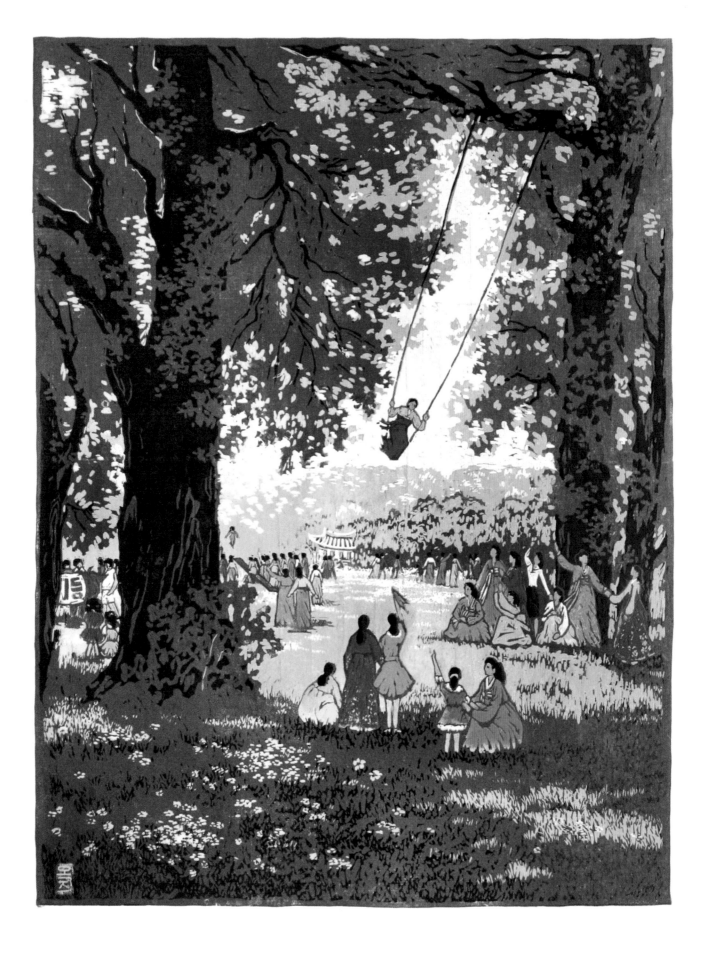

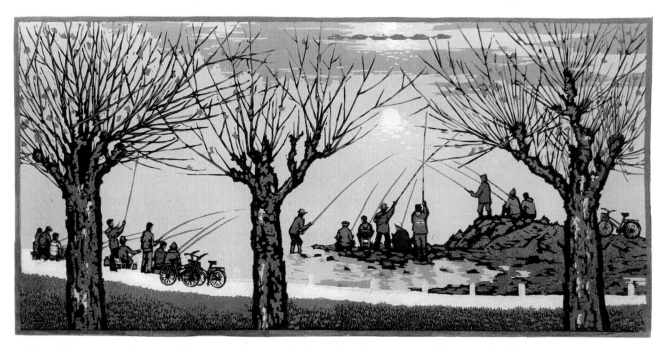

OPPOSITE TOP: *Sunday* by Jong Il Son, OPPOSITE BELOW: *Holiday* by Pak Yong Il, 2007 and <u>ABOVE</u>: [Untitled] by Kim Won Chol. North Koreans typically spend Sunday and holidays with family or friends. Outdoor barbecues in parks for a shared meal, singing and dancing accompanied by a guitar (or portable karaoke machine) are popular. House parties and group visits to the sauna are also common. Some families spend their free time watching television or at the cinema (only day screenings are available). Choson Central Television (the DPRK's national broadcaster) plays at least one film a night – mostly domestic productions but sometimes Russian or Chinese programmes. If football is the most popular sport among the youth in the DPRK, fishing and Korean chess are the most popular among the elderly, and Pyongyang has an annual fishing competition for the city's many retirees.

ABOVE: [Untitled]. Depicting Uiju, in North Pyongan Province, this print expresses the anti-Japanese movement begun by Kim Hyong Jik (1894-1926), the father of President Kim Il Sung. Kim Hyong Jik reportedly gave clandestine lectures to stir people with anti-Japanese sentiment. He is claimed to have been one of the leaders of the March First Movement in Pyongyang, a public uprising against Japanese colonial rule in 1919. In North Korean history, the failure of the March First movement to topple Japanese rule is explained by the absence of a genius leader (subsequently understood to be Kim Il Sung). On his deathbed, Kim Hyong Jik bequeathed 'two pistols' and the 'aim high' motto to his son and the future revolutionary leader Kim Il Sung. This story is important in establishing a revolutionary pedigree that allowed for the creation of a socialist dynasty.

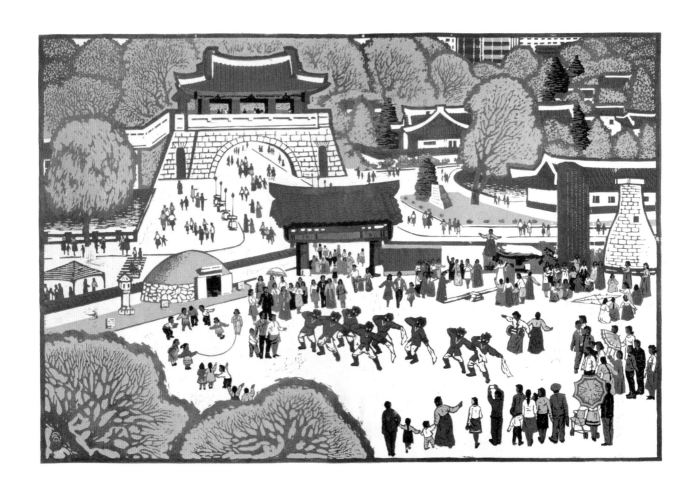

<u>ABOVE</u>: *Folk Street* by Ryu Sang Hyok, 2008. Folk Street in the city of Sariwon, the provincial seat of North Hwanghae Province, was built in the Kim Jong Il era and is used to educate the public about 5,000 years of Korean history and culture, and comes complete with replicas of ancient tombs, gates and houses. In 2004 UNESCO listed the complex of Koguryo Tombs and their mural paintings as the first World Heritage site in North Korea. Then in 2013 UNESCO recognised twelve sites in Kaesong, the city at the heart of the Koryo dynasty, which ruled Korea from 918 to 1392 and unified the now-divided peninsula for the first time. According to the UNESCO citation, these sites embody 'the political, cultural, philosophical and spiritual values' of the kingdom.

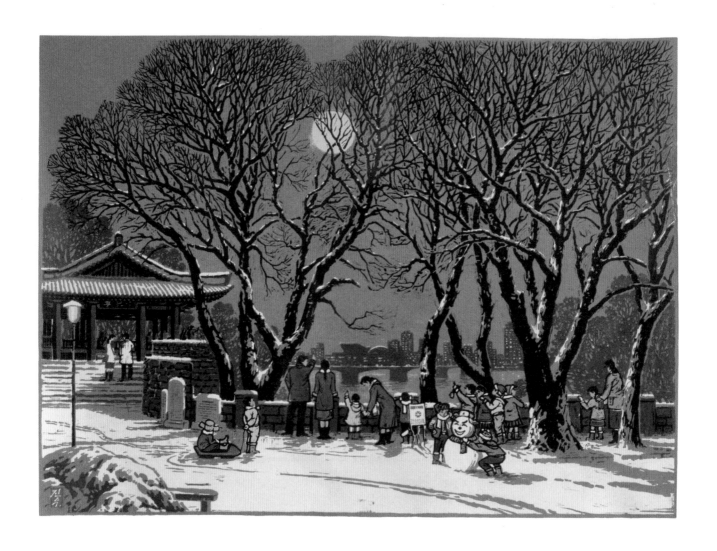

ABOVE: *Daeboreum* by Jang Jin Su, 2007. Watching the full moon from Pubyok Pavilion is one of the iconic 'Eight Scenes of Pyongyang' – a kind of traditional 'must-see' list for anyone living in, or visiting, the city. The pavilion encapsulates the traditional beauty of 'a pavilion floating on the clear blue water on the Taedong River'. It is where the *kisaeng* – Korea's equivalent to the Japanese *geisha* – Kye Wol Hyang plotted with General Kim Ung So to assassinate a Japanese general during the occupation of Pyongyang in the sixteenth century Imjin War. On Daeboreum, the full moon festival, Koreans share traditional food with their families, relatives and neighbours.

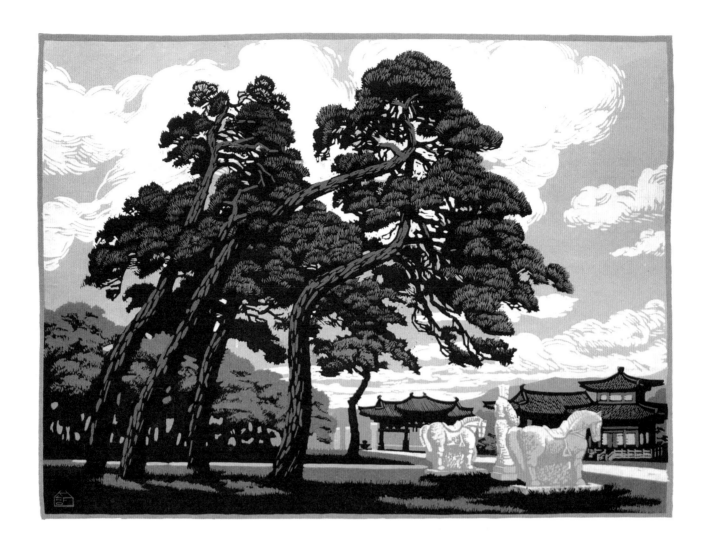

ABOVE: *Pine Trees at the Tomb of King Tongmyong* by Hwang So Hyang, 2004. The Mausoleum of King Tongmyong, (Ko Ju Mong, the founder of the Koguryo kingdom (37 BCE-668 CE) is located in Ryongsan-ri, Pyongyang. The mausoleum was originally located near Ji'an on the Yalu River in present-day China, but when the Koguryo kingdom transferred its capital to Pyongyang in 427 the mausoleum was relocated. The artist of this print gives the impression of pine trees bowing to the king. Koguryo-era tombs are characterised by vibrant murals of daily life and mythology from 1500 years ago. The DPRK has identified eighty mural tombs, with the paintings in varying states of preservation. Similar examples have been found in north-east China and near Nara, Japan.

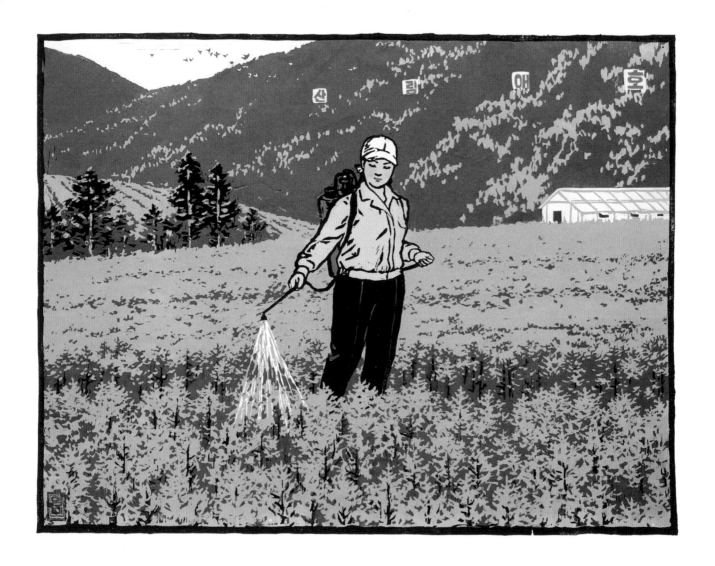

ABOVE: *For a Green Forest* by Pak Yong Mi, 2008. A worker sprays seedlings in a nursery with the slogan
'Protect the Forest' in the background. Korea's forests are an important source of timber and forest
products, particularly pine mushrooms and herbs. Forests also play an important role in flood and
erosion control, but energy and food shortages after the collapse of the Soviet Union have put pressure
on this resource. Over the years, various campaigns have been launched to promote reforestation and
the government has recently invested in modern nurseries. The annual 'Tree Planting Day' on 2 March
is when adults and children are mobilised to head off to the countryside and plant. Perhaps the most
important tree planting episode took place in 2018 in Panmunjom where South Korean President Moon Jae
In and North Korean Leader Kim Jong Un completed the planting of a pine tree, with a stone marker that
read, 'Planting Peace and Prosperity'.

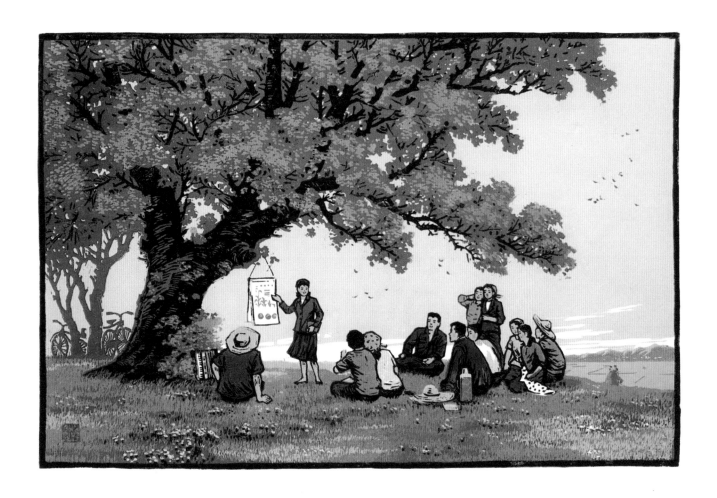

ABOVE: *During Break Time* by Kim Pong Ju. Farmers are given a lecture on crop management during their break. The term 'agricultural front line' is widely used in the DPRK, emphasising the importance of the agricultural sector in the nation's economy. Similar terms used throughout the country include 'steel front line', 'economic front line', and 'coal front line'.

FOLLOWING PAGE: *Meteorological Observations* by Pae Nam Jun, 2004. On 30 July 1946, gender equality was declared in North Korea. In the 1980s and 90s, North Korean women workers were mainly concentrated in light industry and the education sectors, while men worked in heavy industry and mining. However, the role of women has shifted to a more diverse status after going through the 'Arduous March' in the late 90s. Since the early 2000s, a renewed interest in technological development, known as the 'CNC Era' (Computer Numerically Controlled machine tools), has led to women playing a more prominent role in science. In art however, women are typically depicted in nursing roles (agriculture, food, health and education) and gender roles are usually quite clear when men and women appear together in work.

ART IS A BUGLE, A POWERFUL ENCOURAGEMENT, FOR THE REVOLUTIONARY ADVANCE TO BUILD A THRIVING COUNTRY

Kim Jong Un

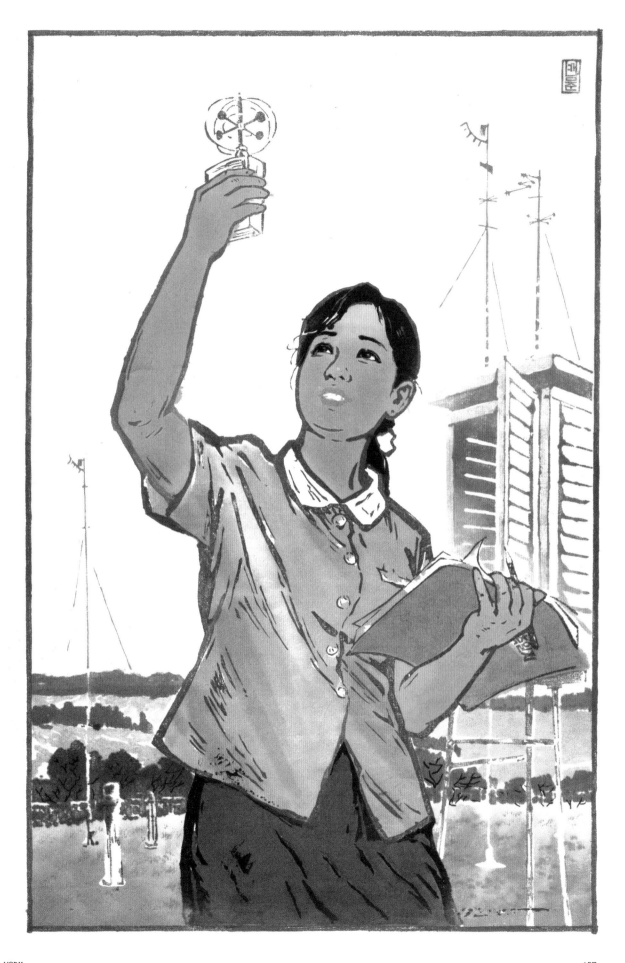

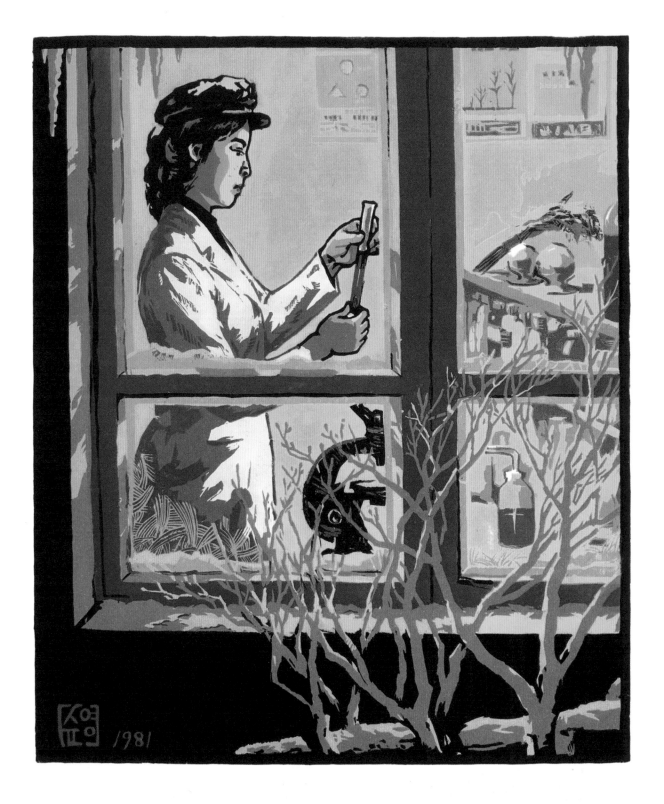

ABOVE: *Researching New Seed* by Choe Yong Sun, 1981. An agriculture scientist researches a new type of seed in the depths of winter at night. Burning the midnight oil is a common way to show devotion to one's work. Scientist Paek Sol Hui is a well-known 'Hidden Heroine' of North Korea. She spent fourteen years researching oil seed. The film *Fourteenth Winter* is based on her life and triggered the movement to learn from the 'Hidden Heroes' in the 1980s. OPPOSITE: *Teen Brigade Leader* by Pak Song Kil, 1980. A farm work brigade leader estimates corn yields by counting kernels. North Korea has a system of collectivised farming divided into community-based cooperatives and a lesser number of government-run state farms. Each farm is subdivided into specific work brigades responsible for different aspects of farming, such as field crops, livestock and machinery.

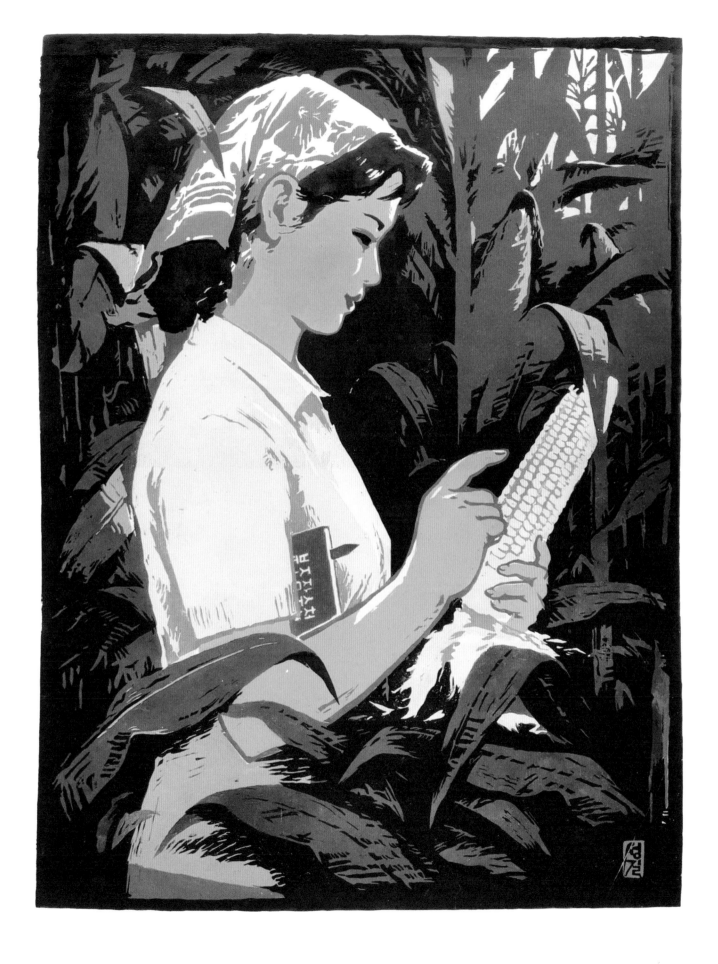

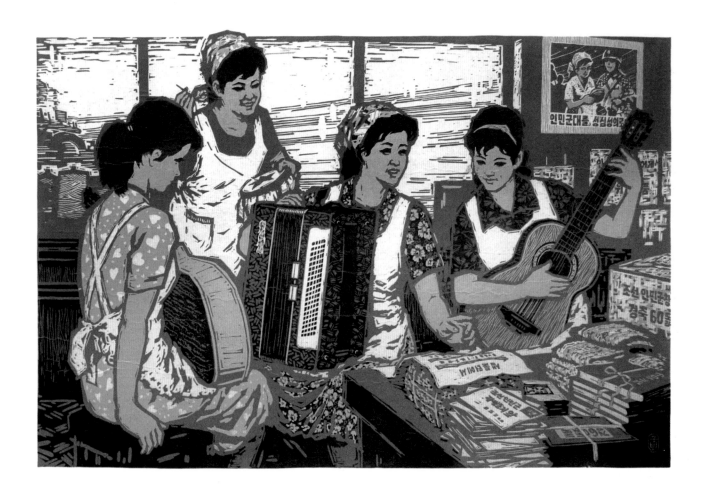

ABOVE: *With Affection* by Kim Kuk Po, 1992. The workers seen here are sending provisions to the army for the celebration of the 'Sixtieth Anniversary of the Korean People's Army Foundation' (written on the boxes) while preparing an artistic performance for the soldiers. A poster in the background states 'Treat the Army Wholeheartedly' and reinforces the relationship between the army and the people. The Korean People's Army is a major institution in North Korean society and seen as not only responsible for defense but also tasked with construction, logistics and the maintenance of key infrastructure.

OPPOSITE: *The Dance in Her Thoughts* by Choe Jae Sik, 1989. Hong Jong Hwa, known as the 'Queen of the *Janggu* dance', (*Janggu* is an hourglass shaped drum) was loved by North Korean audiences for her beautiful, elegant, swift and witty movements as she played the main roles of her own ten solo compositions. Through her extraordinary artistry, she actively contributed to the development of modern Korean dance and participated in various foreign performances. One of her masterpieces, *Cat Loaded With Iron Pots Runs*, vividly reflects the combat spirit of the military. She was rewarded with many medals, including the first rank of the 'National Flag Medal'.

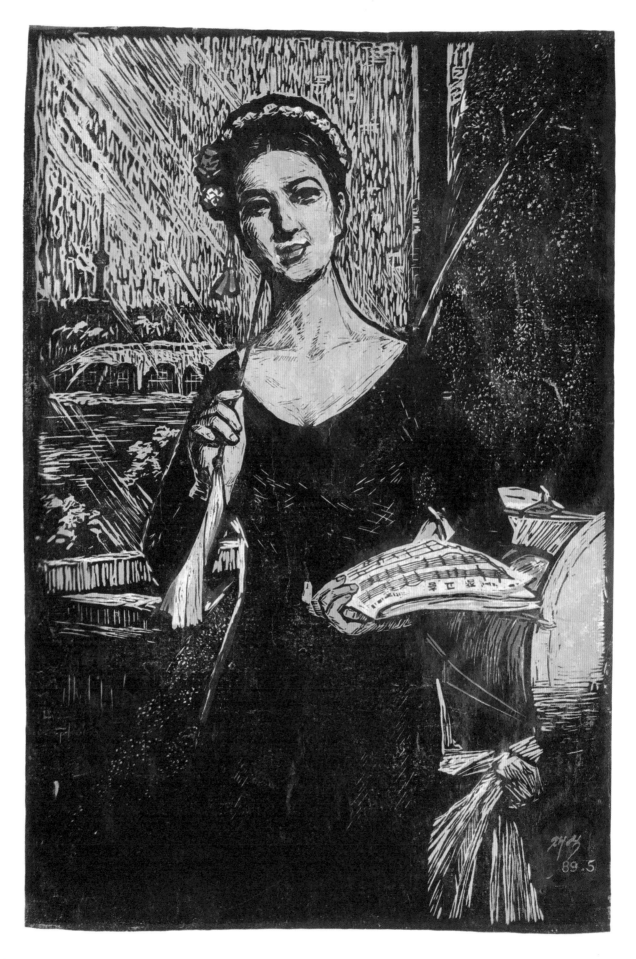

OPPOSITE: *Research* by Jon Myong Sul, 2000 and <u>ABOVE</u>: *Potato Researcher* by Paek Un Ju, 2000. Many female scientists and researchers are highly regarded as 'Hidden Heroes' in North Korea. There are several films featuring women endeavouring to find ways to improve soy milk yields and pest-resistant rice seeds. In the 1990s, North Korean policy focused on potato farming in order to solve the problem of the shortage of rice. Potatoes can be cultivated on highlands less suitable for corn or rice production. The view from the researchers window and the azalea flower indicates that she is working in Taehongdan near Mount Paekdu. Leader Kim Jong Il visited Taehongdan in 1998 to promote a large potato farm and advocated the 'Potato Revolution'.

<u>FOLLOWING PAGES LEFT</u>: *Bean Harvest* by Hwang In Jae, 2008. Soybeans are one of most important staple crops aside from rice and corn, making their way into tofu, soy milk and animal feed. As fixers of atmospheric nitrogen in the soil, soybeans are an integral part of double and triple cropping in North Korea aimed at maximising land use and maintaining yields. Images of the annual bean harvest were added to the iconic 'Scenes of Songun' after various 'on-the-spot guidance' visits to military units, in which leader Kim Jong Il stood proudly in front of a bumper harvest of beans. <u>FOLLOWING PAGES RIGHT</u>: *Fruits of Love* by Kim Kuk Po, 1994. A women's youth brigade works to process a bumper harvest of corn. North Korea's co-operative farms have on-site processing and storage facilities. A portion of the crops are provided to the state, which redistributes the food, while a portion is kept by the farm for local consumption, and more recently, for selling on the open market. The billboard reads 'Let's Hold up High the Legacy of President Kim Il Sung'.

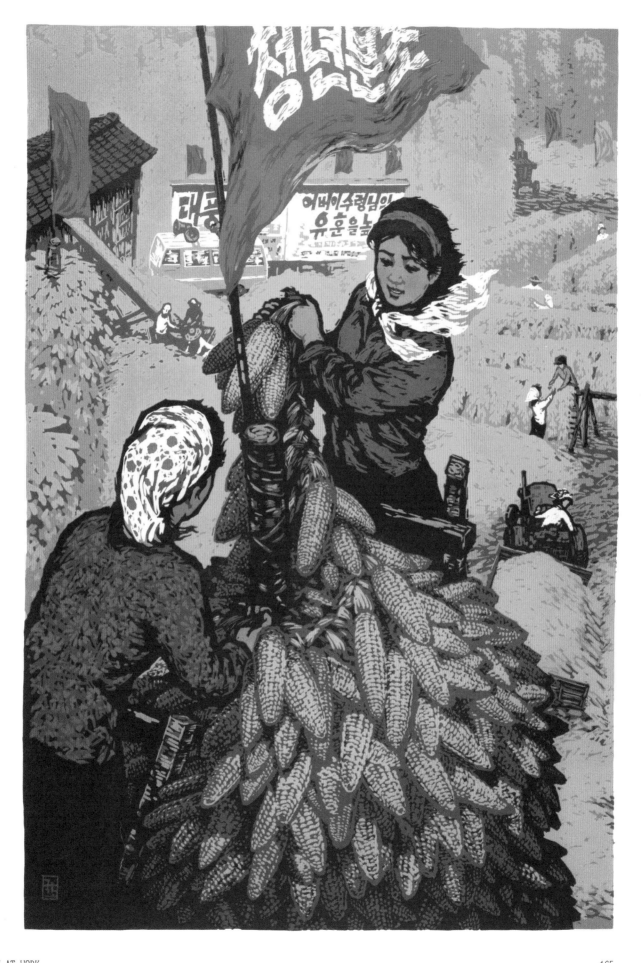

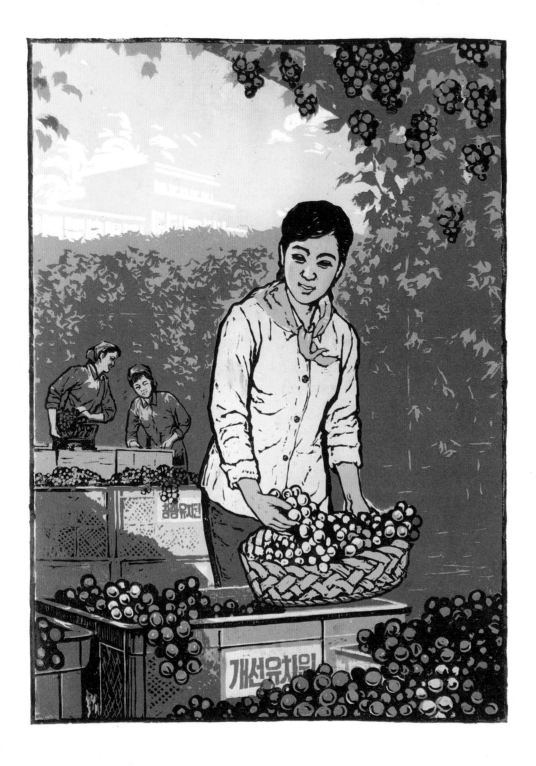

ABOVE: *Worthy* by Pak Un Ju, 2005. Women sending grapes to Kaeson kindergarden and Changgwang kindergarten. Changgwang kindergarten is the most prestigious kindergarten in North Korea and the competition to study there is fierce. The kindergarten is famous for detecting early intelligence and fostering the artistic development of children – many famous musicians in North Korea began their studies there. It was opened in 1982 as part of the celebrations for President Kim Il Sung's seventieth birthday, along with the Arch of Triumph and the Juche Tower, also in Pyongyang. Then in 1989, it was awarded the title of 'Model Kindergarten' for its exceptional educational work.

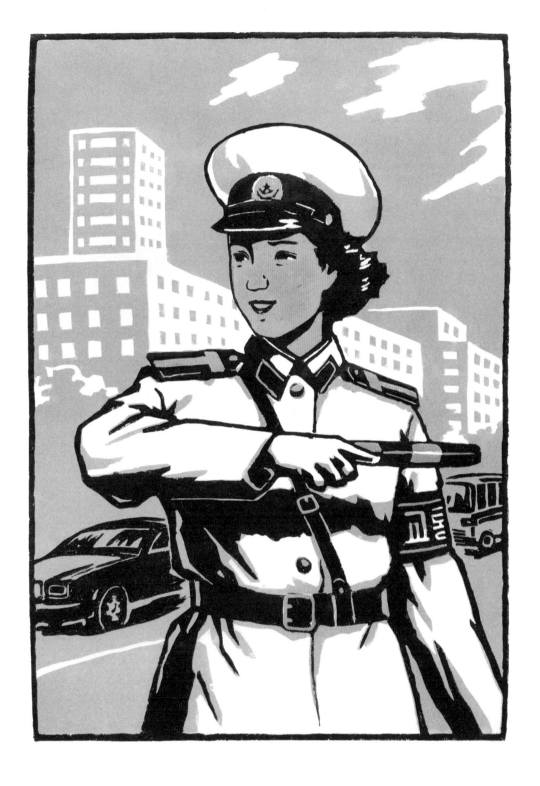

ABOVE: [Untitled] by Kim Kwang Nam, 2015. Pyongyang's iconic 'traffic ladies' direct traffic at cross-roads, salute drivers with Workers' Party number plates and deter jaywalkers. The advent of traffic lights in recent years has sadly meant the choreographed displays by the traffic ladies are now only seen when there is a power blackout. Outside the capital all traffic officers are men, and even in Pyongyang the traffic officers at roundabouts are also male, so the Traffic Ladies have a special place in the daily life of Pyongyang, both past and present.

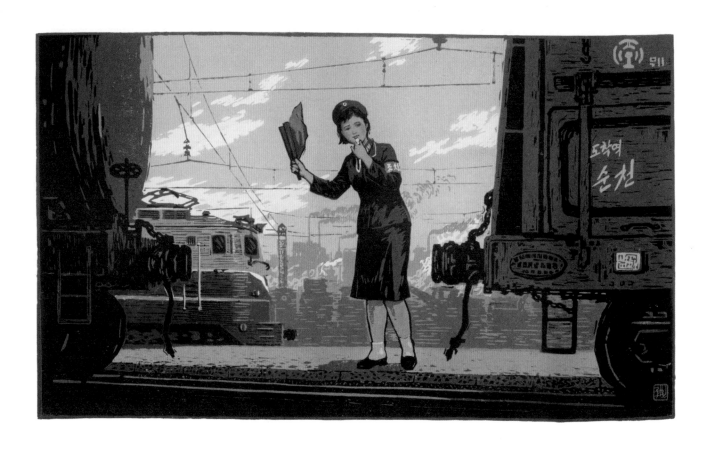

ABOVE: *Marshalling Woman* by Kang Jae Won, 1986. A rail worker directs train cars bound for the city of Sunchon, an industrial hub north of Pyongyang. At the 'Panmunjom Declaration' in April 2018, between North Korean Leader Kim Jong Un and South Korean President Moon Jae In, it was agreed that the two sides should adopt practical steps to improve the connection and modernisation of the railways and roads on the eastern transportation corridor as well as between Seoul in the south and Sinujiu in the north.
OPPOSITE: [Untitled] by Kang Jae Won. The slogans 'My Country is the Best' (also the name of a popular song) and 'Beautiful Land of Korea' are the two most common slogans on the buses in North Korea. This print demonstrates the sense of pride and responsibility of the bus conductor and the joy of serving the people by keeping the buses neat and tidy.

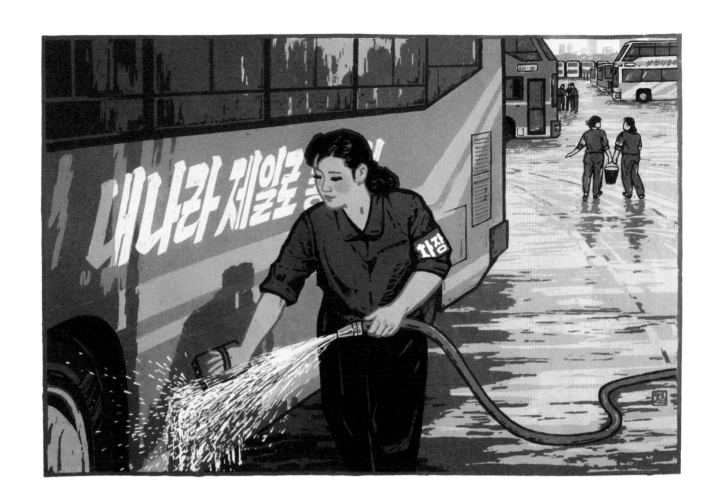

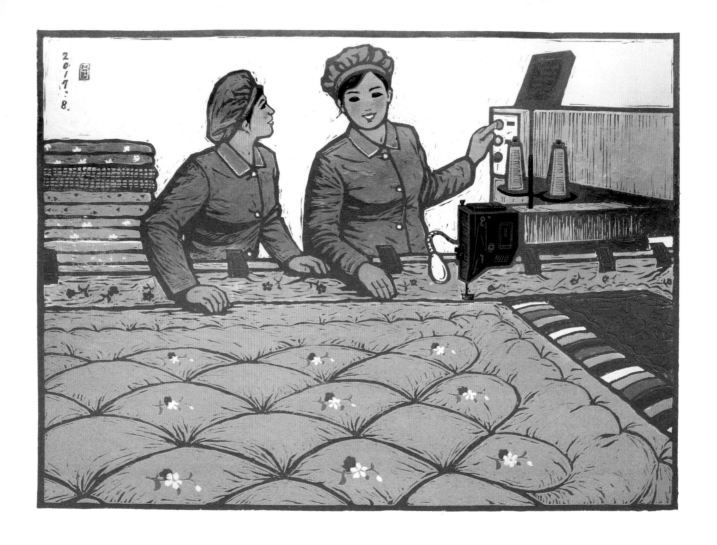

<u>ABOVE</u>: *Our Blanket* by Kim Yong Pom, 2017. A textile factory produces silk quilted blankets. This particular kind of blanket is purchased as part of a traditional wedding dowry and given to a couple for their married life together. The blanket trim reflects the traditional Korean colour range.
<u>OPPOSITE</u>: [Untitled]. Cotton spinning in a textile factory. Workers in such places do indeed tend to dress like the woman shown in the print – clothes that immediately identify them to local Koreans as light-industry workers. New clothing designs entering the market from China have meant that the North Korean textile industry is having to adapt to stay relevant. However, many clothes that bear the label 'Made in China' may actually have been made in the DPRK. Before sanctions were introduced, Chinese clothing and textile firms increasingly relied on North Korean factories to take advantage of cheaper but skilled labour across the border.

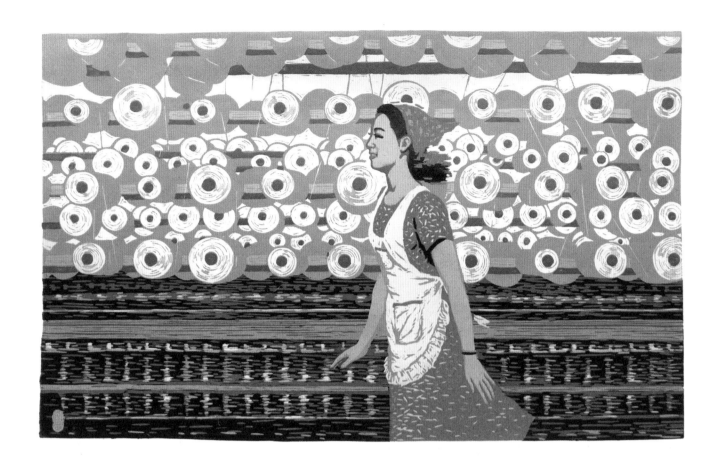

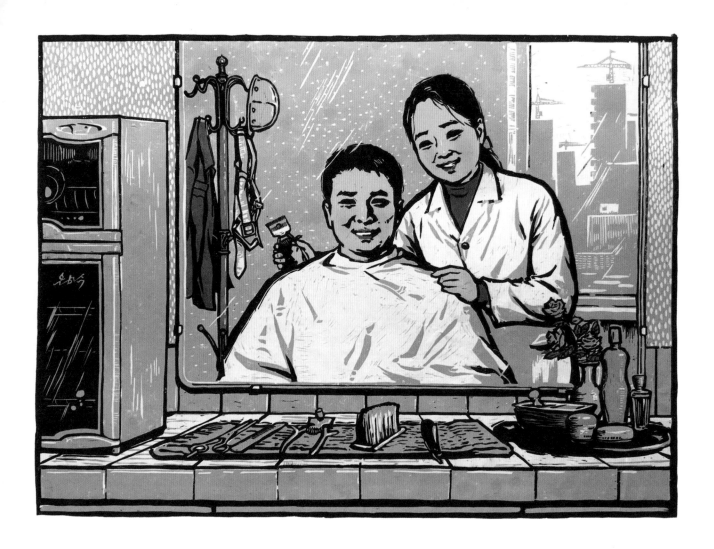

ABOVE: *I Really Like the Haircut*. A scene that could have come right out of the film *The Girl Barber* in which a girl volunteers to be a barber on a construction site even though she has better alternatives. In the end she proves that her decision is right by gaining respect for her work. While it is most certainly not true that all men must have the same haircut in North Korea, it is true that there have been campaigns to encourage men to keep their hair shorter than five centimetres and not to look scruffy and unshaven. OPPOSITE: *Rail* by Paek Kil Un, 1980. A railway worker cleans a train signal. North Korean work units are charged with taking good care of their 'precious workplace'. There is a famous slogan that advocates taking care of equipment in the way that, 'the anti-Japanese guerrillas cherished and loved their weapons as their own eyes'. In the 1960s, there was a movement to 'model oneself after the twenty-sixth lathe' when is was deemed that the twenty-sixth lathe in a particular textile factory was found to have been kept in excellent condition. Even today 'No. 26' awards are given to well-managed and maintained machines. Even individual pieces of equipment can receive awards for years of service or performance – hero elevators, hero air-conditioners, and in one of the tourist hotels there is even a hero Italian-made espresso coffee machine.

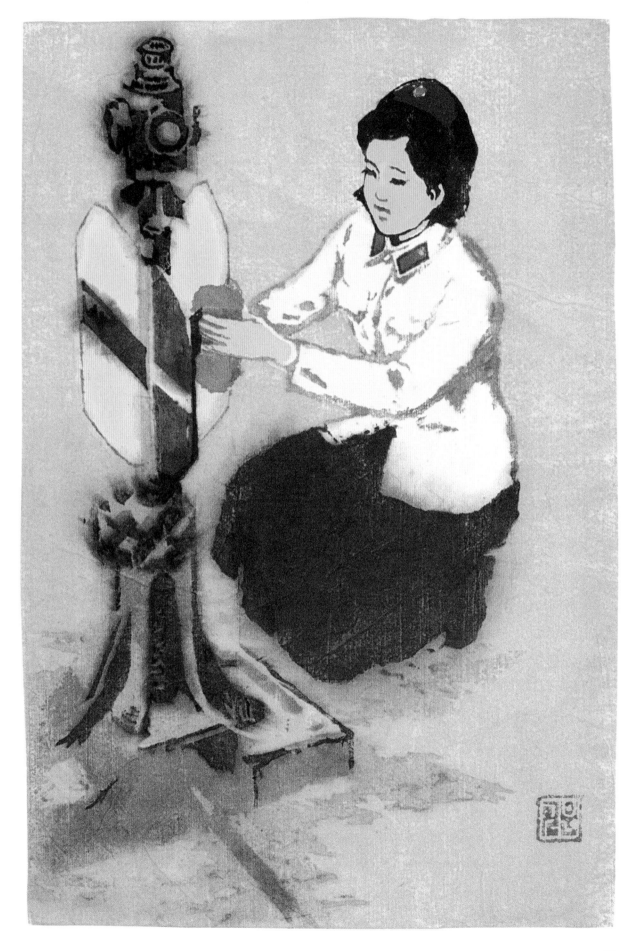

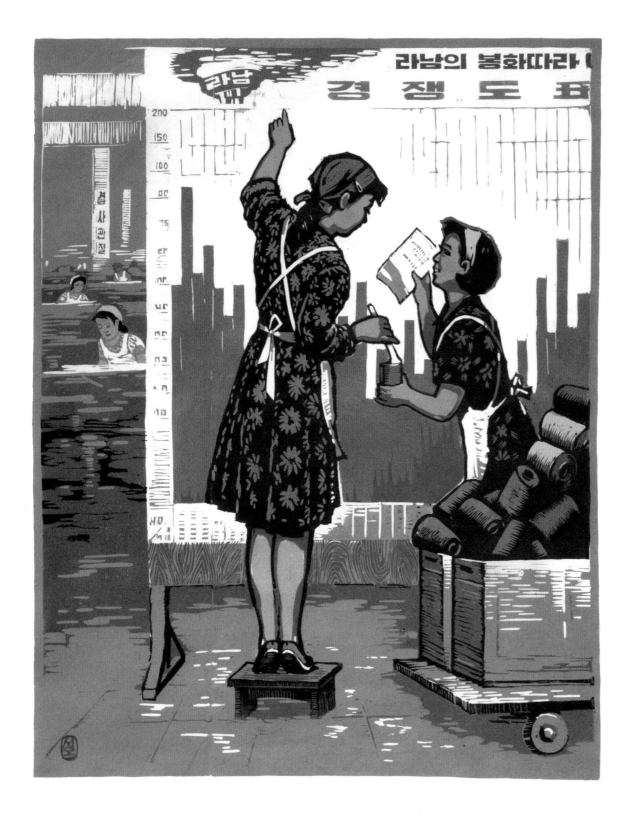

ABOVE: *News* by Han Song Ho, 2002. All farms, factories and places of work in the DPRK will have this kind of chart on display recording the levels of individual output from various work units. It is essentially a league table of who is doing well and who is underperforming. There are prizes (as well as glory) to be won by those who reach targets first and those who overfulfil quotas. The slogan at the top of the chart reads, 'Let's Follow the Signal Fire of Ranam'. OPPOSITE: *Train Attendant*. A young woman starts her first day of work on the railway. Many North Korean films and socialist realist novels tell the stories of individuals starting a new job. All recent North Korean graduates receive an official posting to a work unit as part of a centrally planned economy.

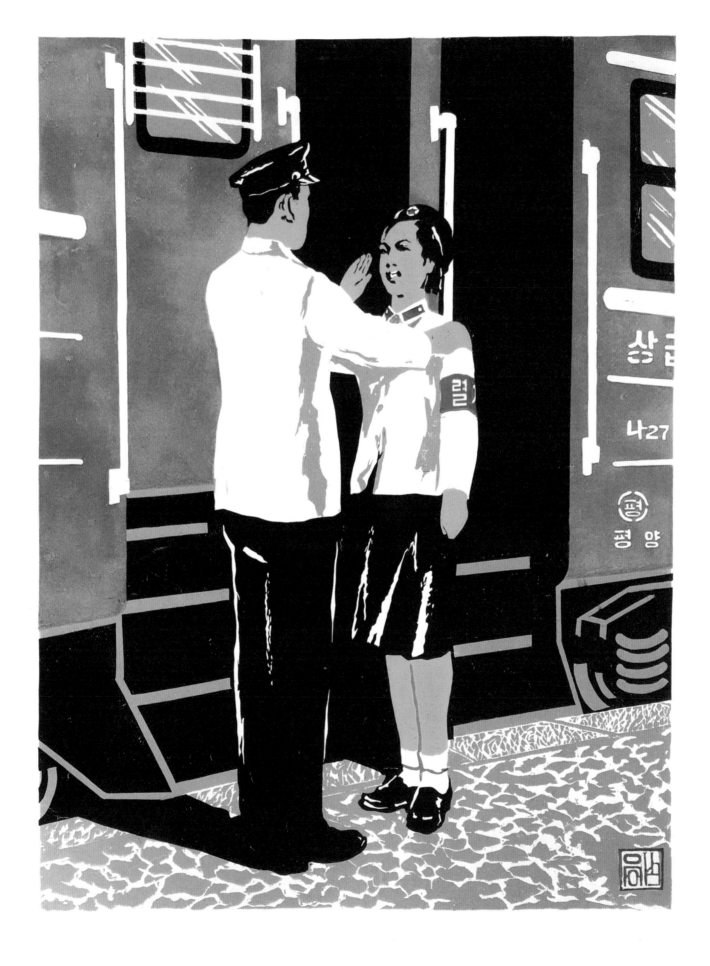

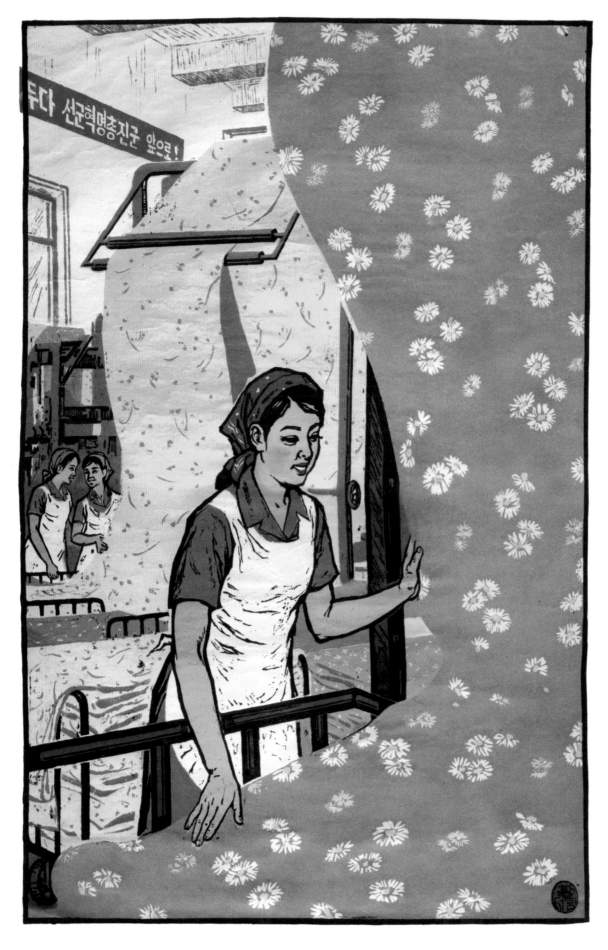

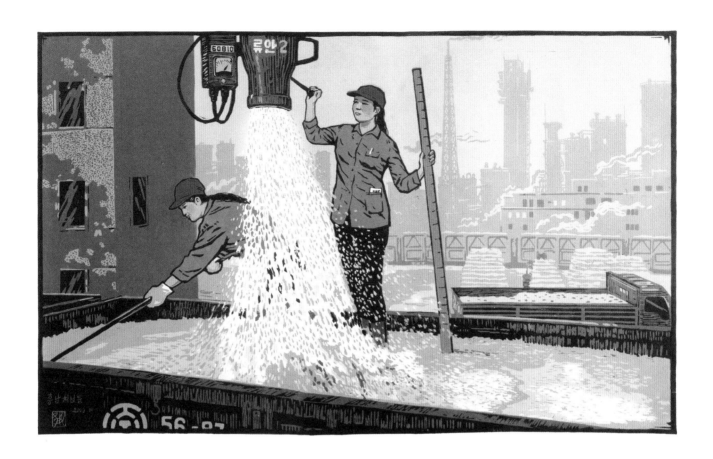

OPPOSITE: *Silk Girl* by Hwang So Hyang, 2005. One of the major industries in Pyongyang is textiles, with mills producing reams of fabric for domestic as well as industrial uses. The Kim Jong Suk textile complex is the most famous in the country and is named after the wife of Kim Il Sung and mother of Kim Jong Il; she is considered to be the epitome of Korean womanhood, as well as a crack-shot and daring military commander. ABOVE: *Hungnam Girls*. Hungnam girls at an ammonium sulphate production factory. Hungnam Chemical Fertiliser Plant is Korea's largest and produces nearly half the country's chemical fertiliser. Hamhung and Hungnam form a conurbation that makes up the second largest city in North Korea. In this industrial heartland the people are regarded as being tougher than those in Pyongyang because of their engagement in heavy industry.

ABOVE: *Congratulations From Their Son* by Kim Sang Ki, 1982. A couple of railway workers receive praise for their service from their son. By contrast, the 2007 film *The Schoolgirl's Diary* which depicts a teenager's struggle to understand her father's absence as he spends the vast majority of his time at work as a computer engineer in a distant town. She is upset that he has abandoned his family and is content leaving them in a ramshackle house while she dreams of living in a modern apartment. The protagonist only realises how selfish she has been when she understands the sacrifice he has made for the country. OPPOSITE: [Untitled] by Ik Hyon. Textile workers crowd around one of their comrades who is dressed in her traditional *jogori* and has been awarded the 'Hero of Labour Medal'. This title was the highest civilian award until the establishment of the Order of Kim Il Sung in 1972, which is awarded for exceptional merit and efficiency in professional labour.

ARTISTIC WORK SHOULD BE CONDUCTED AS IF IT IS DONE ON A BATTLEFIELD, ON A FRONT LINE

Kim Jong Un

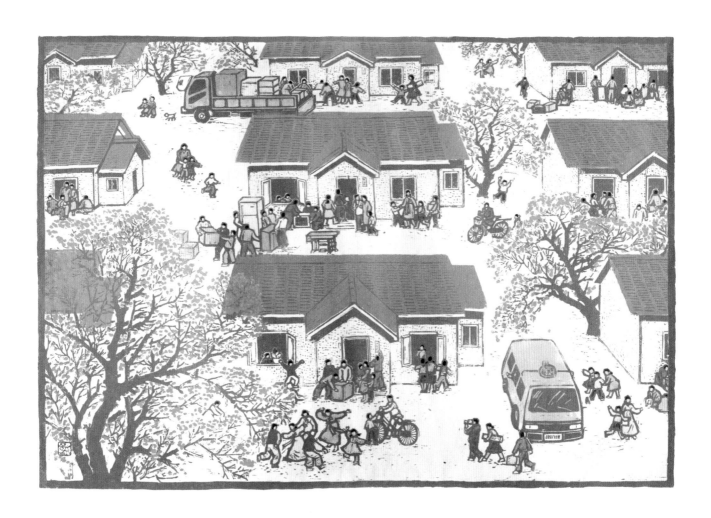

ABOVE: [Untitled]. Village people moving into their new 'ground houses' given to them by the government. Almost all housing in rural areas is grouped, with villagers living side by side to allow for the necessary controls for communal farming. Fridges and televisions are likely to be gifts from the leadership. In Pyongyang, the 100th anniversary of the birth of Kim Il Sung in 2012 sparked a construction boom in which three new districts were created – Changjon Street (2012), Mirae Street (2015) and Ryomyong Street (2017). Mainly educators, scientists and workers' families were assigned to the fully-furnished and finely decorated apartments in the new neighborhoods.

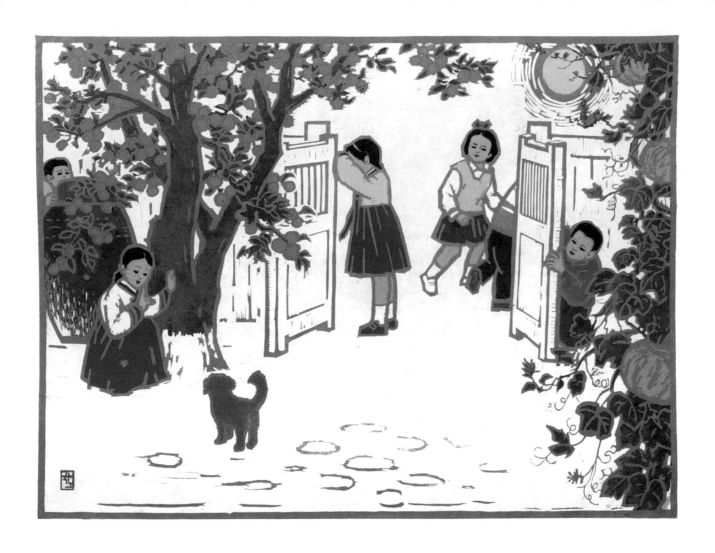

ABOVE: *Hide-and-Seek* by Kim Kuk Po and Paek Un Ju, 2006, OPPOSITE TOP: *Jegichagi* by Ri Hong Chol, 2006 and OPPOSITE BOTTOM: *Folk Games, Horse Riding* by Hwang In Jae. These three prints depict children playing games such as hide-and-seek, *Jegichagi* and piggy-back fighting. Artworks such as these images, as well as images of dogs and cats and landscapes, will often be hung in North Korean homes. Each room (apart from the bathroom and kitchen) will display portraits of the Leaders, but pure propaganda images are not part of home life in the DPRK.

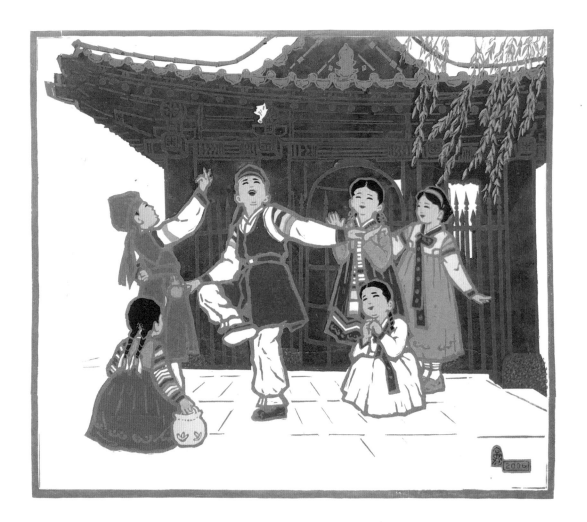

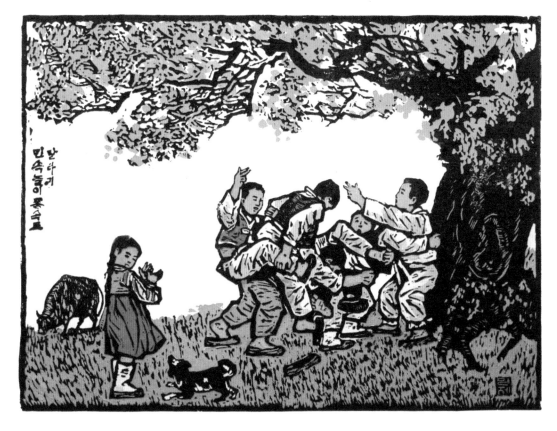

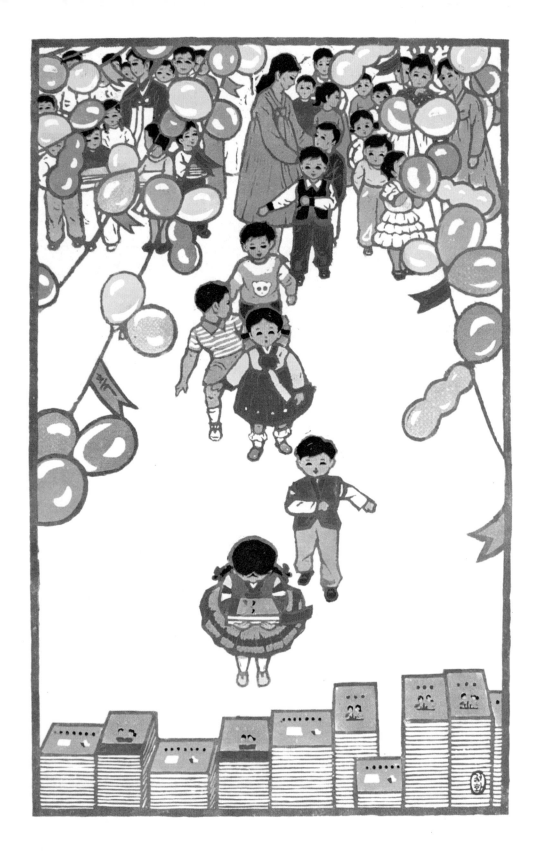

ABOVE: *New Text Books* by Ri Jong Hwa, 1999. In 2013, North Korea introduced twelve years of compulsory schooling, adding one more year to the previous eleven-year policy. Textbooks, school fees and uniforms are free, and in their two years of kindergarten and five years of primary school, students receive presents on the 'Day of the Sun' (the birthday of Kim Il Sung on 15 April) and the 'Day of the Shining Star' (the birthday of Kim Jong Il on 16 February). Presents include sweets, biscuits and other treats.

ABOVE: *Rabbits* by Chol Su. The ranking of two stripes and one star as seen on this girl's school uniform is given to just three students per class (each class consists of 30-40 students) - the 'Class Monitor', the 'Socialism Moral Monitor' and the 'Physical Training and Hygiene Monitor'. Here, the Socialism Moral Monitor is taking care of the rabbits, serving as a model to other students to love every plant and animal in the country.

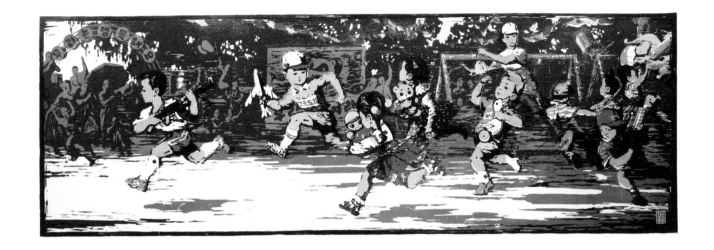

OPPOSITE TOP: *Thoughts*. A preschool teacher lost in thoughts about how to make a better teaching plan for her students. The slogan 'We Are Happy!' can be seen in the background, a slogan that every elementary school has at its entrance. Her presence at school after dark demonstrates her devotion to her students. OPPOSITE BOTTOM: *The Hero Who Returned to his Alma Mater* by Kae Chung Il, 2003. A soldier who became the 'Hero of the Republic' visits his alma mater and is educating the junior students to join the army and become a hero like himself. The slogan 'Let's Learn for Korea' is shown in the background. TOP: *6.1 Holiday* by Jong Hyon Ho. A 'cultural life' in sports, arts and music is encouraged from childhood in addition to regular study and sports competitions are held on Children's Day on 1 June each year. ABOVE: *Music Class* by Ri Chang Ho, 2011. Students practise for their performance under the willow trees. Schoolchildren's Palaces in cities and after-school classes provide extracurricular activities ranging from music and dance to computer study and mathematics.

OPPOSITE: *Morning at Lighthouse Island* by Pak Chang Ho. Primary school children are seen here on their compulsory week-long camping course. There are many youth camping centres in areas of natural beauty such as Mount Ryongak and Mount Myohyang. Songdowon International Children's Camp in Wonsan opened its doors in 1960 and is one of the last vestiges of a type of cultural exchange seen in similar countries from across the Communist Bloc. TOP: *Flourishing Dreams* by Pak Kwang Hyok, 2007. High school students celebrate graduation day holding their graduation diploma and wearing special graduation accoutrements such as flowers on the girl's dresses. The young people frame a monument in the distance dedicated to the Three Revolutions (Ideological, Technological and Cultural). ABOVE: *Introduction of a New Book* by Ri Kuk Chol. The North Korea state education system provides free text books, notebooks, pencils, uniforms and student bags. Students must wear prescribed uniforms from primary school to university. In 2015, primary, secondary, high school and university uniforms were changed into brighter colours and more modern designs.

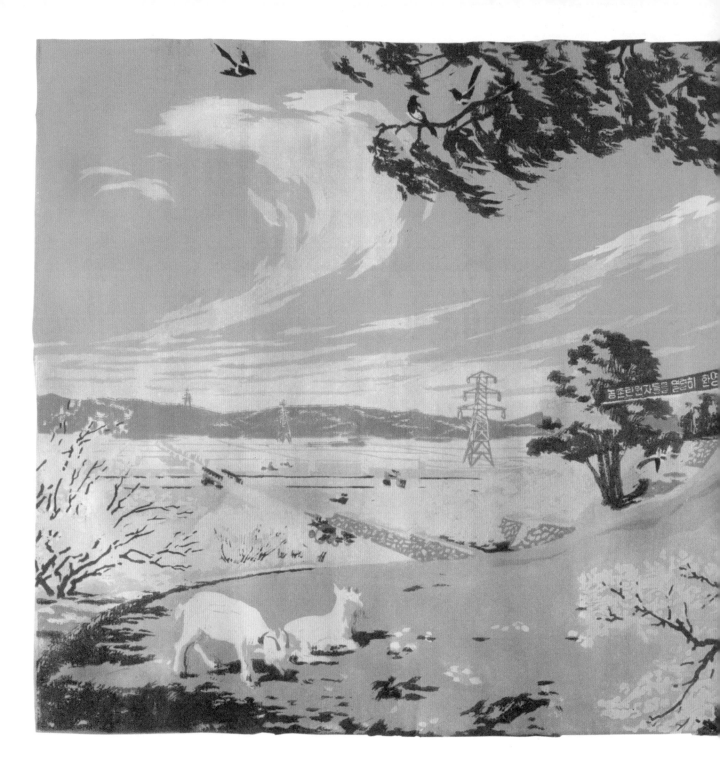

<u>ABOVE</u>: *Spring Wind* by Kim Ok Son, 2007. Slogans read, 'Welcome the Volunteers to the Countryside!' and 'Long Live the Great Socialist Rural Theme!'. Students volunteering in the countryside after graduating from high school is very common in the DPRK and is a form of additional labour during planting and harvest seasons. It is also a form of social bonding in what North Koreans call 'the organisational life'. During one of Leader Kim Jong Il's 'on-the-spot guidance' visits to Kim Il Sung University exactly one year before his death, he urged students to 'Stand firmly on your own land and look at the world'. The implied meaning was for students to study their homeland and learn new skills to contribute to the development of North Korea.

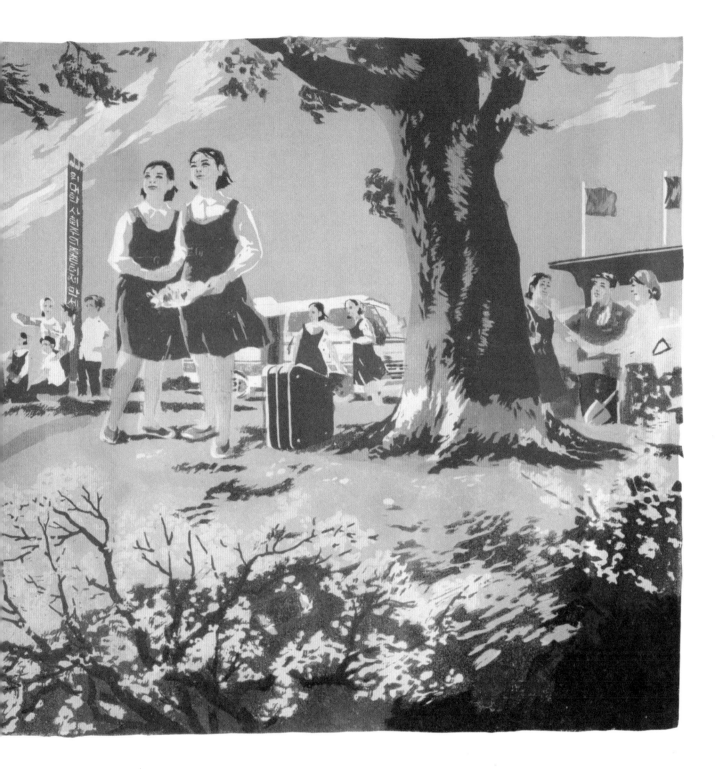

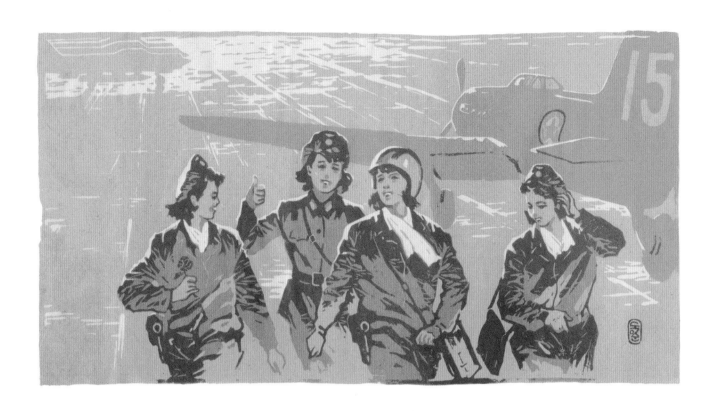

OPPOSITE: *Large County* by Hong Ji Song, 1993. A rural youth, bag packed with books, takes time to pick flowers as she walks through golden fields of grain on her way to begin her naval career. While women make up a minority of the armed forces, their involvement is often praised as the sacrifice is considered to be greater than that of men, who from a young age perceive their role in the defence of the country as a sacred duty. ABOVE: *After Training* by Ri Tong Sun, 1999. An army soldier (second from left) showing her admiration for three airforce pilots. In 2015 Kim Jong Un praised the first female supersonic fighter pilots in the North Korean Air Force, Jo Kum Hyang and Rim Sol, as 'flowers of the Songun sky'. Around this time the first driving schools for women opened in Pyongyang.

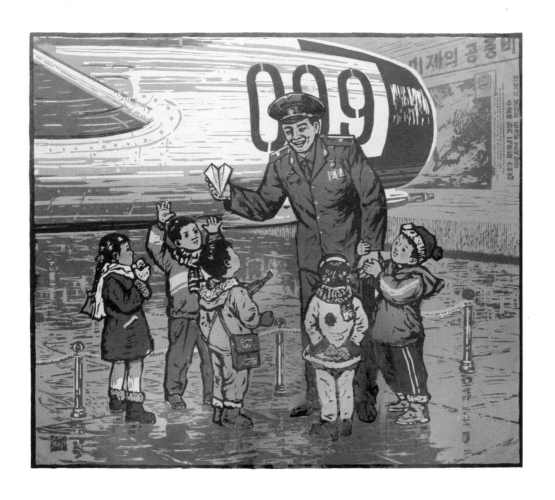

OPPOSITE TOP: *The Hero and the Children* by Ryu Sang Hyok, 2007. An airforce veteran lectures children about his experiences during the Korean War at the Victorious Fatherland Liberation War Museum. The museum employs veterans who work part-time to tell their stories in person. Two sailors who took part in the capture of the USS Pueblo in 1968 are among the veterans who work at the museum. OPPOSITE BELOW: *To My Dear Grandmother* by Kim Po Sok, 1960. A scene that could have come from the classic multi-part TV series *Nation and Destiny* in which a granddaughter writes a letter to her grandmother in South Korea even though she knows it can never be delivered due to national division. In the background, there is a glimpse of a poster that declares 'Let's Give a Unified Korea to the Future Generation!'. ABOVE: *February Night* by Hong Jun Sik, 2001. Every village, town and city in the country has an exhibition area for displays of the *Kimilsungia* (an orchid) and *Kimjongilia* (a begonia). The biggest display is in Pyongyang and major exhibitions take place over the birthdays of the leaders - Kim Il Sung on 15 April and Kim Jong Il on 6 February. During these national holidays, Korean institutions, work units and schools arrange the flowers with models of the Leaders' birthplaces, their factories, satellites and other notable structures to form displays of patriotism.

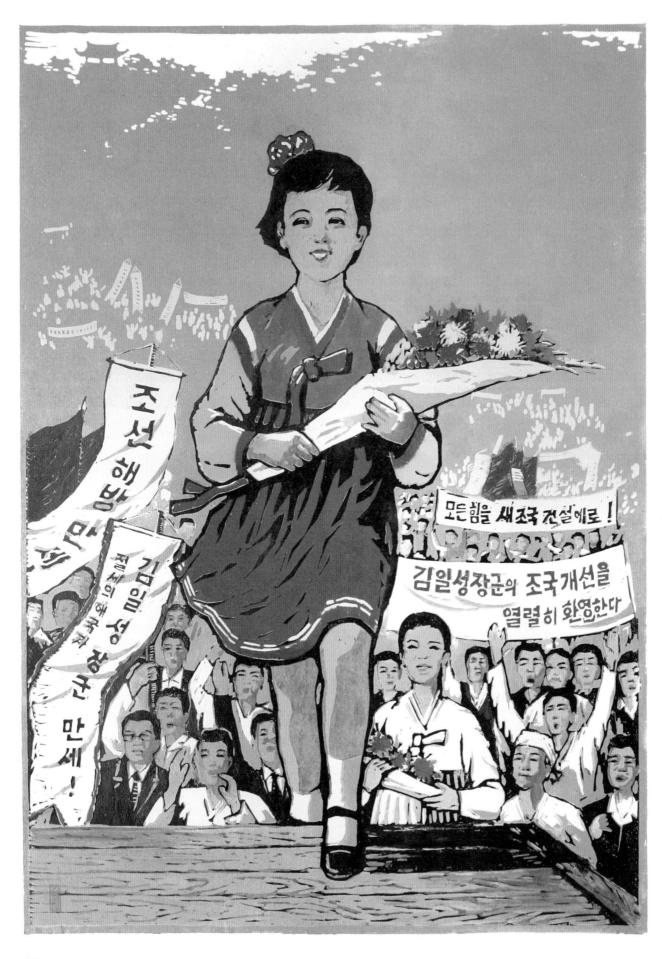

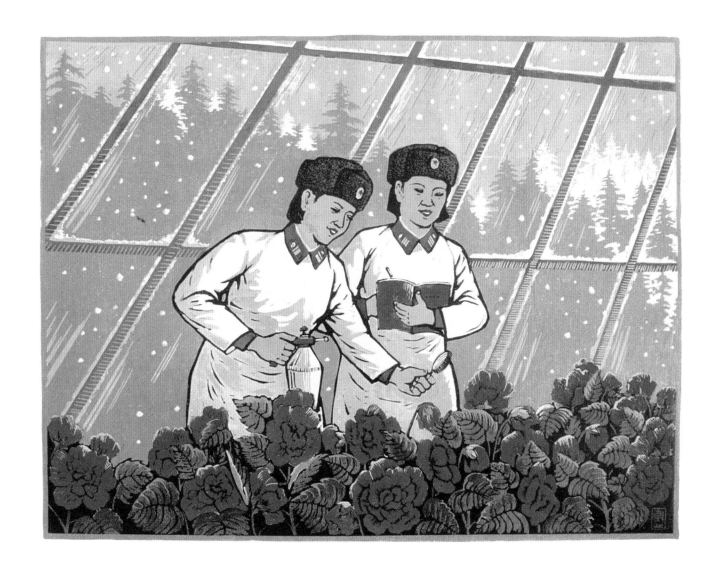

OPPOSITE: *First Flower of the Triumphant Return* by Kim Won Chol, 2003. On 14 October 1945, future President Kim Il Sung gave a speech to a huge crowd of people at the Pyongyang athletic field, which now features a stadium bearing his name. This marked Kim Il Sung's 'Triumphant Return' from fighting against the Japanese occupation of the country after twenty years. Today the Arch of Triumph marks the spot of the speech. This print evokes the 1945 speech and scenery, and the girl is walking to give the bouquet to Kim Il Sung. One of the slogans reads, 'Warm Welcome to General Kim Il Sung'. <u>ABOVE</u>: *February of Northern Part* by Kim Won Chol, 2005. Every February there are flower festivals across the country for displaying the *Kimjongilia*, a flower of the begonia family named after Kim Jong Il by its Japanese developer. As this flower would normally not be grown in winter, great efforts are made by work units, regiments, schools, institutions and even individuals to cultivate the best flowers and perhaps be awarded honours for doing so.

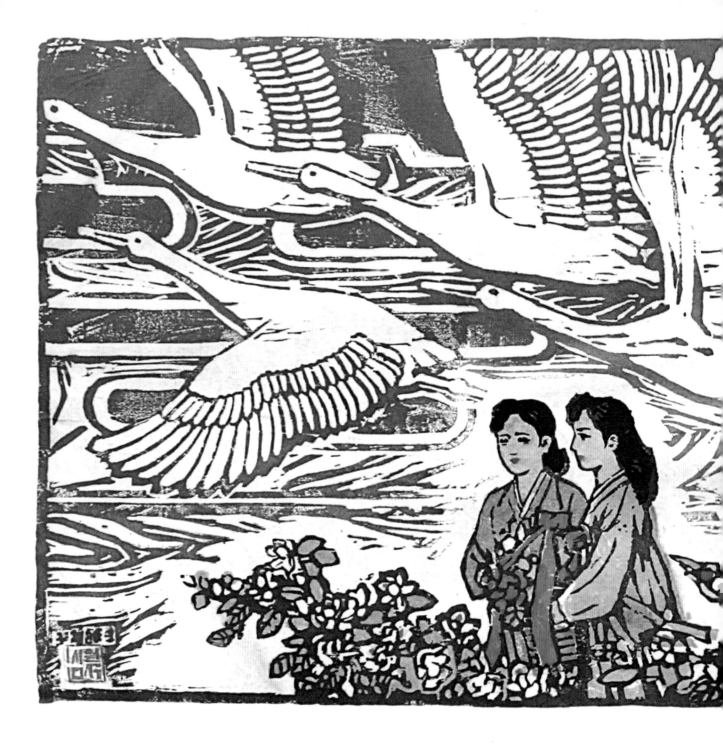

ABOVE: *Visiting the Memorial Palace* by Ri Kuk Chol. Kumsusan Palace of the Sun was built in 1976 as the official residence of the Leader, Kim Il Sung. It now serves as a mausoleum for him as well as his son, Kim Jong Il, both of whom were posthumously designated as eternal leaders of North Korea. Koreans and foreign visitors are invited on specific schedules to pay their respects. The palace contains exhibits of personal vehicles, medals and foreign awards as well as the train carriages in which the leaders travelled within North Korea for 'on-the-spot guidance' visits as well as for journeys abroad. The palace is surrounded by a stone wall with carved cranes that represent longevity, and the magnolia in the front is the national flower.

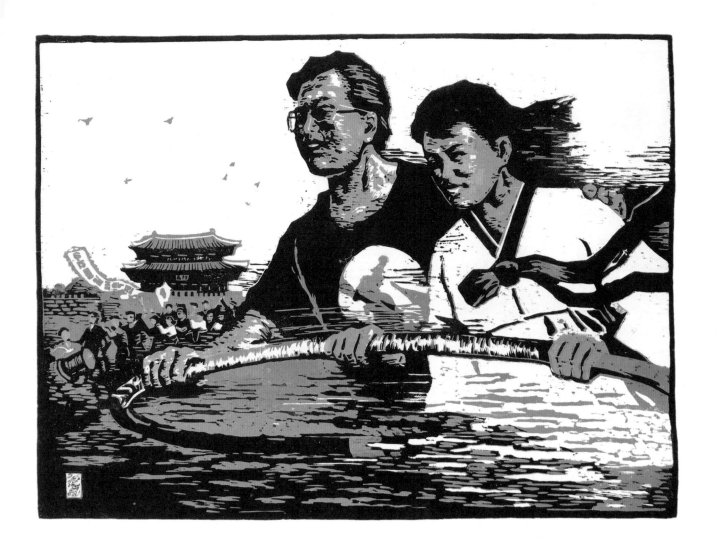

ABOVE: [Untitled] by Kang Chol Won. North Korean art and propaganda have certain identifiable tropes that make themes instantly identifiable. For example, we know that this man is a South Korean because he is wearing a T-shirt (something rarely done by North Koreans) and the shirt shows the emblem of a united Korea. Here, he and a woman from North Korea take part in an idealised joint North-South sports event in Pyongyang's Taesongsan Park. Civilian contact between North and South Korea has ebbed and flowed with the political relations on the peninsula. Koreans from both sides are forbidden to make contact with one another even if in a neutral country such as China. OPPOSITE: *Reunify the Country* by Yang Yong Su. Outside the old railway station in Seoul, South Koreans are portrayed as protesting against almost everything their government represents. The public carry slogans stating, 'Let's Get Rid of the Americans and Achieve the Unification of our Country!', 'Abolish the Security Law!', 'Layoffs Don't Make Sense!' and 'Punish the Butcher and Assassin Americans!'.

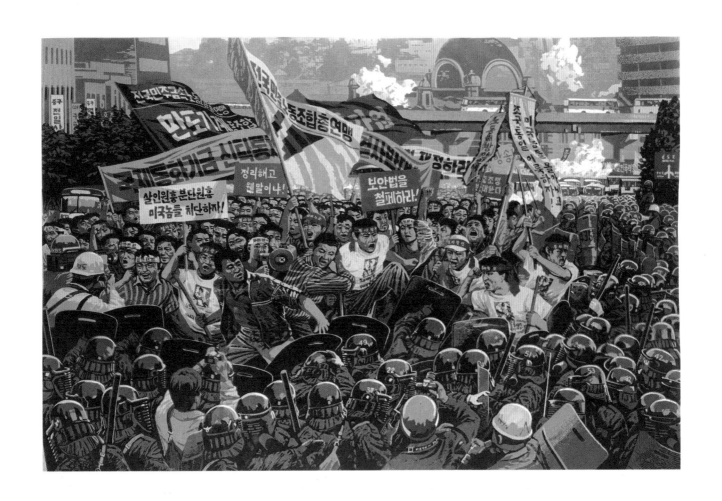

202

OPPOSITE: [Untitled] by Pak Myong Chol. Anti-government or anti-American events in South Korea are often depicted in order to show the South Korean people struggling for liberation. This particular print shows the student occupation of the United States Information Services library building in Seoul in May 1985. The banners and leaflets refer to the (alleged) US role in the bloody suppression of the May 1980 Gwangju Uprising, a seminal moment in the development of the democratisation struggle in South Korea. The slogans include 'Clarify the Gwangju Incident', 'The USA Owes a Public Apology', and 'Long live Democracy'. ABOVE: [Untitled]. A South Korean political activist during the democratisation struggle of the 1980s. The suggestion in this work is that the path to reunification is being prepared under North Korean leadership. The student is teaching workers in an underground night school about Juche thought, using Kim Jong Il's book *On the Juche Idea*. On the blackboard it reads, 'Dear Leader Comrade Kim Jong Il, Commander of Reunification, let us become flames following the Lode Star,' while on the desk is the underground journal *Mal* ('Word'). The boxes of 'chemical-free food' in the background relate to a recurrent theme in North Korea that the USA is responsible for poisoning the South Korean people by carelessly handling their industrial waste.

ABOVE: *The Sound of the Bell* by Hong Jun Sok, 2007. A schoolteacher in a guerrilla camp during the anti-Japanese War rings a newly installed bell to summon the children for class. The Korean saying, 'Everyone for the Liberation of the Country,' referred to everyone, including the elderly and even children, who fought against the Japanese in an indirect way. There are several children that hold the title of 'Hero of the Republic' for fighting against the Japanese, including Kim Kum Sun, who at the age of twelve, was captured and killed by the Japanese on one of her missions as a messenger.

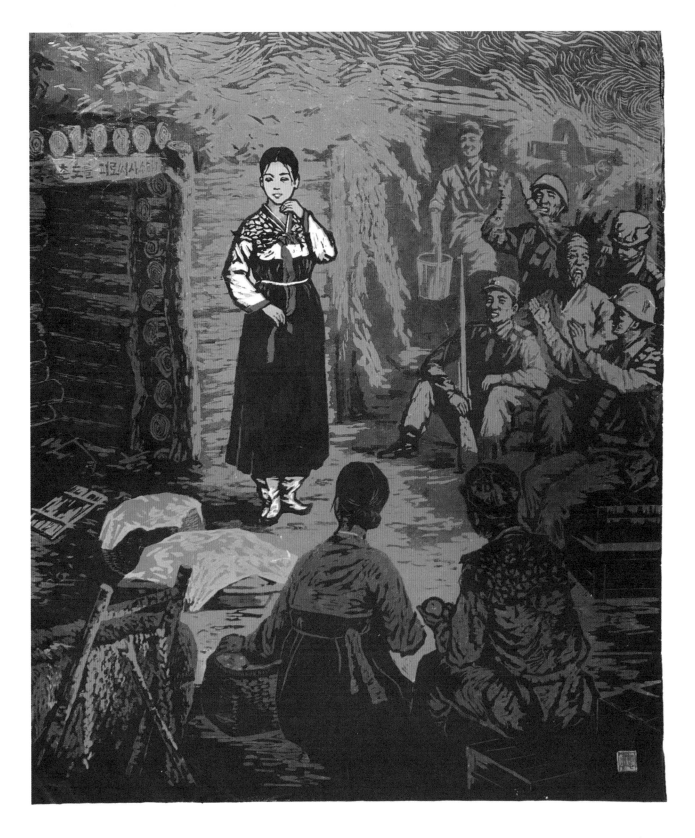

ABOVE: [Untitled], 2007. A scene from the Korean War features a slogan over the door that reads, 'Defend the Homeland with our Blood!'. Despite almost constant aerial bombardment, entertainment continued throughout the war. Some underground bunkers and fortifications included spaces for showing films and putting on stage plays, and musicians travelled to frontline units. To this day North Korea maintains mobile propaganda units that visit factories, construction sites, farms and military units to encourage and entertain. Even the Pyongyang Circus troupe performed during the war and still heads out on provincial tours.

THE STRENGTH OF ART IS GREATER THAN THAT OF A NUCLEAR BOMB

Kim Jong Un

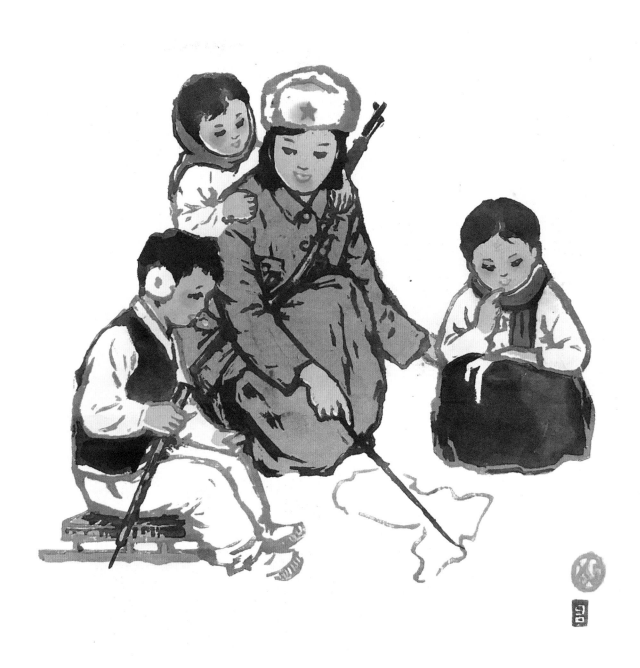

ABOVE: *Our Country* by Tong Ha To. A guerrilla soldier outlines the shape of the Korean Peninsula and points to Mount Paekdu, the sacred mountain of the Korean people and the base of operations for anti-Japanese guerrilla units opposed to Japanese rule. The ideals of patriotism and the nation are prominent themes in Korean education from an early age. During the Japanese occupation of the Korean Peninsula, many nationalists fled into northern China, then raised children who knew little about their homeland.

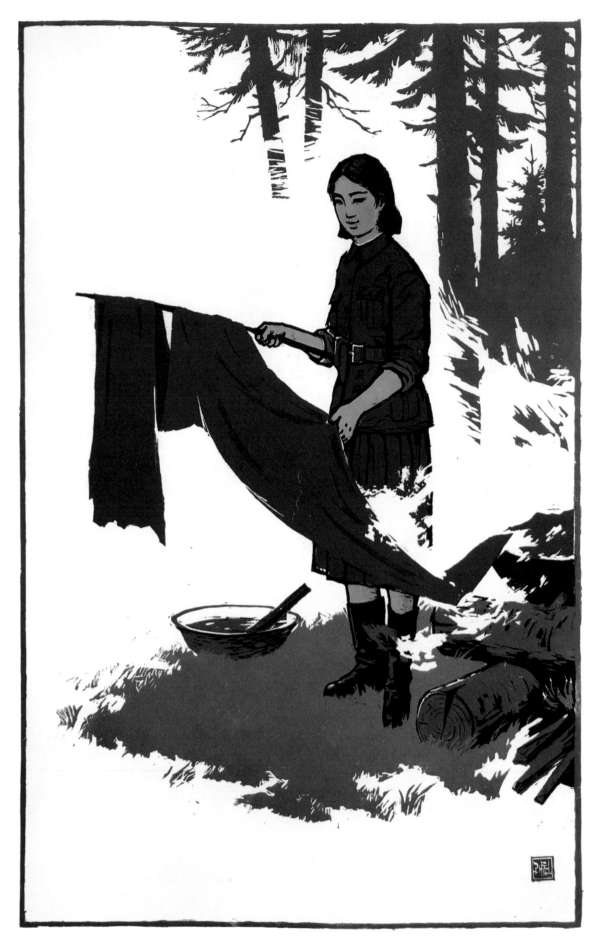

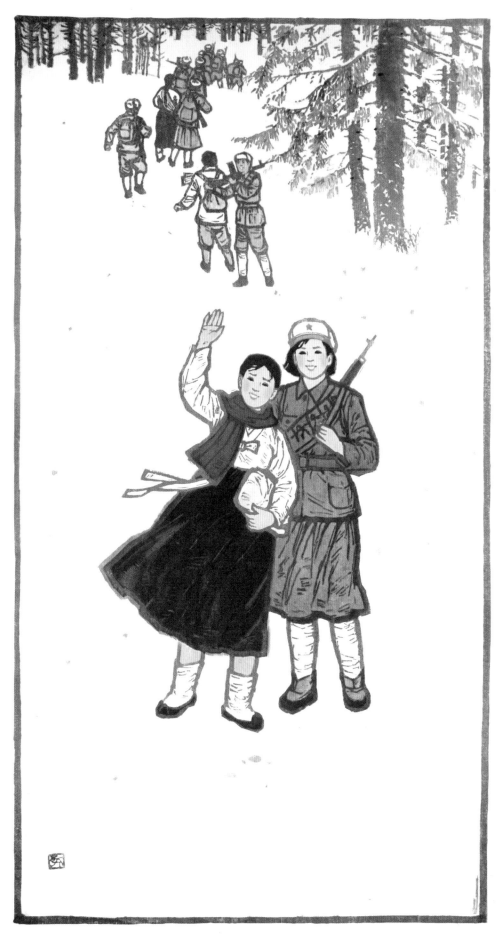

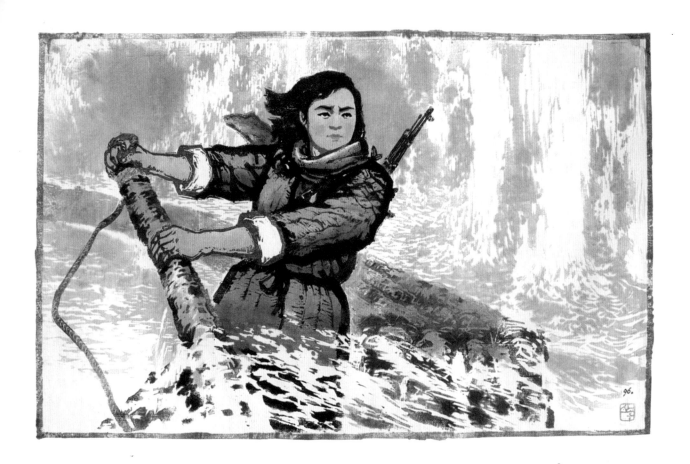

PREVIOUS PAGE LEFT: [Untitled]. In the Anti-Japanese Guerrilla War women were in charge of the daily chores, such as laundry duty, while the men were tasked with fighting the Japanese. These simple images of day to day guerrilla life help build the story of the revolution, and remind contemporary North Koreans that others struggled for their life today. PREVIOUS PAGE RIGHT: *Wait For Us* by Kim Pong Ju, 2005. Korean guerrilla units cross into Manchuria to conduct armed struggles against the Japanese, waving goodbye to their countrymen as they go. In the 1930s, the wild and semi-lawless expanse of Manchuria, today's northeast China, served as a base of operations for Korean and Chinese guerrillas fighting the Japanese. Many of the future leaders of the DPRK, including Kim Il Sung, came of age in Manchuria.

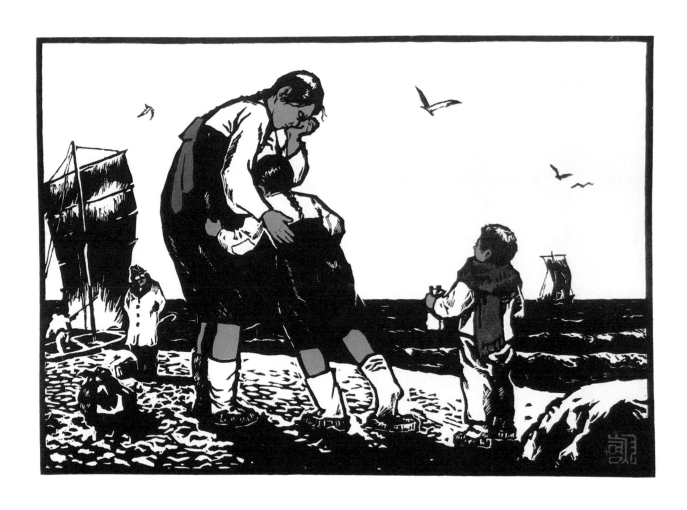

OPPOSITE: *Plunge Under Fire* by Kang Sang Ho, 2008. An image of bravery amid the colonial occupation in which a guerrilla soldier plunges down a raging river on a raft while shells explode around her.
ABOVE: *Separation*, 2008. One of the most tragic aspects of the Japanese occupation of Korea was the use of many young women as 'comfort women' - essentially sexual slaves for Japanese soldiers throughout their Empire. Here, a female student is about to be taken away to this fate by a sinister Japanese man (often portrayed with round glasses). She says a tearful goodbye to her younger siblings. The legacy of comfort women remains a contentious subject between all of those on the Korean Peninsula and Japan.

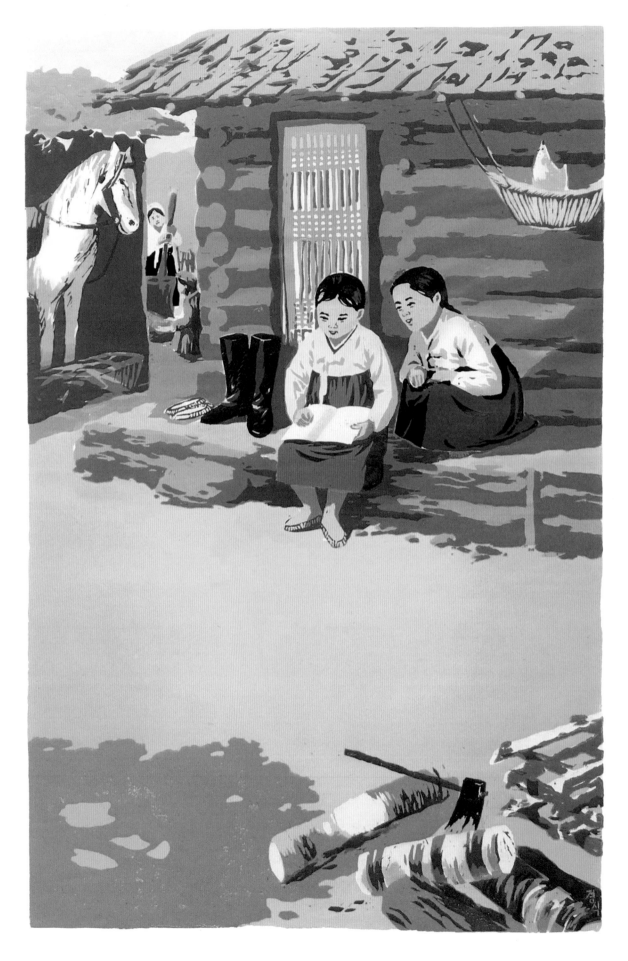

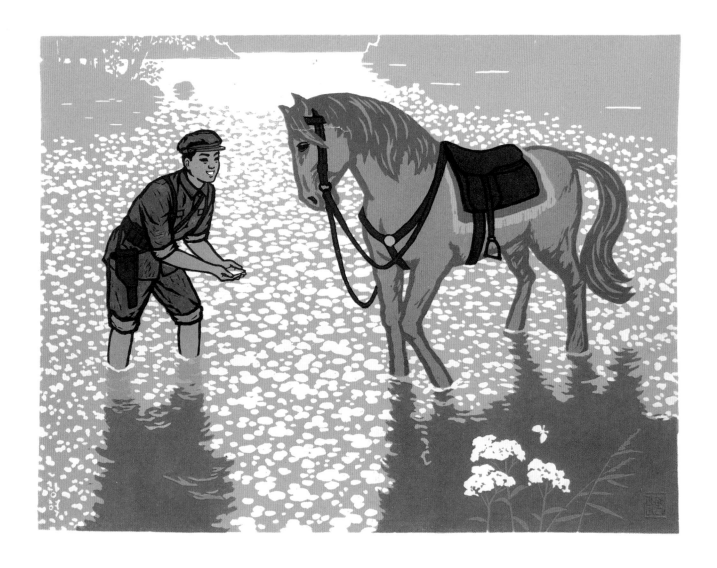

OPPOSITE: *After the Liberation* by Han Kyong Sik, 1998. The boots and the white horse indicate the presence of Kim Il Sung in the wake of the liberation of Korea. The children have been given a new book to learn about their country and sticky rice is being made for the guest. During the colonial era, the Japanese discouraged the study of the Korean language in school and even the use of Korean names. Learning about one's country, heritage and traditions became an important part of the independence struggle. <u>ABOVE</u>: *Messenger* by Pak Kwang Hyok. Only Kim Il Sung had a white horse during the anti-Japanese campaign and this image reflects the soldier's love of the Leader. A whole chapter of the Leader's book *Reminiscences of Kim Il Sung* is devoted to his white horse.

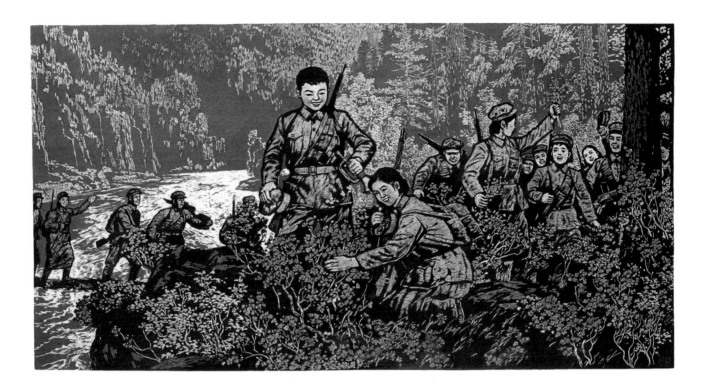

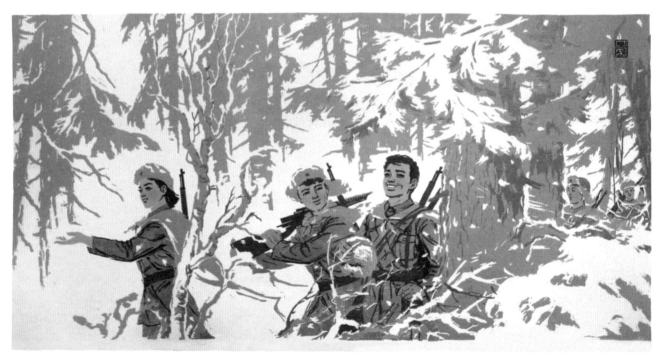

TOP: [Untitled] by Hwang In Jae and <u>ABOVE</u>: *First March* by Kim Ok Son. In the 1930s, Korean anti-Japanese guerrilla forces operated on foreign soil in the Japanese puppet state of Manchukuo (Manchuria), in what is today northeast China. The region's vast expanse and long border with the Soviet Union provided a relatively safe base of operations, but meant Korean guerrilla fighters were disconnected from the population they sought to liberate from colonial rule. The advance into Korea was an important symbolic victory and soldiers were greeted with beautiful azalea fields found in the northern reaches of the peninsula. The struggle, however, would continue until 1941 when they were forced to relocate to the USSR. Such perennial commitment to the nation during hardship has been widely promoted so that each new generation follows the example of the anti-Japanese campaigners' heroic spirit.

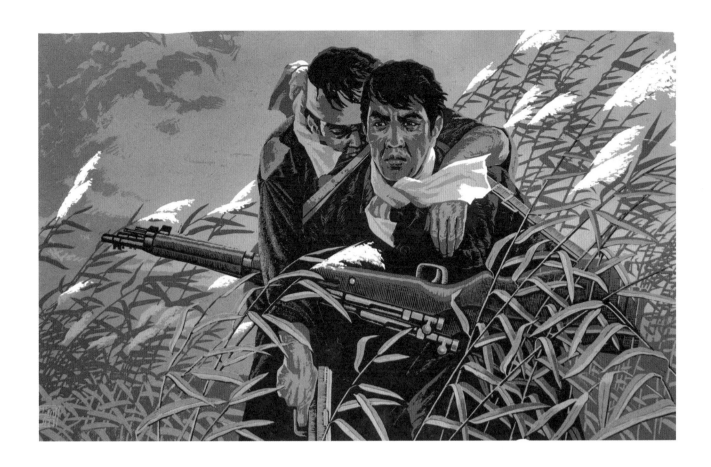

ABOVE: [Untitled], 2008. This print is likely referencing a mission to steal weapons from the enemy. A major stepping-stone towards the Japanese occupation of Korea was the Japan-Korea Treaty of 1905 in which the then-Korean Empire was declared a protectorate of Japan. Japanese military police took severe measures to put down all forms of resistance. Following the protectorate treaty in 1905, armed resistance garnered strength when the decommissioned national army fled into the mountains and brought weapons and skill to the armed resistance. Sporadic fighting occurred until 1915. On 1 March 1919, coordinated protests sprung up across the country following a peaceful 'Declaration of Independence' delivered to Japanese officials in Seoul, but this was brutally suppressed and Koreans regrouped and reorganised resistance in and outside of Korea. On 16 December 1931, Kim Il Sung declared openly to annihilate the Japanese forces under the slogan, 'Arms for Arms, Revolutionary Offensive for Counter-Revolutionary Offensive'.

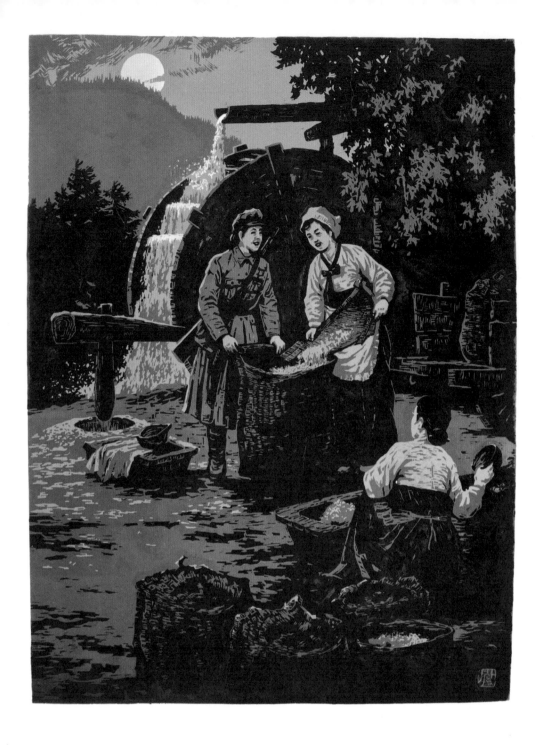

ABOVE: [Untitled] and <u>OPPOSITE</u>: *Watermill Under Moonlight* by Ko Yong Chol, 2007. North Korean history tells of the guerrilla forces who fought in the forests during the day and came down to the villages during the night to educate the locals about their beliefs and efforts to free the country from occupation. In support, the villagers provided food supplies. The revolutionary opera *The Sea of Blood* (credited to Kim Il Sung) was first performed in 1971 and is set in the 1930s during the Japanese occupation. It follows the life of protagonist Sun Nyo and her family as they suffer numerous tragedies at the hands of the Japanese before eventually gaining the willpower and means to join the Communist revolution and fight against their oppressors.

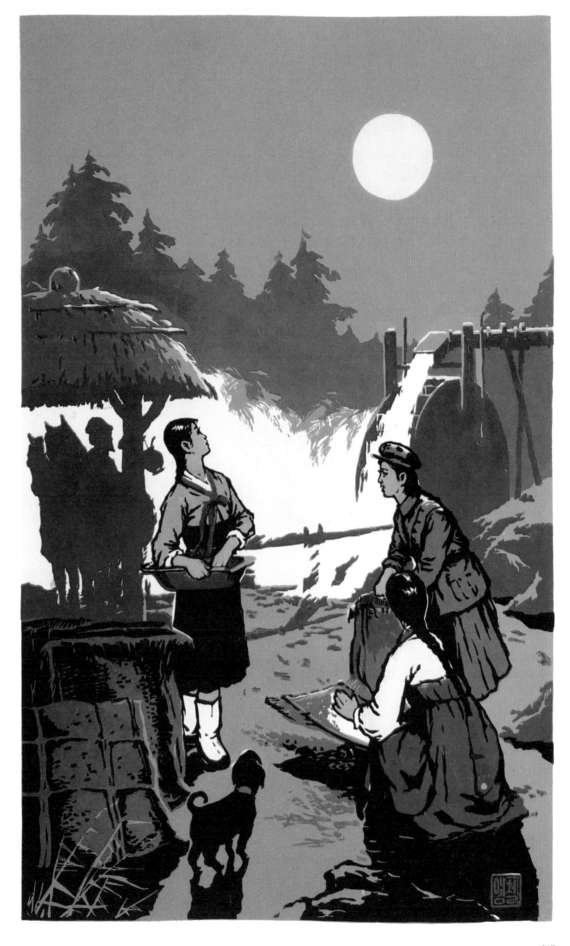

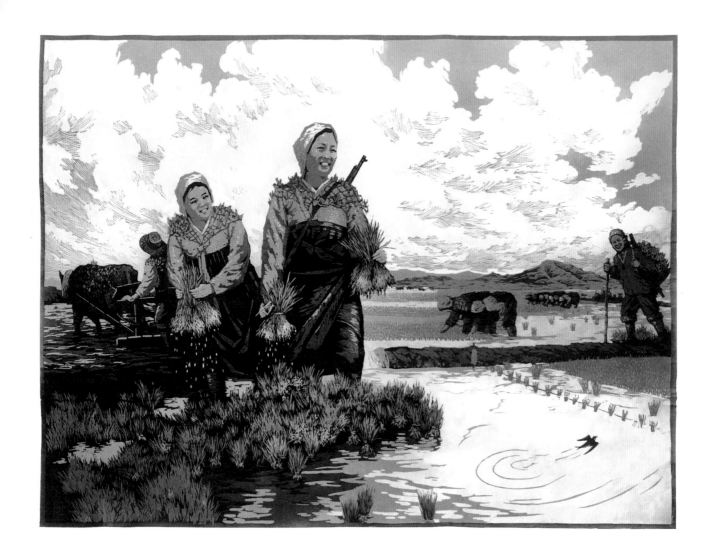

<u>ABOVE</u>: *1953 Spring* by Pak Yong Il. In North Korea the Korean War is referred to as the Fatherland
Liberation War (1950-53). The film *Namkang Village Girls* tells the story of a women's organisation
providing food supplies as part of the war effort. <u>OPPOSITE TOP</u>: *Be Sure to Win Teacher!* by Ri Chang
Su. A teacher volunteers to join the military during the Korean War. As in pre-modern Korea and
South Korea today, teachers have an exalted role in society and are expected to serve as an example
to students in life. <u>OPPOSITE BOTTOM</u>: *Advancing to Victory* by Hwang Chol Ho, 1994. A North Korean
soldier playing his 'instrument' made out of shell cases after a fierce battle. To this day, music
plays a central role in North Korean society. North Korean music draws on a number of themes: loyalty,
faithfulness, patriotism, politics, the military, traditional culture, the economy, romance and science
and technology. Contemporary music groups such as the Moranbong Band have introduced a domestic form
of 'pop music' with new releases and the remastering of old songs.

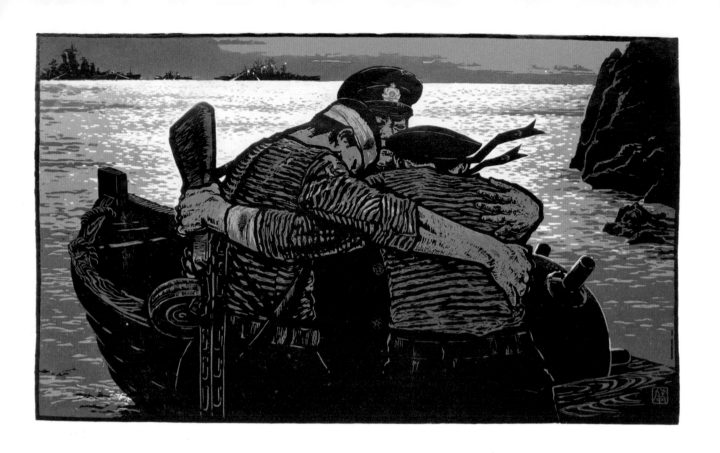

ABOVE: [Untitled] by Song Ho, 1993. Sailors embrace as they prepare to embark on a one-way mission to destroy a US ship with their rowing boat complete with naval mine. This is one of the scenes from the famous Wolmi Island battle where, according to North Korean history, a small group of soldiers delayed MacArthur's Incheon amphibious landings for three days. The sailors become martyrs after their heroic action and are immortalised in the 1982 North Korean film *Wolmido*. OPPOSITE: *Beansprouts of Love* by Kim Yong Nam, 2008. During the Korean War, soldiers fighting in the trenches were given *kongnamul* (bean sprouts) that helped them stay healthy and could be grown underground in the tunnel systems. In the Victorious Fatherland Liberation War Museum, the guide tells the anecdote of Kim Il Sung personally calling Choi Hyun, the commander of the Army at Height 1211 (known as 'Heartbreak Ridge' to the Americans), emphasising that the soldiers should be supplied with bean sprouts.

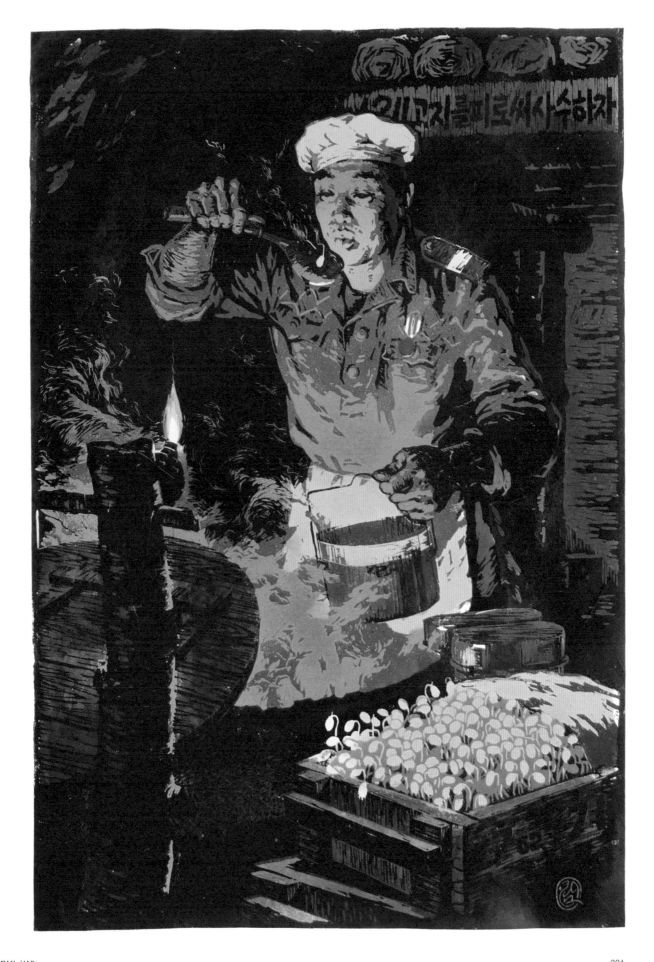

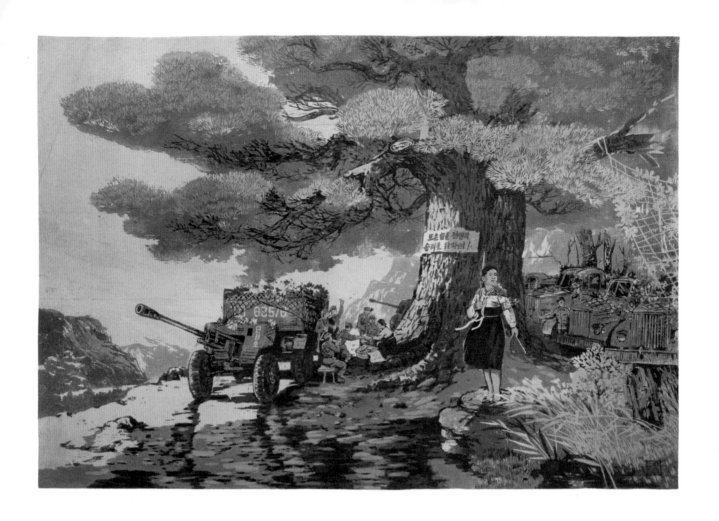

<u>ABOVE</u>: *Heroic Pine* by Ri Pyong Kil, 1984. There are a great many tales of heroism from the Korean War that are known by everyone in North Korea. One of the most unusual is about the 'Heroic Pine' that saved many lives by sheltering vehicles and people from enemy bombers under its extensive branches and canopy. The tree was eventually lost to bombing but the remains of its burned trunk remain on display in the Victorious Fatherland Liberation War Museum in Pyongyang. <u>OPPOSITE</u>: This image of a young Korean girl is from the Korean War. Her dress is the tradional *jogori*, also worn by the guerrilla fighter during the anti-Japanese campaign, however this girl is more likely to be a farmer - the camouflage net she wears around her shoulders is the clue to a different time and conflict - it is to hide from strafing from the US airforce. She is clutching a letter from her loved one fighting on the front lines.

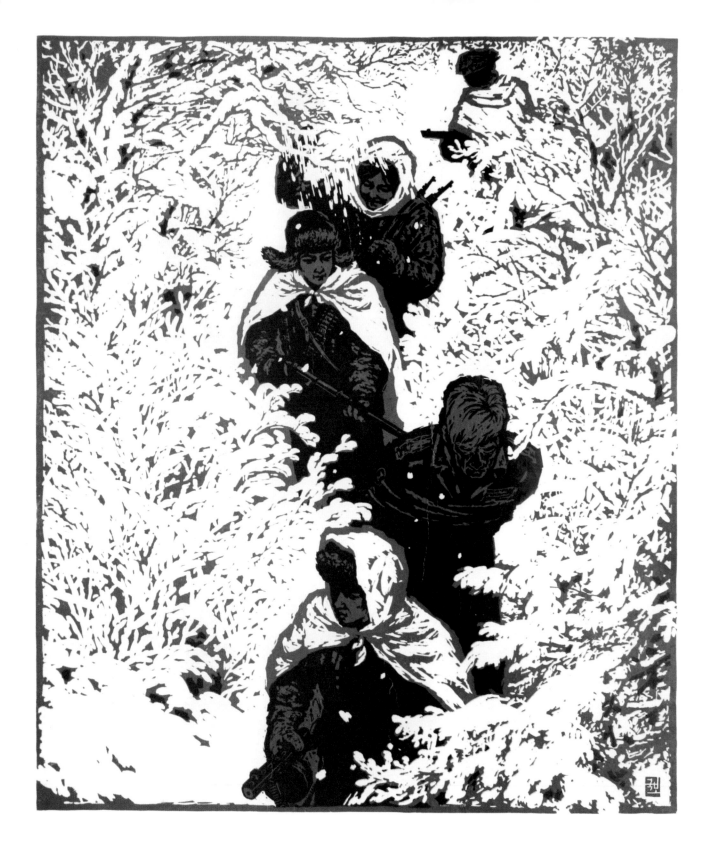

OPPOSITE: *First Accomplishment* by Kim Kuk Po. Soldiers from the Korean People's Army capture a US soldier. Some of the most fearsome and harrowing fighting during the Korean War took place in the midst of winter. It was reported that the conditions were probably the most severe that an American army had ever experienced. <u>TOP</u>: *Teacher* by Kim Un Sun, 1998. A boy performs the Schoolchildren's Union salute to his teacher returning from war. This salute was universal among children in the socialist world. It is accompanied by the shouted words, 'Always Ready!'. <u>ABOVE</u>: *The Spring of Victory* by Ma Yong Chol, 2003. An army nurse brings azalea flowers into a hospital ward, where a poster declares, 'Advancing to Victory'. In film, however, not all is portrayed so brightly. In *The Story of a Nurse*, the heroic nurse dashes into a spray of bullets to save her comrade who lies wounded in the battlefield.

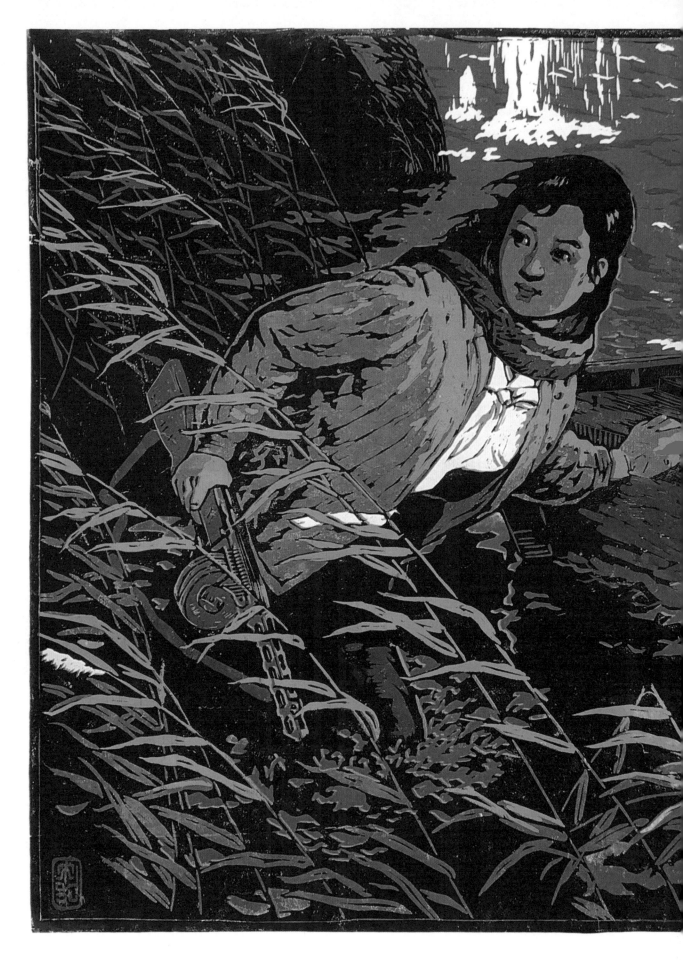

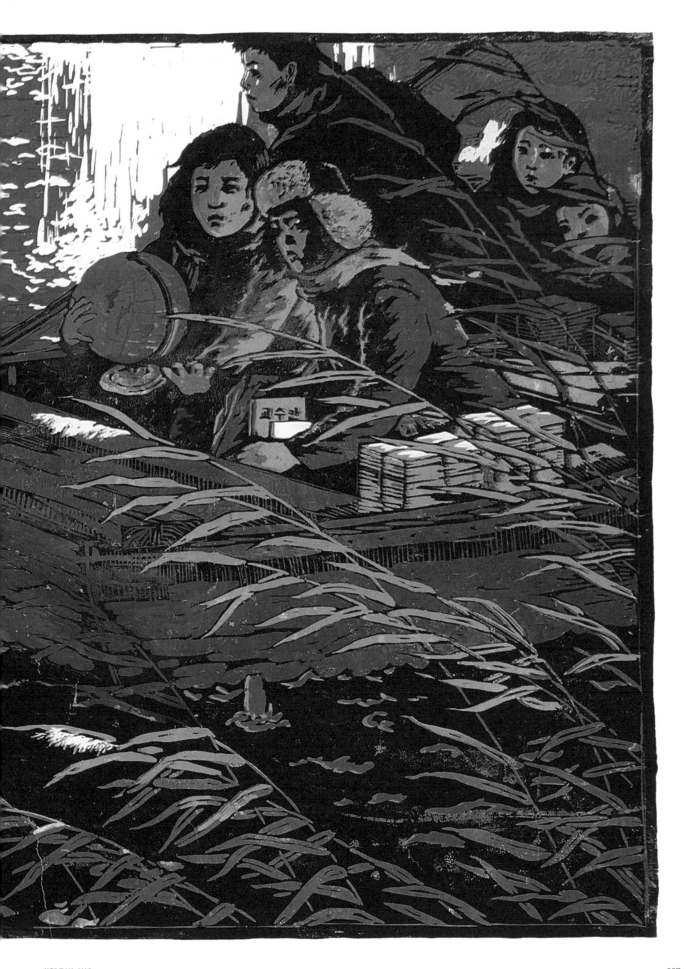

PREVIOUS PAGE: *Going to the General* by Kwon Su Won, 1997. Intellectuals are shown escaping from South Korea during the Korean War and taking their teaching and study tools, including books and a globe, with them to the North.

ABOVE: *Wishing* by Jong Hyon Pok, 1990. Artistic compositions are often copied if seen as the embodiment of a particular theme, in this case an emotive one. The image is of a mother sewing 'Faithfulness and Loyalty' on to her son's rucksack before he undertakes the Exploration March called 'One Thousand-ri Journey for Learning'.

ABOVE: *Waiting For The Victorious Day* by Choe Ryon Pok, 2009. A nurse embroiders 'Victory' into a handkerchief with the image of the Hero of the DPRK medal. Korean girls used to express their love by embroidering the handkerchief of their lovers. During the Korean War, when it was impossible to pop out and buy decent flowers, lovers used to pick wild camomile flowers from the fields. Over the decades, camomiles have become a symbol of love and faithfulness.

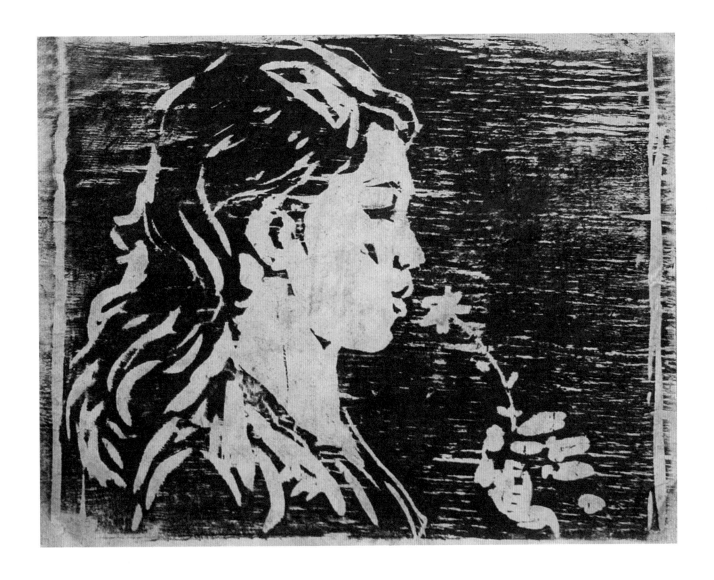

OPPOSITE: [Untitled], 2008 and ABOVE: *Memories of the Girl* by Kim Gon Jung. The image of a Korean girl with a camouflage net over her shoulders watching North Korean MiG fighters in the skies over Korea seems to tie in with the image above, which reflects the vibrancy of youth. This woodcut of a girl with a flower was found in a collection of works by the artist Kim Kon Jung, who has long since died. It probably dates from around the 1950s or 60s. On the reverse the artist had written 'Memories of the Girl' and it seems to be a very personal and intimate work, perhaps of a lost love, but certainly of someone important to the artist. There is an enormous amount of access and study required to understand not only the government-sanctioned art of North Korea as well as the work artists have created in their own time such as this touching example, but also the personalities and background of the artists themselves.

CHOP MARKS

Every DPRK citizen will have an official 'chop' (seal), which they use for official business. These are very simple and commonly made of a clear material such as resin, or wood. The chop is inked by placing it in a thick red paste followed by stamping with enough pressure to leave a clear impression - the imprint of the name is intended to be clearly readable. In contrast, artists' chops are creative and often difficult to decipher. Artists may carve their own seals or design the seal then pass it on to an expert to cut. Once made, the imprint of the seal is registered and cannot to be copied by anyone else - to do so would be considered forgery. Each chop is regarded as personal property and can only be used by that person. Artists may have a dedicated artist name (pen name) with its own chop, and they may have a chop with two names, their true name and their artist's name. The chop marks below represent just some of the chops used on the prints seen in this book.

Ri Sun Sil
19

Ri ong Chun
20

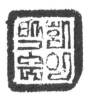

Pak Hwa Song
22

Kim Pun Hui
23

Yun Ok Kyong
24

Ho Kang Min
25

Sok Nam
33

Jae Won
34

Jang Song Pom
35

Ri Hong Chol
35

Han Song Ho
35

Kim Kyong Hun
42

Hwang Chol Ho
49

Kim Kuk Po
30

Hong Chun Ung
60

Jon Chol Nam
27

Kim Un Suk
64

Kim Un Hui
65

Kim Song Ho
67

Pak Chang Nam
68

Chun
68

Jang Song Pom
72

ak Hwa Sun
74

Ro Chi Hyon
75

Pak Won Il
76

Ri Kwang Chol
76

Jong Il Son
84

Kim Won Chol
87

Han Kyong Sik
88

Won Jong
91

Chol Ho
92

Kim Yong Pom
105

Kim Pyong Kil
107

Jong Yong Chol
108

Kim Ung
109

Won Chol Ryong
115

Tong Ha To
117

Kim Kyong Chol
120

Choe Il Chon
125

Kim Hyon Chol
138

Hwang Pyong Kun
141

Kim Hak Rim
142

Kwang Su
143

Hwang In Jae
145

Jang Song Pom
147

Kim Won Chol
149

Jang Jin Su
152

Pak Yong Mi
154

Kim Pong Ju
155

Pae Nam Jun
157

Choe Yong Sun
158

Pak Song Kil
159

Jon Myong Sul
162

Kang Jae Won
168

Choe Yong Sun
169

Kim Sang Ki
178

Ik Hyon
179

Ri Tong Sun
193

A

AFC Asian Cup 140
agriculture 20-32, 141, 163-5
 'agricultural front line' 155
 Arduous March 97
 corn 158, *159*, 163
 land available for 96, 98
 potatoes 100, 163
 rice *24*, *35*, *86*, *88*, 90, 144,
 163
Anbyon Plain *136-7*, 138
animals 22, 185
animistic shamanist practices 133
anthracite 49
anti-aircraft guns *79*
anti-Japanese Guerrilla War 150,
 206-17, 222
 guerrilla fighters in 121, 124,
 126, 131, 172, 204
Arch of Triumph 166, 197
architecture, styles of 61
'Arduous March' *32*, 97, 100, 114,
 155
armistice agreement (1953) 16
army 9
 age of joining up 92
 army and people 84-93
 building labour 99
 contemporary 72-83
 uniforms 72, *72*
 women in the 193, 204-5, 210-11,
 210
Army Paper 63
art, themes *16*, *34*, 111
azaleas 124, *162*, 163, 214, 225, *225*

B

barbecues 149
barbers 172, *172*
beansprouts 220, *221*
Big Dipper constellation 78, *78*
birds, cranes *135*, 138, 198
blankets 170, *170*
Buddhism 133
*Bumper Harvest Has Come to
 Chongsan-ri* (song) 141
Busan International Film Festival
 111
'Byungjin Line' 92

C

camomile flowers 229
camping centres 189
Carter, Jimmy 94
Central Committee of the Korean
 Workers' Party 63
'Cha Kwang Su Youth Shock Brigade'
 34, *37*
Changgwang kindergarten 166
Changja River 116, *116*
Changjon Street, Pyongyang 181
children and childhood 181-7
 male heirs 105
 military games 76
 schools *51*, 184, 186-7, 189
Children's Day (1 June) 187

China 200
 clothing 170
 fishing industry 18
Chinese People's Volunteer Army 55
Choe Chang Hyon, *Night at the
 Persimmon Guard Post 80*
Choe Il Chon,
 Water of Our Homeland 125
Choe Jae Sik, *The Dance in Her
 Thoughts 161*
Choe Myong Kuk, *Scientists 50*
Choe Ryon Pok, *Waiting For the
 Victorious Day 229*
Choe Yong Sun
 Painting Pyongyang 59
 Researching New Seed 158
 Untitled 32
Choi Hyun 220
Chol Ho, *Untitled 92-3*
Chol Hun, *Untitled 89*
Chol Su, *Rabbits 185*
Chollima Movement 44, 46, 66
Chollima Steelworks 44, *45*
Chon, Lake 120
Chondogyo 133
Chongbong Bivouac 121
Chongsan-ri cooperative farm 141
'Chongsan-ri method' 141
'Chongsan-ri speed' 141
chop marks 232-5
Choson Central Television 149
Choson Dynasty (1392-1910) 133
Christianity 133
Chun, *Untitled 71*
cinema 149
class distinction, elimination
 of 53
Class Monitors 185
clothing 170
 guardian clothes 76
 jogori 144, *179*, 222, *223*
 military 72, *72*
 school uniforms 185, 189
CNC (Computer Numerically
 Controlled machine tools) Era
 155
co-operation, socialist 111
'coal front line' 155
coal mining 48-9, 52, 107
 staff ranking 50
colours, residential buildings 58
'comfort women' 211
Communist Bloc, collapse of 106
Comrade Kim Goes Flying (film) 111
Confucianism 133
construction, infrastructure 106-13
corn 158, *159*, 163
cotton spinning 170, *171*
cranes 198
 red-crested white *135*, 138

D

Daeboreum Festival 144
Dano Day 144
Day of the Shining Star (16
 February) 184, 195
Day of the Sun (15 April) 184, 195
Declaration of Independence (1919)
 215
decorations, workplace 52

deforestation 134, 154
Demilitarised Zone (DMZ) 16, 134
Dokdo Island 16
driving schools 193

E

Echoes of the Ulim Falls (song) 126
ecology 134
education 62, 184, 186-7, 189
 camping courses 189
 school report cards *51*
 uniforms 185, 189
'Eight Scenes of Pyongyang' 152
Eighteenth Fishery Company *18*
embroidered handkerchiefs 229
energy 107, 114, 116
Exploration March 124, *124*, 126, 228

F

factory workers *38-9*
families, male heirs 105
farming 20-32, 141, 163-5
 'agricultural front line' 155
 Arduous March 97
 corn 158, *159*, 163
 land available for 96, 98
 potatoes 100, 163
 rice *24*, *35*, *86*, *88*, 90, 144, 163
Fatherland Liberation War (Korean
 War) (1950-53) 62, 195, *205*,
 218-31
 Big Dipper constellation 78
 deforestation and pollution 134
 industrial base during 44
 Jo Gun Sil 64
 rail network during 118
fertiliser 20-1, *34*, 107
films 163
 Ask Yourself 30
 Comrade Kim Goes Flying 111
 Fourteenth Winter (film) 158
 The Girl Barber 172
 Namkang Village Girls 218
 Road 58
 The Schoolgirl's Diary 178
 A State of Mind 116
 The Story of a Nurse 225
 themes *16*, *34*, 111
 Wolmido 220
fishing
 fishing competition 149
 fishing industry 14-19
flags, Supreme Commander's 76, *76*
flowers
 azalea 124, *162*, 163, 214, 225,
 225
 camomile 229
 flower festivals 197
 Kimilsungia 195, 197
 Kimjongilia 195
 magnolia 200
 national flowers 198
 rosa rugosa 81
folklore 114
food 134
 beansprouts 220, *221*
 military food 72
 production of 96, 97

 Public Distribution System 72
football (soccer) 140, *141*, 149
forests *154*
 deforestation 134, 154
 reforestation 154
Fourteenth Winter (film) 158
fridges 181
front line, women on the 204-5
funfairs 144, *147]*

G

games, traditional 141, 142-5, 182-3
gender equality 105, 155
The Girl Barber (film) 172
goats 22, *23*
gold 49
grapes 166
greenhouses 74
ground houses 181, *181*
Guerrilla War, anti-Japanese 150,
 206-17, 222
 guerrilla camps 204
 guerrilla fighters 121, 124,
 126, 131, 172, 204
Gwangju Uprising 203

H

haircuts 172, *172*
Han Kyong Sik
 After the Liberation 212
 One Mind 88
Han Song Ho, *Winter of Samsu 114*
Han Sung Won
 Steel Soldier 44
 *Train Whistle of the Northern
 Part 115*
handkerchiefs, embroidered 229
Hang Song Ho
 News 174
 Untitled 35
harvest *29*, *33*
heirs 105
helicopter stories 118
Hero of Labour Medal 178
Hero of the Republic *186*, 187, 204
Heroic Pine 222
Heungbu and Nolbu 89
Hidden Heroes 158, 163
hide-and-seek 182
Ho Kang Min, *Support 25*
Ho Song Chol,
 *Congratulations to my
 Innovative Father 48*
holidays 149
 national holidays 184, 195
Hong Chung Ung, *Pride 60-1*
Hong Ji Song, *Large County 192*
Hong Jong Hwa *160*, 161
Hong Jun Sik,
 February Night 195
Hong Jun Sok,
 The Sound of the Bell 204
horses, white *212*, 213
housing, rural areas 181
'Huichon Hour' 26
Huichon Power Station *25*, 26, *112*
'Huichon Speed' 26
Hungnam 34

Hungnam Chemical Fertiliser Plant 177, *177*
Hungnam girls 177, *177*
Hwang Chol Ho
 Advancing to Victory 219
 Coal Miners 49
 The Father and the Son 51
Hwang In Jae
 Bean Harvest 164
 Big Blast and Controlled Explosion at Construction Site 99
 Break Time 47
 Folk Games, Horse Riding 183
 The Scent of Potatoes 100-1
 Seesaw 145
 Untitled 105, 122, 214
 Worthwhile 46
Hwang Pyong Kun, *Our Player Has Won! 141*
Hwang So Hyang
 Pine Trees at the Tomb of King Tongmyong 153
 Silk Girl 176
 Stardust of Samjiyon 96
hydroelectric power 107, 114, 116
Hyonam Temple *133*

I

ideological study 16
Ik Hyon, *Untitled 179*
Imjin War (16th century) 152
Immortality Towers 135
industrial plants *34*, *35*
industries 38-55
 coal mining 48-9, 50, 52, 107
 farming 20-32, 96, 97, 98, 100, 141, 154-5, 158-9, 163-5
 fishing 14-19
infrastructure 106-13
iron 49
irrigation projects 100

J

Jae Won, *Untitled 34*
Jagang Province 114
Jang Jin Su, *Daeboreum 152*
Jang Ok Ju, *Holiday 146*
Jang Song Pom
 August Morning 70
 Hyonam of Mount Jangsu 133
 Older Brother 72
 Taesongsan Resort 147
 Untitled 35
Jang Su Il, *Ulim Waterfall 128-9*
Janggu 160
Jangsu, Mount *133*
Japan *67*, 70
 anti-Japanese Guerrilla War 110, 121, 124, 126, 131, 134, 150, 172, 204, 206-17, 222
 'comfort women' 211
 Dokdo Island *15*
 industry 42
 Korean language 110, 213
Japan-Korea Treaty (1905) 215
Jegichagi 182
Ji'an 153

Jo Chol Jin, *Untitled 97*
Jo Gun Sil 64, *64*
Jo Gun Sil Wonsan Technical University *64*
Jo Kum Hyang 193
Jo Yong Pom, *Untitled 28*
jogori 144, *179*, *222*, *223*
Jon Chol Nam
 Today's Newspaper 63
 Untitled 27
Jon Chun Hui, *Il Dang Paek Soldiers 77*
Jon Myong Sul, *Research 162*
Jong Ho, *Untitled 113*
Jong Hyon Ho, *6:1 Holiday 187*
Jong Hyon Pok, *Wishing 228*
Jong Il Son
 One Mind 84-5
 Spring at the Orchard 96
 Sunday 148
Jong Kwang Su, *Untitled 52*
Jong Sung Ok 140
Jong Yong Chol, *Untitled 108*
Jong Yong Chong, *Creators of Reclaimed Lands 98*
Ju Si Ung, *Night at the Port 15*
Juche Flame 64
Juche Realism 11
Juche Tower 166

K

Kae Chung Il, *The Hero Who Returned to his Alma Mater 186*
Kaeson kindergarten 166
Kaesong 151
Kalma 99
Kang Chol Won, *Untitled 200*
Kang Jae Won
 Marshalling Woman 168
 Untitled 169
Kang Sang Ho, *Plunge Under Fire 210*
Kangson Steelworks 42, 44, *44*
Kangwon Province 138
Karyun Conference (1930) 40
kelp 18, *19*
Kim Chol Ho, *Pyongyang Girl 53*
Kim Chol Hun, *Big Blast and Controlled Explosion at Construction Site 99*
Kim Chol Jun, *Innovators 48*
Kim Chol Un, *Night 28*
Kim Chol Won, *The Birds Flying In 90*
Kim Chung Kuk, *Soldiers and the Future 86*
Kim Dal Hyon, *They Hear the Rice Sway 86*
Kim Gon Jung, *Memories of the Girl 231*
Kim Hong Po, *Fighting Against Time 105*
Kim Hyan Chol, *Bumper Harvest Has Visited the Chongsan Plain 142*
Kim Hyon Chol, *Players 138-9*
Kim Hyong Jik, anti-Japanese movement 150
Kim Il Sung,
 100th anniversary of birth 58, 181
 Anti-Japanese Guerrilla War 121, 126, 215
 birthplace 71
 Changgwang kindergarten 166

childhood 124, 210
Day of the Sun 184, 195
formation of North Korea 131
importance of steel 42
Kim Hyong Jik 150
Korean War 78, 220
Kumsusan Palace of the Sun 135, 198
liberation of Korea 213
'One for all and all for one' slogan 46
Order of Kim Il Sung 178
Reminiscences of Kim Il Sung 213
The Sea of Blood 216
seventieth birthday 64
Songun policy 40
Taedoksan 53
'Triumphant Return' 197
West Sea Barrage 94
white horses *212*, *213*
wife 70, 177
Kim Il Sung University 190
Kim Jong Il
 Day of the Shining Star 184, 195
 Juche realism 11
 Kim Il Sung University 190
 Kimjongilia 195, *197*
 Kumsusan Palace of the Sun 135, 198
 'military-first' policy 78
 mother 177
 On Fine Art 11
 On the Juche Idea 203
 Persimmon Squadron 74, 81
 Sariwon 151
 'Serve the People' slogan 86
 soybean harvest 163
 Taehongdan 163
 Ulim Waterfalls 126
Kim Jong Suk, grave of 70
Kim Jong Suk textile complex 177
Kim Jong Un
 'Byungjin Line' 92
 fishing industry 18
 Panmunjom Declaration (2018) 168
 quotes by 13, 36, 56, 82, 102, 130, 156, 180, 206
 supersonic fighter pilots 193
 tree planting 154
Kim Kon Jung 231
Kim Kuk Po
 Autumn in Anbyon 136-7
 First Accomplishment 224
 Fruits of Love 165
 Girl in the Forest 30-1
 Hide-and-Seek 182
 On Empty Lands 55
 Proud 121
 With Affection 160
Kim Kum Sun 204
Kim Kwang Nam
 Artistic Propaganda Group 37
 Untitled 167
Kim Kyong Chol, *Summer at Chongbong 120*
Kim Kyong Hun, *Flames 42*
Kim Ok Son
 First March 214
 Spring Wind 190-1
Kim Po Sok, *To My Dear Grandmother 194*

Kim Pong Ju
 During Break Time 155
 Wait For Us 209
Kim Pun Hui, *Joyful Farmers 23*
Kim Pyong Kil, *The Country Will Not Forget the Soldiers 106-7*
Kim Sang Ki, *Congratulations From Their Son 178*
Kim So Wil 117
Kim Song Ho, *We Will Never Forget! 67*
Kim Un Hui, *Going to a Congratulatory Performance 65*
Kim Un Suk, *Jo Gun Sil, The Spirit of the Hero 64*
Kim Un Sun, *Teacher 225*
Kim Ung, *Taechon Power Plant Barrage 109*
Kim Ung So, General 152
Kim Won Chol
 Cable Car of Love 123
 February of Northern Part 197
 First Flower of the Triumphant Return 196
 Helicopter of Love 118
 Morning at Sukyonggak 122
 One Mind 87
 Untitled 149
Kim Yong Ho, *The Big Dipper 78*
Kim Yong Hwan, *Samjiyon 127*
Kim Yong Nam, *Beansprouts of Love 221*
Kim Yong Pom, *Our Blanket 170*
Kim Yong Thae, *Big Blast and Controlled Explosion at Construction Site 99*
Kimilsungia 195
Kimjongilia 195, *197*
kindergartens 10, 166, 184
kisaeng 152
Ko Il Chol, *Rosa Rugusa of my Heart 81*
Ko Ju Mong 153
Ko Yong Chol
 During the Exploration March 124
 Watermill Under Moonlight 217
Ko Yong Il, *Light 116*
Koguryo kingdom (37BCE-668 CE) 153
Koguryo Tombs 151
kongnamul 220, *221*
Korean Artists' Federation 9, 11
Korean Peninsula
 armistice agreement (1953) 16
 division of 131
Korean People's Army 160, *224*
Korean People's Army Air and Anti-Air Force 78, *79*
Korean People's Revolutionary Army (KPRA) 121
Korean War (Fatherland Liberation War) (1950-53) 62, 195, *205*, 218-31
 Big Dipper constellation 78
 deforestation and pollution 134
 industrial base during 44
 Jo Gun Sil 64
 rail network during 118
Koryo Dynasty (918-1392) 133, 151
Kumsusan Palace of the Sun (Kumsusan Memorial Palace) 70, 78, 135, 198, *198-9*

Kwang Su, *Yut Games 143*
Kwangbok Street, Pyongyang *68-9*
Kwon Hyong Man, *Electric Locomotive
 Construction 119*
Kwon Kang Chol, *Romantic Youth 112*
Kwon Su Won, *Going to the General
 226-7*
Kye Wol Hyang 152
Kyong Sik, *Untitled 58*

L

Labour Hero Medal *57*, 58
Lake Chon 120
land, reclaimed 94-101
language, Korean 124
 under Japanese rule 110, 213
leaders 10, 194-9
league tables 50, 174
leisure 144, 146-53
Liberation Day (15 August) 70, 131
Liberation Monument 54, *54*
lighthouses 132, *132*
literature, themes 16, 111

M

Ma Yong Chol,
 The Spring of Victory 225
magnesite 49
magnolias 198
magpies *24*, 26
male heirs 105
Manchukuo (Manchuria) 210, 214
Mangyongdae 42, 71, *71*
Mansu Hill 66
Mansudae Art Studio 9-10
March First Movement 150
marriages 26, *26*, 144, 170
Masikryong Ski Resort 76, 99
Merited Artist award 10
MiG aircraft 78, *79*, *230*, *231*
military 9
 age of joining up 92
 army and people 84-93
 building labour 99
 contemporary 72-83
 uniforms 72, *72*
 women in the 193, 204-5,
 210-11, *210*
Min Song Sik, *Untitled 43*
mineral resources 49, 134
Ministry of Public Security 9
Mirae Street, Pyongyang 181
Miru Plains irrigation channel 100
Mitsubishi Steelworks 44
Modernist 61
Moon Jae In, President 154
 Panmunjom Declaration (2018)
 168
Moranbong Band 218
Moranbong Park *54*
Mount Jangsu *133*
Mount Myohyang 189
Mount Paekdu 120-7, 131, 207
Mount Ryongak 189
Mount Taesong 67
music 218
 *Bumper Harvest Has Come to
 Chongsan-ri 141*

Echoes of the Ulim Falls 126
My Country is the Best 168
The Sea of Blood 216
Song of the Sea ballard 17
*Victorious Workers' Party of
 Korea 132*
Where are you, my General? 78
My Country is the Best (song) 168
Myohyang, Mount 189

N

Namkang Village Girls (film) 218
Nampo 34
Nampo Youth Hero Highway 104, 105
Nation and Destiny (TV series) 195
National Flag Medal 160
national holidays 184, 195
nature 128-37
Neo-Classical 61
neo-Confucianism 133
New Year 66
newspapers 63
norigae 144
North Hwanghae Province 151
North Korean Air Force 193
nuclear programme 94
'No. 26' awards 172

O

'One Thousand-ri Journey for
 Learning' pilgrimage 124, 228
operas, *The Sea of Blood* 216
'organisational life' 190

P

Pae Nam Jun, *Meteorological
 Observations 157*
Pae Un Song
 *After The War Reconstruction
 Site 54*
 *Taetaryong Road Construction
 Site 110*
Paek Kil Un, *Rail 173*
Paek Sol Hui 158
Paek Un Ju
 Hide-and-Seek 182
 Potato Researcher 163
Paekdu, Mount 120-7, 131, 207
'Paekdu Historic Site Exploration
 March' 124, 126
Pak Ae Sun, *The Spring of Life 57*
Pak Chang Ho, *Morning at Lighthouse
 Island 188*
Pak Chang Nam, *Worthy Workplace
 68-9*
Pak Hwa Sun
 The General is Here 74
 Goat Herder 22
 *Rich Supplies of Food for the
 Military 73*
Pak Kwang Hyok
 Flourishing Dreams 189
 Messenger 213
Pak Myong Chol, *Untitled 202*
Pak Song Chol, *The Pride of the
 Inminban 140*

Pak Song Kil, *Teen Brigade Leader
 159*
Pak Un Ju, *Worthy 166*
Pak Won Il, *Soldiers of the North 76*
Pak Yong Il
 1953 Spring 218
 Holiday 148
 Hyonam of Mount Jangsu 133
 Lighthouse 132
 Marching on the First Morning 67
 Night at Tongil Street 66
 The Night of Saja Peak 131
Pak Yong Mi, *For a Green Forest 154*
Pang Son Hwa, *Our Factory 40-1*
Panmunjom 154
Panmunjom Declaration (2018) 168
parties 149
patriotism 207, 218
People's Artist award 10
Persimmon Squadron 74, *74*, 81
Physical Training and Hygiene
 Monitors 185
picnics *16*, *17*
piggy-back fighting 182
pigs 22, *23*
pine trees 135, 222
Pochonbo Battle 126
population 96
potatoes 100, 163
 Potato Revolution 163
Pothong River 138
 Pothong River Improvement
 Project 138
powerplants *35*, 107, 114, 116
pride 34-7
propaganda
 images 8-9, 182, 200
 mobile propaganda units 205
 propaganda vans 52, 106
Public Distribution System 72
Pubyok Pavilion 152
Pueblo, USS 195
Pukchon River 114, *114*
Pyong Su, *Yut Games 143*
Pyongyang
 building of 57-71, 99, 110, 181
 East Pyongyang 58
 energy supply 107
 funfairs 144, *147*
 Immortality Towers 135
 Kimilsungia and *Kimjongilia*
 displays 195
 Koguryo kingdom 153
 post-Korean War reconstruction
 54, *55*
 textile factories *176*, 177
 Tower of Juche Idea 65
 West Pyongyang 58
 West Sea Barrage 94
 wrestling 144
Pyongyang Circus *68-9*, 205
Pyongyang News 63
Pyongyang University of Fine Arts
 (PUFA) 9, 10

R

Railway Ministry 9
railways 168
 electrification 26, *27*, 118
 steam 40, *40-1*

women at work on *173*, *174*, *175*,
 178
religion 133
Republic Hero Medal 70
retirement 58
Retro-Futurism style 61
Revolutionary Martyrs' Cemetery
 67, 70
Ri Chang Ho, *Music Class 187*
Ri Chang Su, *Be Sure to Win Teacher!
 219*
Ri Hak Mun, *During a Break From
 Training 80*
Ri Hong Chol
 Jegichagi 183
 Untitled 35
 *With Our Skill and Strength
 38-9*
Ri Jong Hwa, *New Text Books 184*
Ri Ju Hyok, *Worthy 103*
Ri Ju Song, *War Site of June 126*
Ri Kang Il, *Untitled 18*
Ri Kuk Chol
 Introduction of a New Book 189
 *Visiting the Memorial Palace
 198-9*
Ri Kwang Chol
 Night at Pukchon River 114
 Officers' Wives 76
Ri Pong Chun, *Autumn in Chongsan-
 ri 20-1*
Ri Pyong Kil, *Heroic Pine 223*
Ri Sok Nam, *Sea Farmers 17*
Ri Sun Sil
 Kelp 19
 Untitled 32
Ri Tong Sun, *After Training 193*
Ri Yun Sim, *Night at the Port 14*
rice *24*, *35*, *86*, *88*, 90, 144, 163
Rim Chol, *Steelworkers 45*
Rim Sol 193
Rimyongsu Waterfall 120
rivers 114
Ro Chi Hyon, *The Greenhouse of our
 Company 75*
Road (film) 58
Rodong Sinmun 63
Roman Catholicism 133
rosa rugosa flowers 81
rowing *138-9*
rural 114-19
Ryomyong Street, Pyongyang 181
Ryon Kwang Chol, *The Panorama of
 Migok-ri 97*
Ryongak, Mount 189
Ryongsan-ri 153
Ryu Sang Hyok
 Folk Street 151
 The Hero and the Children 194

S

Sacred Mountain of the Revolution
 120-7
Saja Peak 131, *131*
Sajabong Secret camp 131
salutes, Schoolchildren's Union
 225, *225*
Samji Lake 126, *127*
Samjiyon Grand Monument 126
Samsu 117

sanctions, international 49, 170
Sariwon 151
Sariwon Potassium Fertiliser
 Factory 107
saunas 149
'Scenes of Songun' 163
Schoolchildren's Palaces 187
Schoolchildren's Union 89, 225, *225*
The Schoolgirl's Diary (film) 178
schools 62, 184, 186-7, 189
 camping courses 189
 school report cards *51*
 uniforms 185, 189
The Sea of Blood (opera) 216
seas, crashing 132
secret camps 131
seesaw 144, *145*
Seventh World Championships (1999)
 140
Sex Equality Law (1946) 105
Shamanism 133
Shinto 133
Shock Brigades *37*, 53, *58*, 104, *104*,
 105, *112*
Si Ung, *Untitled 134*
Sim Won Sok, *Snowflakes of
 Rimyongsu 123*
Sixtieth Anniversary of the Korean
 People's Army Foundation 160
ski patrols *76*
ski resorts 76, 99
slogans
 at schools 187
 ideological 106
 most common 168
 slogan trees 121
social adherence 104
Socialism Moral Monitor 185
socialist co-operation 111
Socialist Constitution 46
Sok Nam, *Good Harvest 33*
soldiers
 age of joining up 92
 army and people 84-93
 building labour 99
 contemporary 72-83
 solider-martyrs *62*
 uniforms 72, *72*
 women in the 193, 204-5,
 210-11, *210*
Song Chol, *Untitled 50*
Song Ho, *Untitled 220*
Song In Chol,
 The Girl and the Boy 16
Songdowon International Children's
 Camp 189
songs
 *Bumper Harvest Has Come to
 Chongsan-ri* 141
 Echoes of the Ulim Falls 126
 My Country is the Best 168
 *Victorious Workers' Party of
 Korea* 132
 Where are you, my General? 78
Songun policy *38-9*, 92
South Korea
 anti-government events 203
 armistice agreement (1953) 16
 civilian contact between North
 Korea and 200
 democratisation struggle 203
 identifiable tropes 200

Korean War 62, 78, 134, 195,
 205, 218-31
 teachers 218
 transport networks into North
 Korea 118, 168
Soviet Union 55, 154
 anti-Japanese Guerrilla War 214
 liberation of Korea *54*
 occupation of North Korea 131
 Soviet-style architecture in
 North Korea 61
soybeans 163, *164*
'Speed Battle' slogan *14*
sport 138-41
Sports Paper 63
spring 117
Stalin, Joseph 11
A State of Mind (film) 116
steel 42, 44, *45*
 'steel front line' 155
stereotypes, regional 114
The Story of a Nurse (film) 225
students, volunteering 190
Sunchon 168
Sunchon Cement Plant 40, *40-1*
Sundays 149
supersonic fighter pilots 193
swallows *88*, 89
swinging 144, *146*
Syngman Rhee 131

T

Tabaksol Guard Post 40, *79*
Taechon Power Plant Barrage 107, 109
Taedoksan *53*
Taedong Gate 55
Taedong River *79*, 138, 152
 West Sea Barrage *94-5*
Taehongdan 100, 163
'Taehongdan Spirit' 100
Taesong, Mount *67*
Taesongsan Park 200
Taetaryong Dong 110
Taetaryong Road *110*
Tale of Chun Hyang 144
televisions 181
textile factories and workers 170-2,
 176, 177, *179*
Third Seven-Year Plan (1987-93)
 98, 107
Three-Revolution Red Flag Movement
 141, 189
tidal wetlands 98
timber 134, 154
 timber transportation 114
Tong Ha Nul, *Morning 29*
Tong Ha To
 One Mind 111
 Our Country 207
 Spring of Samsu 117
Tonghak 133
Tongil Street, Pyongyang *66*
Tongmyong, King 153, *153*
Tower of Juche Idea *65*
Traffic Ladies 167, *167*
trains 168
 electrification 26, *27*, 118
 steam 40, *40-1*
 women at work on *173*, 174, *175*,
 178

transportation 114
trees
 deforestation 134, 154
 Heroic Pine 222
 pine trees 135, 222
 reforestation 154
 slogan trees 121
 Tree Planting Day (2 March) 154
Tuman River 114, *115*
tungsten ore 49
TV series, *Nation and Destiny* 195

U

Uiju *150*
Ulim Waterfalls 126, *128-9*
UNESCO 151
unification 200-3
United States of America
 Korean War 220, *224*, 225
 South Korea 131
United States Information Services
 202, 203
unity
 importance of *29*
 of troops *83*, 86
USSR 55, 154
 anti-Japanese Guerrilla War 214
 liberation of Korea *54*
 occupation of North Korea 131
 Soviet-style architecture in
 North Korea 61

V

Victorious Fatherland Liberation
 War Museum *194*, 195, 220, 222
Victorious Pochonbo Battle Monument
 126
Victorious Workers' Party of Korea
 (song) 132
Vietnam War (1955-1975) 78
volunteer work 190

W

West Sea Barrage *94-5*, 104
West Sea of Korea 94, 98
wetland protection 98
Wolmi Island 220
Wolmido (film) 220
women
 anti-Japanese Guerrilla War
 210-11, *210*
 at work 154-79
 'comfort women' 211
 fishing industries 17
 gender equality 105, 155
 male heirs 105
 in the military 193, 204-5, 21
 railways 173, 174, 175, 178
'Women Turn Half the Cartwheel of
 History' 105
Won Chol Ryong, *Raft on the Tuman
 River* 115
Wong Jong, *Spring Rain 91*
Wonsan 189
Workers' Paradise 11
Workers' Party of Korea 8-9, 11, 167

acceptance into 30
 fifty-fifth anniversary 105
 newspaper 63
working week 66
World Cup (1966) 140, 141
World Festival of Youth and
 Students (1989) 70
wrestling 144

Y

Yalu River 116, 117, 153
Yang Yong Su, *Reunify the Country*
 201
Yellow Sea 94, 98
youth 188-93
 heroism and romanticism of 16,
 17
Youth Paper 63
Yun Ok Kyong, Good News 24
yut 141, 144

Z

zinc 49